ERICKA —

TO FINDING THE RIGHT H

GOOD LUCK — Patricia Underwood.

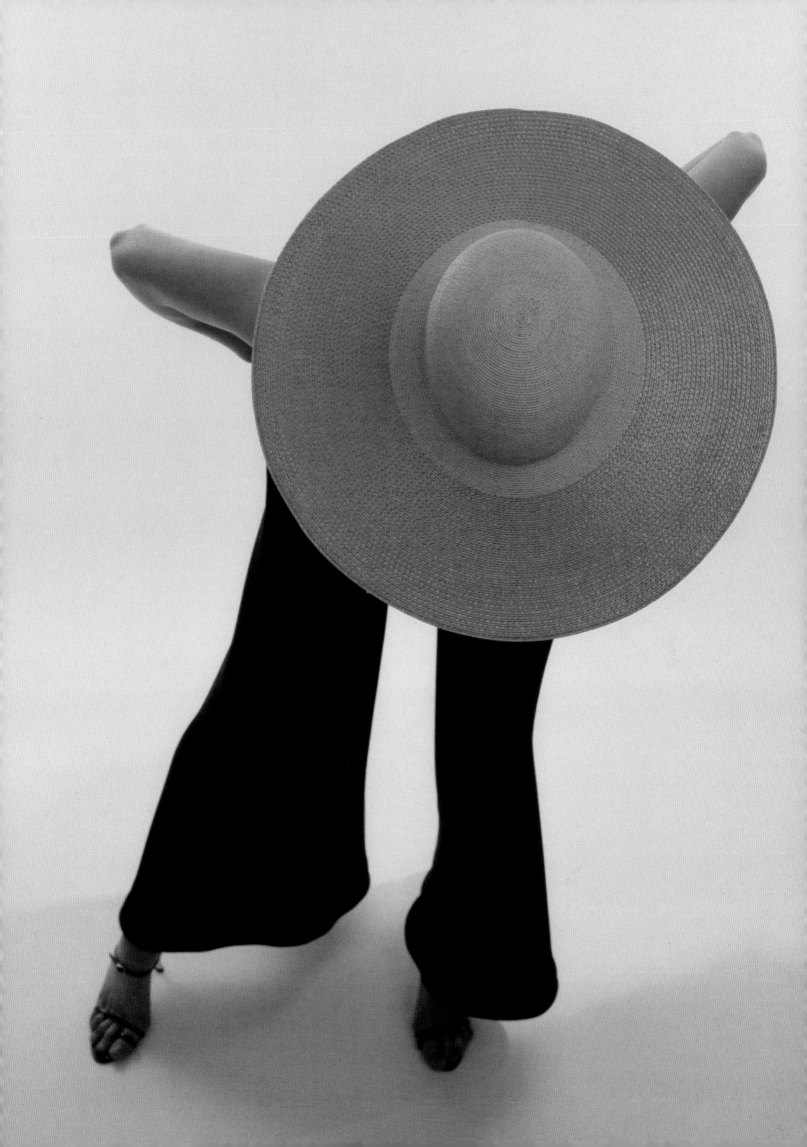

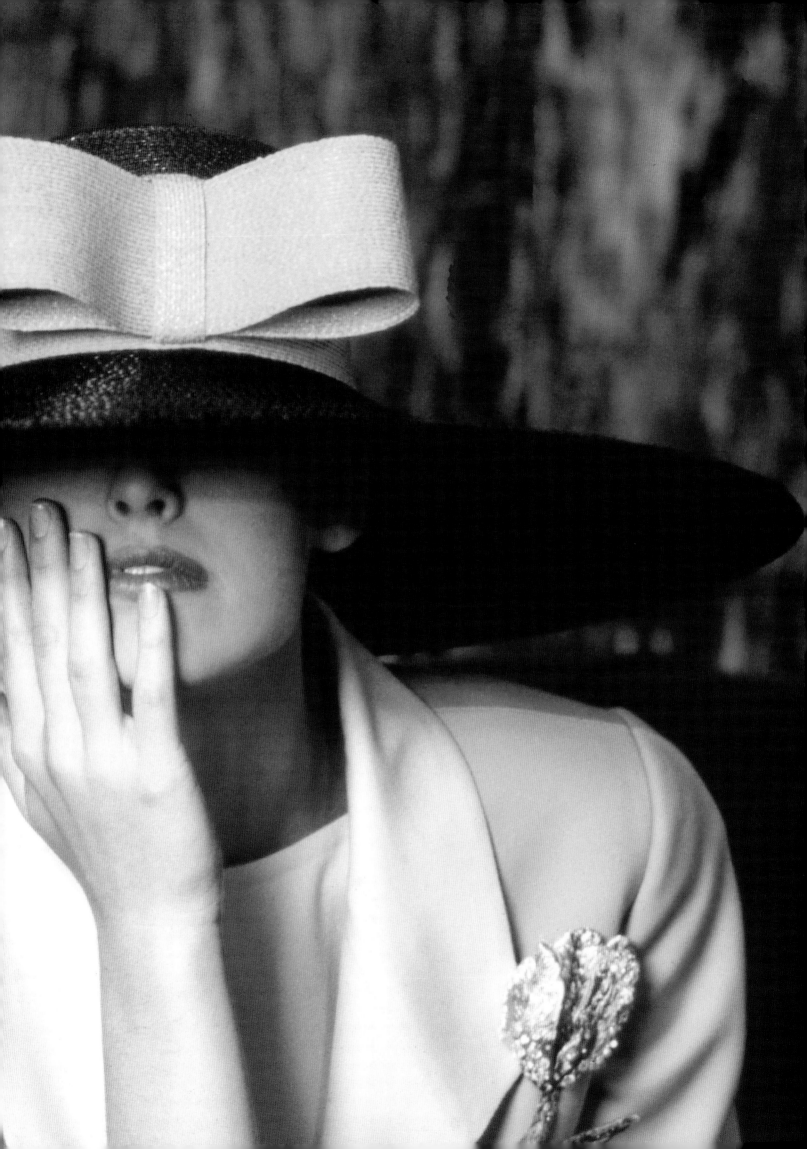

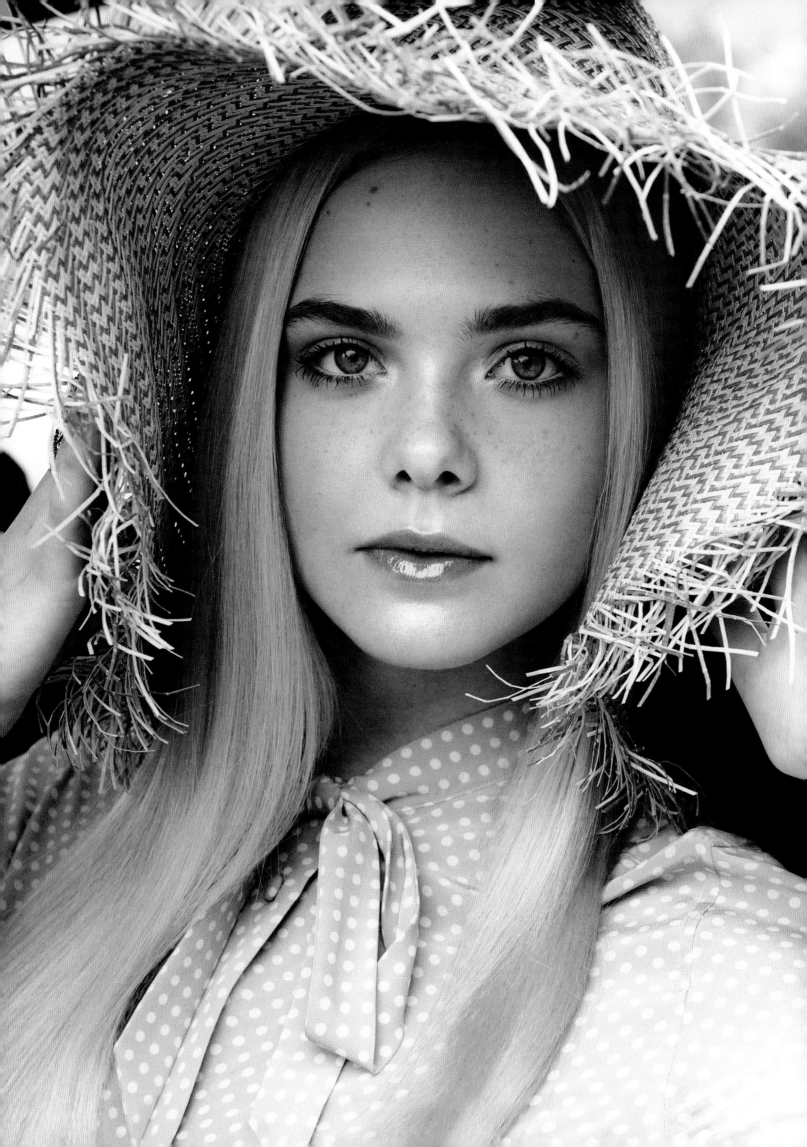

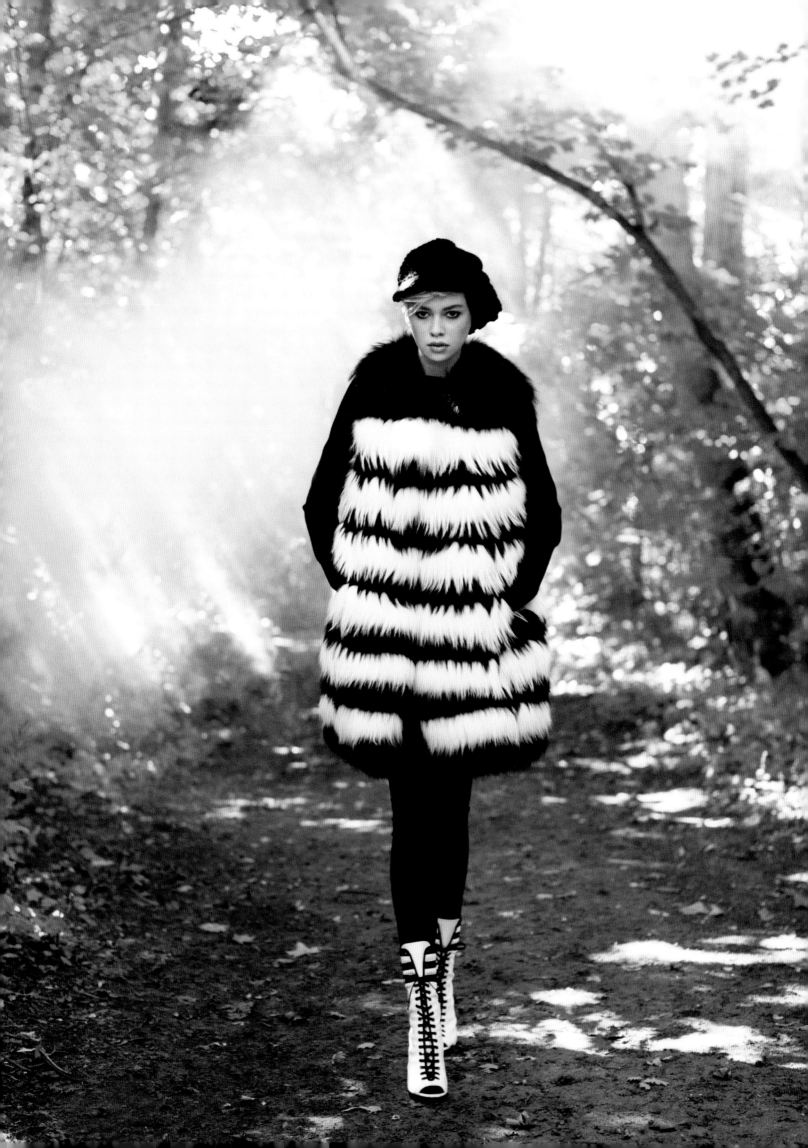

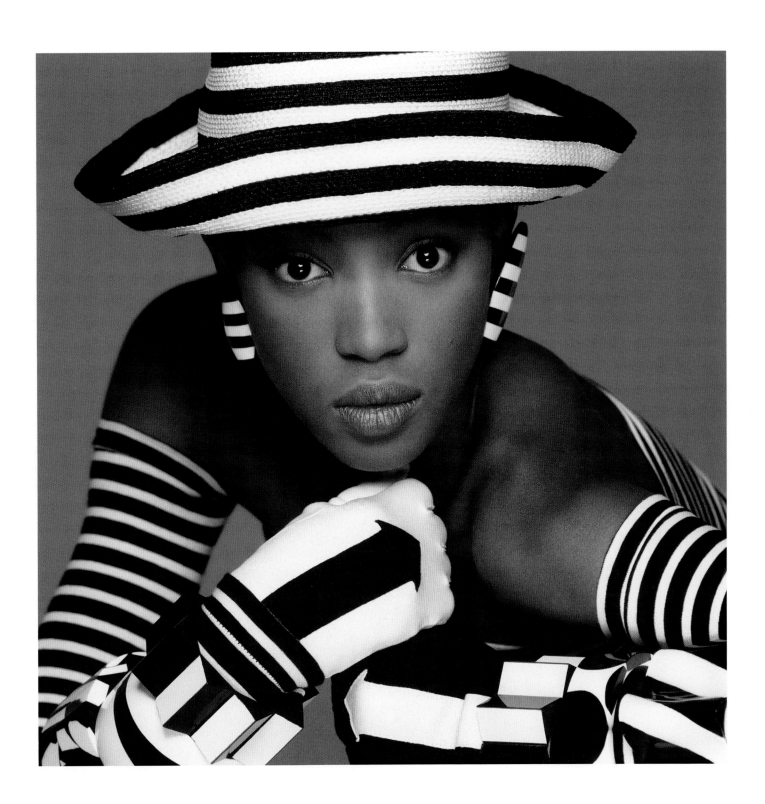

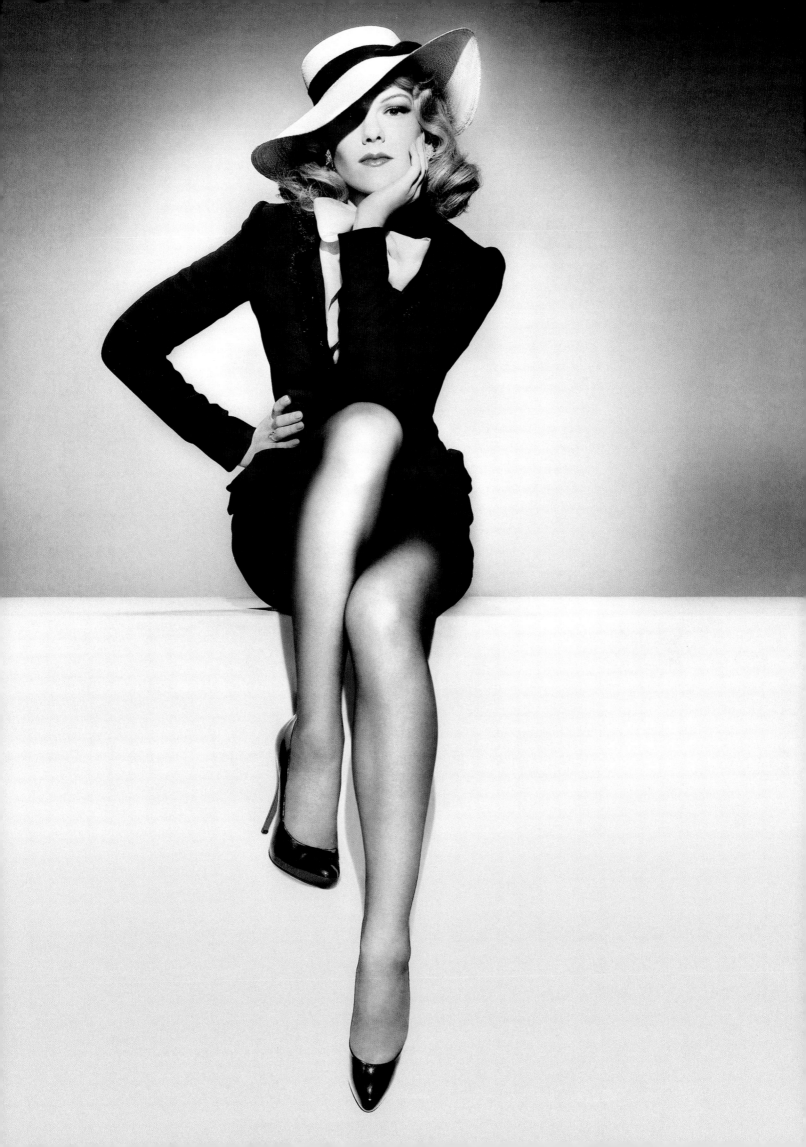

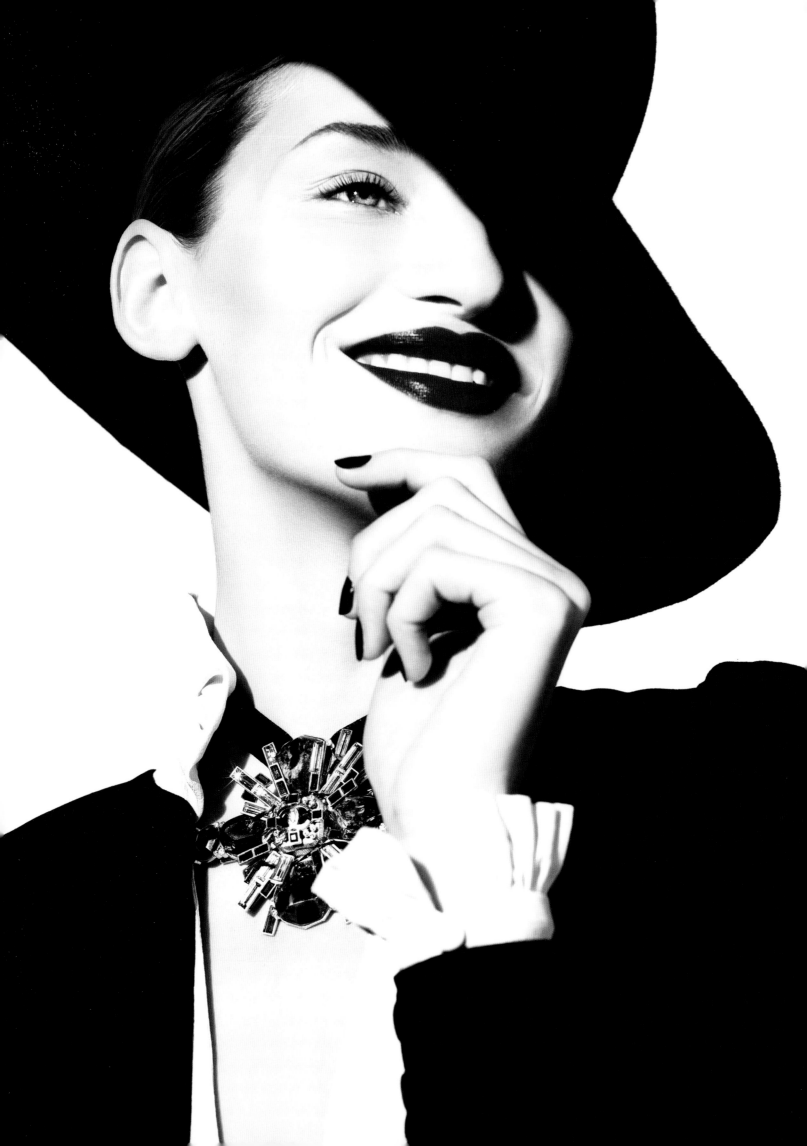

patricia underwood

THE WAY YOU WEAR YOUR HAT

JEFFREY BANKS

DORIA DE LA CHAPELLE

FOREWORD BY ISAAC MIZRAHI

RIZZOLI NEW YORK

New York · Paris · London · Milan

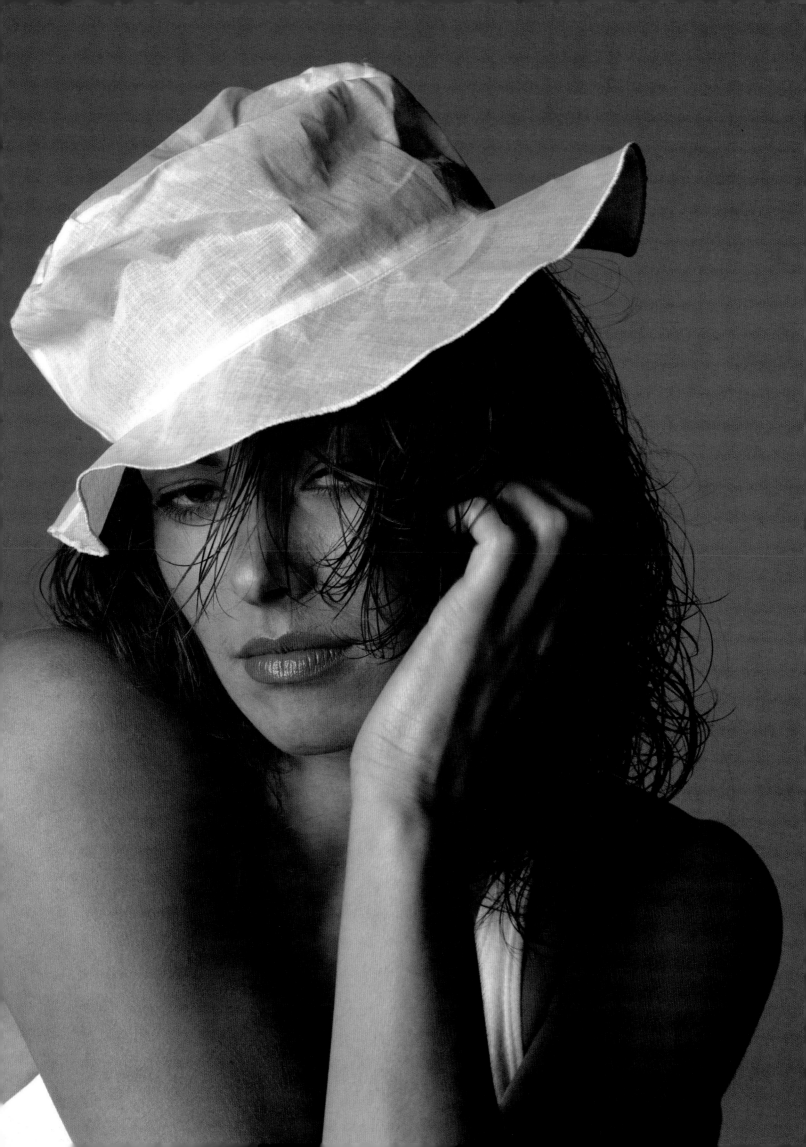

contents

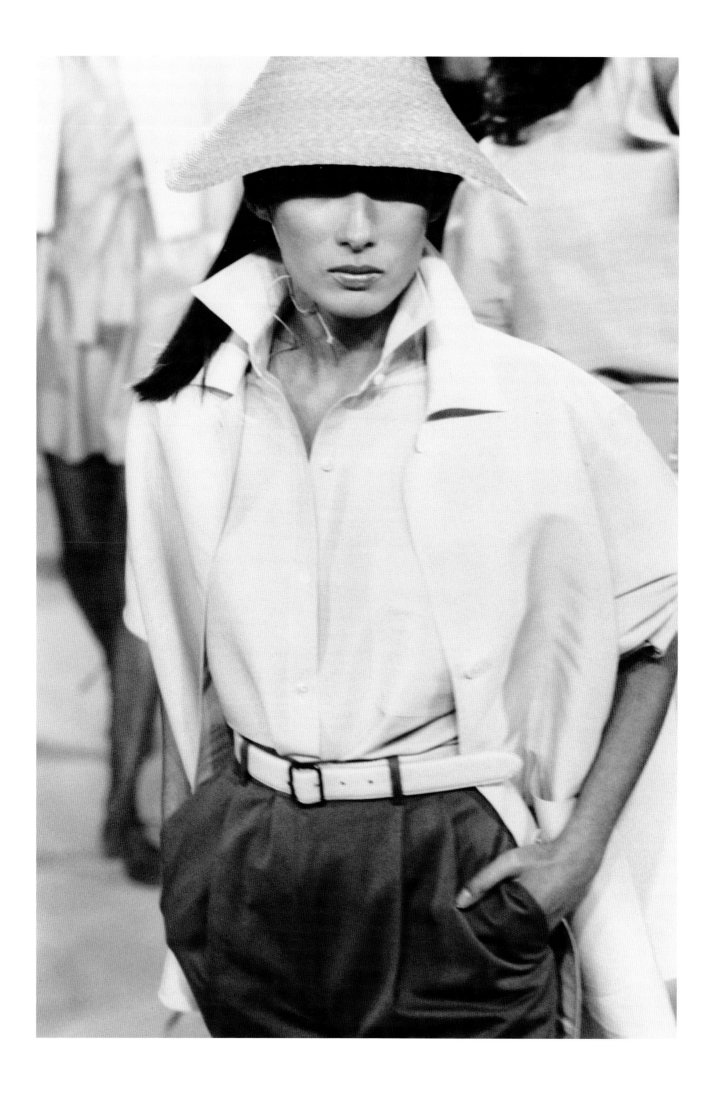

foreword

ISAAC MIZRAHI

PATRICIA UNDERWOOD BELIEVES IN HATS, no irony. Real hats. Fedoras. Panamas. Sou'westers. Berets. Felts. Straws. Knitted caps. She's made fascinators, headbands, gorgeous bits of frippery, but for the most part, this is a milliner who believes in actual hats that look good *and* function. She deeply believes an ensemble is "finished" by the right hat, that women need wardrobes of hats. New hats for each season and occasion. For each event of life. Keepsakes perhaps but more than anything she believes that women's lives are made better by the presence of hats on their heads. And I think she's right. I also think these facts state everything one needs to know about the sanity of this person. And the wit. And the heart. And the commitment.

She started her career over forty years ago when, after one class in hat-making, "a light went on in her head" and she decided that millinery was how she was going to make money to support herself and her daughter. She would make hats to pay the bills. Again I think this describes a certain sanity, or lack thereof, which an artist needs to have in order to pursue her craft, master it, and then rise to the top of it. I can call her a business-woman, a market expert, and a craftswoman: she is all those things at varying degrees of success. But what she is—what Patricia Underwood really, really is—is an artist. A great artist. I think the greatest living hat-maker.

Opposite: Underwood collaborated with Isaac Mizrahi, creating an elongated coolie hat of fine Milan straw to show with his classic ice-cream pale-colored summer linens.

Page 17: Underwood's natural hefty straw boater on Christy Turlington, topping Mizrahi's cool neutrals

Patricia is not only a great maker of hats, she's a great wearer of them too. My dad made little boys' coats and suits for a living and I heard him say again and again, "If you want people to buy suits, to believe in suits, you have to wear them yourself," which is, I think, like Patricia's philosophy. I don't think I've ever seen her without a hat on. And she has such a wonderful Hat Face.** As great as she is at making hats, at wearing hats, she's also great at talking about them. She understands the social impact of hats. Patricia "gets" the manners associated with them, the consequences of being in the wrong or right hat.

Patricia learned what she knows about hats the hard way. I'm not one who believes that "putting in time" is essential to great art, but in this case that phrase does ring somewhat true. Her first hats were made with no knowledge at all, only the vision that was present and the will and a great deal of energy. The rest she made up from scratch. Her hats are more than material and technique. They are expressions of Patricia's life. Every time you put one of her hats on your head you can rest assured that the right amount of craft, neuroses, joy, and pain went into that hat.

I can mark my life by the occurrence of Patricia Underwood hats I've borne witness to. We worked together in our youth and have remained friends who drop in and out of each other's orbits from time to time. And the greatest thing is to watch her work on a hat. She approaches it like a completely foreign thing, something that's never existed before. She made a straw beret for my sister's wedding trousseau about twenty-five years ago. This was by no means a runway hat; it would not be seen by anything resembling fashion *cognoscenti*. And yet the joy and the skepticism she brought to that project was a lesson in artistic commitment. The tiniest details were seen to. Not by an assistant or a manager but by Patricia herself. All this for one little hat. Each of her hats gets that kind of love. I think for Patricia it is creation on a deeper level. When you start with nothing and set your sights as high as she did, the result is actual design, actual invention, actual creation. More than a brand or a trademark, we're talking about a soul. A Patricia Underwood hat has a soul.

** Hat Face: A person whose face actually benefits from the wearing of a hat. A Hat Face can make a hat seem not silly, not pretentious, but essential.

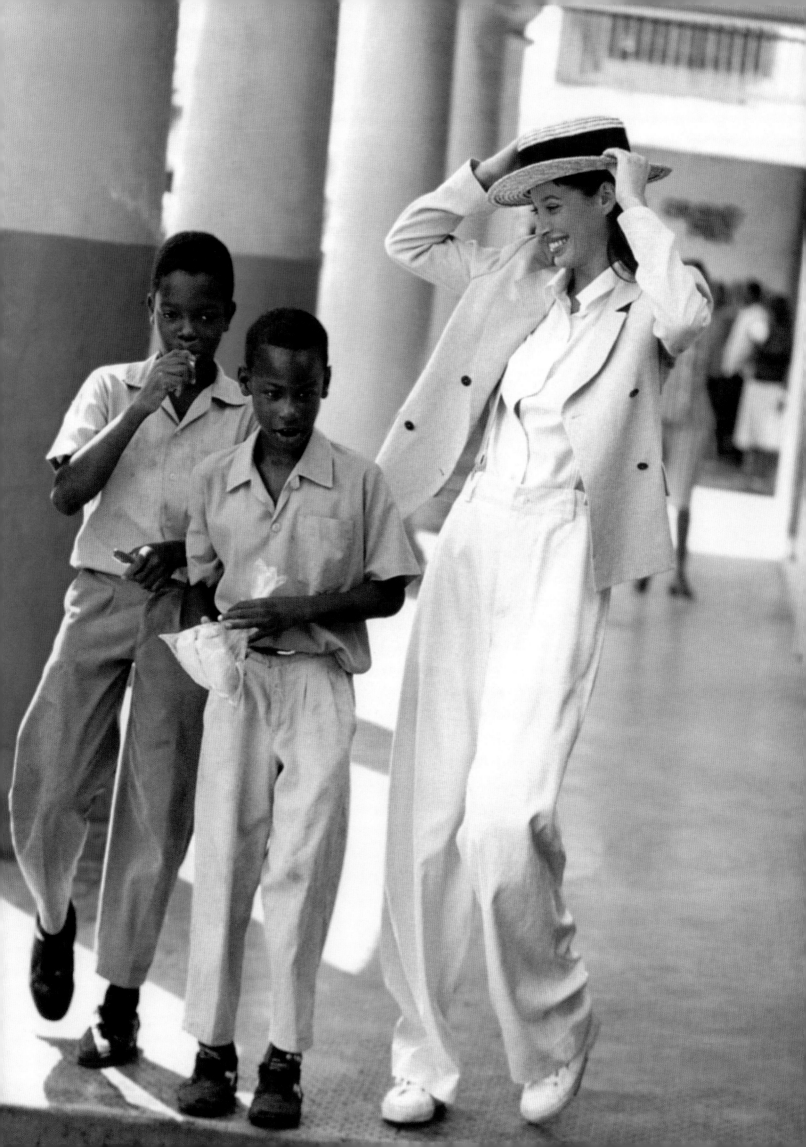

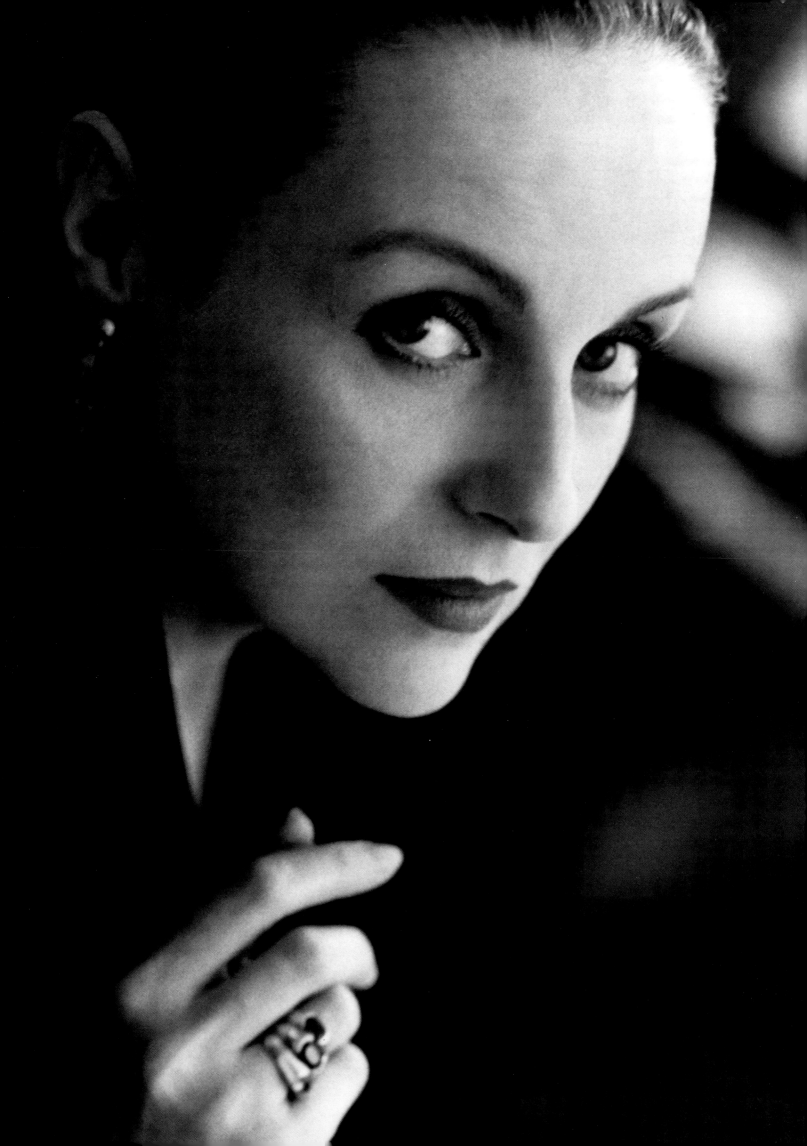

patricia underwood's millinery manifesto

SEEING A CHILD TRY ON HER MOTHER'S HAT, suddenly spying the silhouette of a state trooper in the rearview mirror, watching a bride sweep by in her wedding veil: each of these images evokes undeniable emotions in us all. One cannot be neutral in the presence of a hat: It sends a message. When I think about the design of a hat, I consider what that message might be and what is inside the head upon which the hat might sit. For it is with our minds that we manage and manipulate the world.

The first element of design is how the hat will frame the wearer's face. The gaze is usually directed to the face and the eyes and the person sporting the hat has to be comfortable with the likelihood of attracting the attention of perfect strangers. I try to imagine myself as the woman who will wear a particular design and thus consider how serious or frivolous the hat should be. I know the decoration may divert the gaze away from the eye, so the hat-wearer may be perceived as a bunch of red roses or a bird of paradise going by: in design there is a fine line separating a lovely adornment from one that is slightly ridiculous, but the true character of a hat is in how it is worn. Personal style and state of mind are what make a hat mysterious or alluring or demure.

We are lucky today that one may choose to wear a hat or not, unlike fifty years ago when a hat was considered a necessity of good grooming. Now hat-wearing has become a matter of personal style and a way of stimulating response. For instance, one of my greatest friends, recently divorced, had come to live in New York. She was in an elevator, wearing one of my hats, as it happened, when a gentleman entered the elevator and said, "You look wonderful in that hat." A conversation ensued and marriage followed. Hats create amazing possibilities.

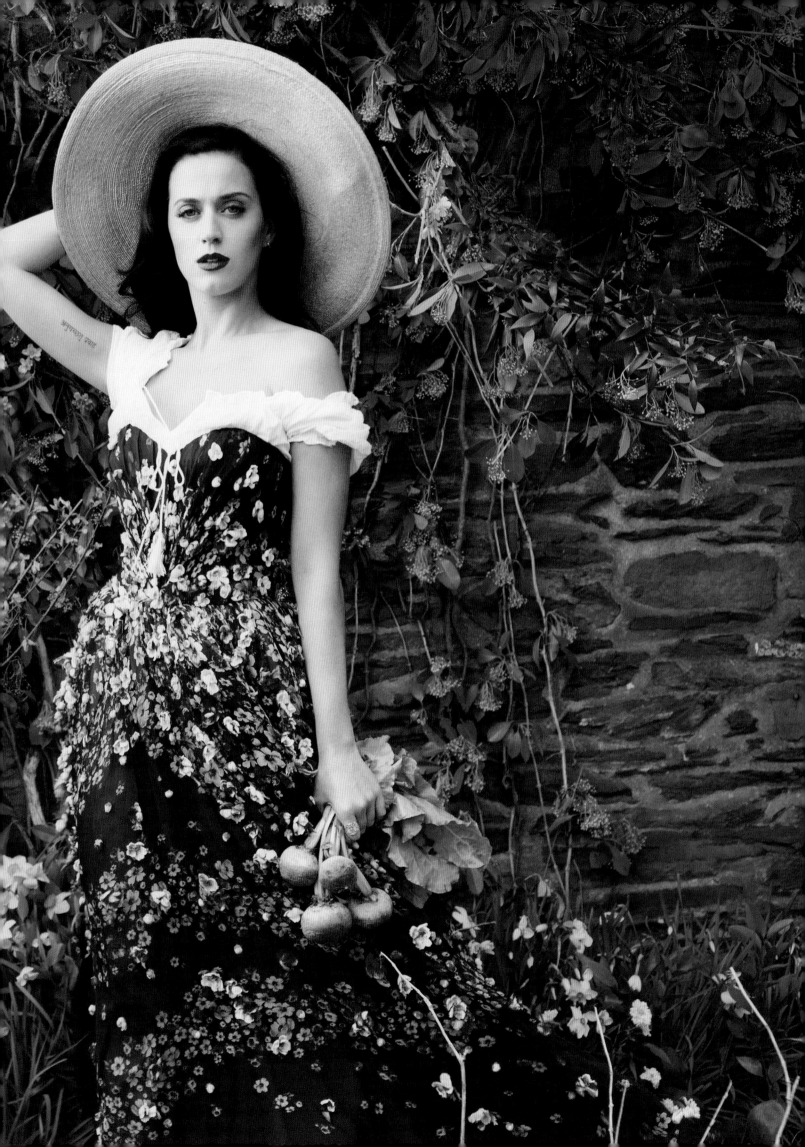

patricia underwood:
queen of hats

DORIA DE LA CHAPELLE

A HAT IS NEVER *just* a hat, but a statement about the person who wears it. Whether it's the questionable school beanie you had to wear; your fluttery, flattering pastel straw; or an over-the-top derby like the one Pharrell Williams wore at the 2013 Grammys, a hat is a highly effective communicator. At a single glance, it can reveal volumes about the person who wears it: the way she *does* feel, the way she would *like* to feel, or even, the way she would like people to *think* she feels. Worn with a certain self-assurance, tilted at the right angle, a hat is all about attitude: it is capable of creating a whole new persona, enhancing the wearer, endowing her with an aura of mystery, whimsy, sexiness, and style. Best of all, just as a hat *projects* the wearer's mood and confidence, it also is likely to *provoke* a response: Who *is* that in that hat?

As role-players and signifiers, hats have transmitted status and identity, occupation and political affiliation for centuries. Our ancestors understood the value of a hat: one needed to look only at what was sitting on a person's head to determine who he was and what he did. Early on, one could read the lowliness of the peasant's skullcap, the majesty and authority of the queen's crown, the religious might of the archbishop's mitre. Similarly, today, one can observe the starched efficiency of a nurse's cap, the plumed hat of the Knight of Columbus, the badge-of-belonging that

is a baseball cap—whichever way the visor (or "peak" as they might say in England) is turned.

Practically speaking, hats are remarkably functional: shielding us from the hot sun, protecting us from the cold, furnishing us with a disguise, a hiding place, a cover. Simultaneously, hats are wonderful showcases, bringing the face and eyes into focus, framing them in an artistic or theatrical way, allowing the world a view of new angles, interesting aspects of you. It is that notion of creating a new persona that first attracted the young Patricia Underwood (née Gilbert) to hats. As a child she was always delighted to accompany her grandmother to Madame Julienne, her milliner in London, where Patricia would sit happily among the fabrics, ribbons, and flowers, marveling as Granny amused herself, viewing her changing image in the mirror each time she donned a new, intriguing hat. Patricia realized at an early age that she, too, looked good in hats: *Different! Better! More interesting!* A prescient observation for a young girl and one to which she would return, years later, when she began to practice the sorcery of hat-making.

Patricia Underwood, milliner *extraordinaire*, has been creating beautifully understated, handmade hats in America for over forty years. Despite her four decades of living and working in New York City, the designer, who was born in England, still seems every bit as British as the characters in your favorite PBS series, with her cut-glass accent, impeccable manners, and deliciously dry wit. But when it comes to the topic of hats, although highly respectful of Great Britain's storied millinery heritage, Underwood underscores the fact that it was in America that she learned the art and craft of her profession, forged her design sensibility, and developed her award-winning reputation. And she is very proud to say that it is in America, indeed the New York area, indeed Manhattan, where all her hats are made.

It has been said that almost all of our civilization's basic hat shapes were created hundreds of years ago and that, in the end, hats divide into two styles: brimmed and un-brimmed. As a result, the development of modern headwear is a process of changing scale, proportion, and decoration.

All this plays to Underwood's strength, which lies in tweaking the expected relationships between the elements of the hat, crown, and brim, thereby reducing the form to its modern, graphic essence.

Underwood's thoroughly modern millinery is designed specifically to work with clothing and to complement it. Her hats are characterized by an almost Shaker-like purity of line, light but luxurious materials, and a minimal use of ornament so that the emphasis in on a woman's entire silhouette, not merely the hat. The milliner's sophisticated shapes and textures are designed to make a woman look polished, glamorous, or mysterious, but never ridiculous: no "walking flowerpots" here. Underwood's hats are subtle, but in a sublimely sexy, wearable way.

Underwood understands that, in essence, hat design is both an artistic and a functional endeavor, a balance that demands the combination of fine materials and flawless construction. This milliner possesses a sculptor's talent, an unerring eye for shape, color, and proportion, and a deeply honed devotion to her craft. Underwood, herself, owns and oversees her own millinery workroom in the center of Manhattan's garment district where her pure and deceptively simple custom hats are created the same way that good hats have always been made: *one at a time and very slowly*. In addition to her own Patricia Underwood–label couture line, she also has collaborated with the kind of fashion designers who are known by first name only, making the cloches and Cossack hats, berets, and brims that have "finished" the runway looks of Ralph, Donna, Oscar, Isaac, Bill, Marc, Michael, Perry, and a host of others. Her hats have played starring roles on the heads of royals, Broadway and Hollywood icons, and models, and they continue to grace the covers and flatter the celebrity faces on magazines around the globe. After over forty years of creating refined and innovative millinery, it is no wonder that Patricia Underwood is often referred to as "America's Queen of Hats."

Born in Maidenhead, England, about thirty miles west of London, Patricia Underwood grew up an adventurous little girl with giant green eyes and a slightly rebellious streak. She was dispatched to a strict Catholic school by her mother who also saw to it that her "fidgety"

daughter busied herself with sewing and needlework. At the end of her schooling at age sixteen, she was persuaded to take a secretarial course that, she was assured, would "set her up for life." When she was offered a job as a "lady clerk/typist" at Buckingham Palace, it was at the lowest rung on the clerical staff, among a pool of young women. For a time, she was delighted by the rhythms of it: the emphasis on procedure and the two meals a day, a sit-down lunch and a sit-down tea, plus nine pounds sterling a week! But, in truth, Underwood was not really a fit: in the mode of swinging '6os London, she had begun to sport miniskirts and trendy Biba frocks—not quite one of the "girls with pearls" in the office. Eager

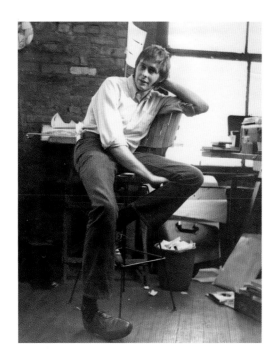

for new adventures and ready to break out, she decided to leave London for Paris. While in the City of Light, she met a lanky young American named Reginald Underwood, an industrial design graduate who was traveling in France. The two fell in love and decided to get married, and Reg persuaded her to return with him to the United States. In 1967, they boarded a plane bound for New York City.

Settling in downtown New York with her husband was not as easy she might have thought. During the first six months of their marriage, Underwood did "bodywork" on sports cars with her husband, specializing in classic Jaguar XKEs. Despite the fact that she was thoroughly unschooled in the world of automobiles and did not even have a driver's license, she turned out to have the makings of a crackerjack assistant mechanic. Lacking a college education, when she sought to move on, she was relegated to low-paying positions and those only because she spoke with that lovely British accent. After a series of monotonous jobs—secretary, typist, salesgirl, none of which seemed to suit her—she began to feel desperate.

Walking by the prestigious Fashion Institute of Technology one night, Underwood saw a sign posted for night classes in hat-making and on a total whim signed up for the semester. She remembers analyzing it this

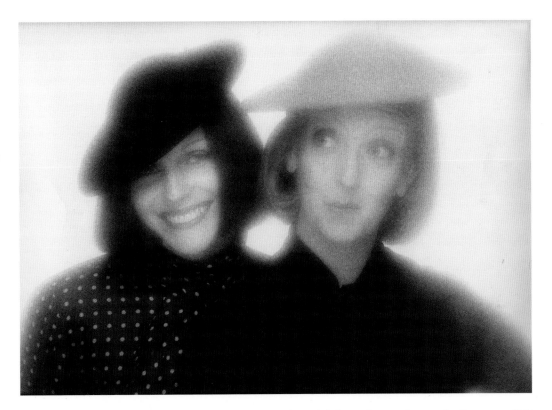

way: "I'd really like to try making hats, but if that doesn't work, I guess I'll just have to get a license and learn to drive a truck!"

One day, a young man approached her and offered to pay her $150 if she would get a crew-cut and allow him to photograph her for a German magazine. She agreed to do it; the money sounded irresistible. True to his word, the photographer, Bert Schaefer, sent her a copy of the magazine with her picture in it, along with the promised money. But, then he made a new offer: he would pay her $500 if she would shave her head and "go bald." Underwood, having just happily learned that she was pregnant, declined the offer, thinking that "bald and pregnant might be too weird," but she briefly mentioned that she was in the process of starting a little business and trying to scrape together enough money. Several months later, out of the blue, a money order in the amount of $500 arrived from Schaefer, with a note saying, "Good luck with your new business!" It became the seed money for her start-up.

Fortunately, hat-making made a great deal of sense. Both mechanically and artistically talented, Underwood was a natural; she loved working in a three-dimensional medium, especially when it came to the art of "sculpting" millinery. Fortuitously, the FIT course, taught by the highly

respected professor Mme. Lola Eckstein, included several other women who were also to become name hat designers: the accomplished, Danish-born Lipp Holmfeld, whom Underwood joined as a partner in business; the irrepressible Eileen Carson—a later business partner; and Marsha Akins, a hat-maker for many years in Manhattan.

While they were taking millinery classes, Underwood and Holmfeld (who had herself worked on Seventh Avenue for fashion designer Maxime de la Falaise) would spend two nights a week making hats and meeting people like Frank Olive, a respected hat designer in New York, who was a wonderful mentor. The young women decided to partner in business and scouted out some handsome vintage wooden hat blocks and "dusty old bits of machinery" for their operation in the millinery district, which was gradually disappearing from the large area from 36th to 40th streets between Fifth and Sixth avenues, where hat-making had once been a thriving business. Veteran milliners like old Mr. Feldman were still working there in the 1970s, but while they were generous with their advice to the ambitious young hat-makers, they couldn't refrain from asking, "What are you young girls doing in this dying business?" It was definitely an inauspicious moment in the hat business; the year was 1973—a time in America when most women had given up wearing hats altogether. A hat was about the last thing a girl thought to wear with her long peasant dresses and shag haircut.

As though starting a new business at an inopportune moment was not enough, Underwood's pregnancy with her daughter, Vivecca, created further issues. Underwood recalls, "I'd do the blocking and Lipp would do all the finishing work in her studio apartment, using the kitchen counter and stove to dry the hats. I was increasingly pregnant as time went on and had to position myself farther and farther away from the oven for fear of overheating the baby." Talk about having a bun in the oven!

Since Lipp Holmfeld had already created her own label in the hat-making business, the partners used the name "Hats by Lipp," making and selling their bonnets out of Holmfeld's tiny Greenwich Avenue studio. Through Holmfeld's friends Marvin Israel, then art director of *Harper's Bazaar*, and his wife, Margaret, the hats were shown to Polly Mellen,

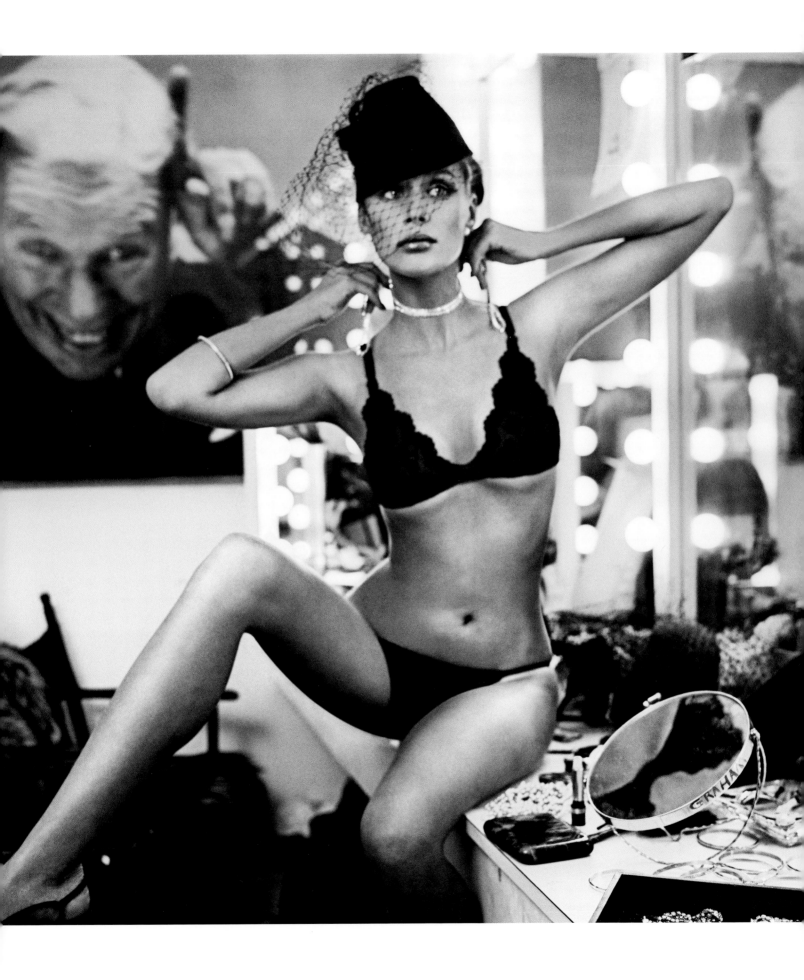

senior fashion editor at *Vogue*. This was the big break! Mellen rang up one day out of the blue and requested a few hats for a shoot *Vogue* was doing with famous photographer Richard Avedon that afternoon. The model was Lauren Hutton, then one of the top models in the world and the girl whose face has appeared more times on the cover of *Vogue* than anyone else's. Avedon photographed her in black lingerie with a beguiling little veiled hat from Holmfeld and Underwood perched on her head.

When *Vogue*'s merchandising department called the milliners' showroom to find out where the hats were sold, the girls, who had no retail outlets at all, rang up Bloomingdale's ladies' hat buyer, Rhoda Ribner, and persuaded her to order some of the *Vogue*-photographed hats for the store. They also approached Lancy Bader, hat buyer at Saks Fifth Avenue. When she asked the milliners the cost of the hat, they replied, "Twenty-five dollars." The formidable Bader countered, "A dozen?" "No," the girls said timidly, "that is for one hat." Nonetheless, Bader went ahead and wrote an order, at the same time providing constructive suggestions to the neophytes as to how to turn themselves into a real business.

Now, things began to snowball. Editor Priscilla Tucker brought Bill Cunningham with her to visit the milliners' studio and later featured their hats in *New York Magazine*'s "Best Bets" pages, further enhancing their popularity. Later, Lipp brought some sample hats to show Claire Nicholson, the ultra-chic accessories buyer at Henri Bendel, who was famous for holding Friday morning open sessions at the store where she would "discover" unique new design resources. It was said that once Nicholson put your designs in Bendel, you were launched. And that's pretty much what happened.

Left: Steven Meisel's illustration of a Patricia Underwood felt toque from the pages of *Women's Wear Daily*, 1974

Opposite: Model Toukie Smith in a shiny Starbrite coolie from Eileen Carson's collection

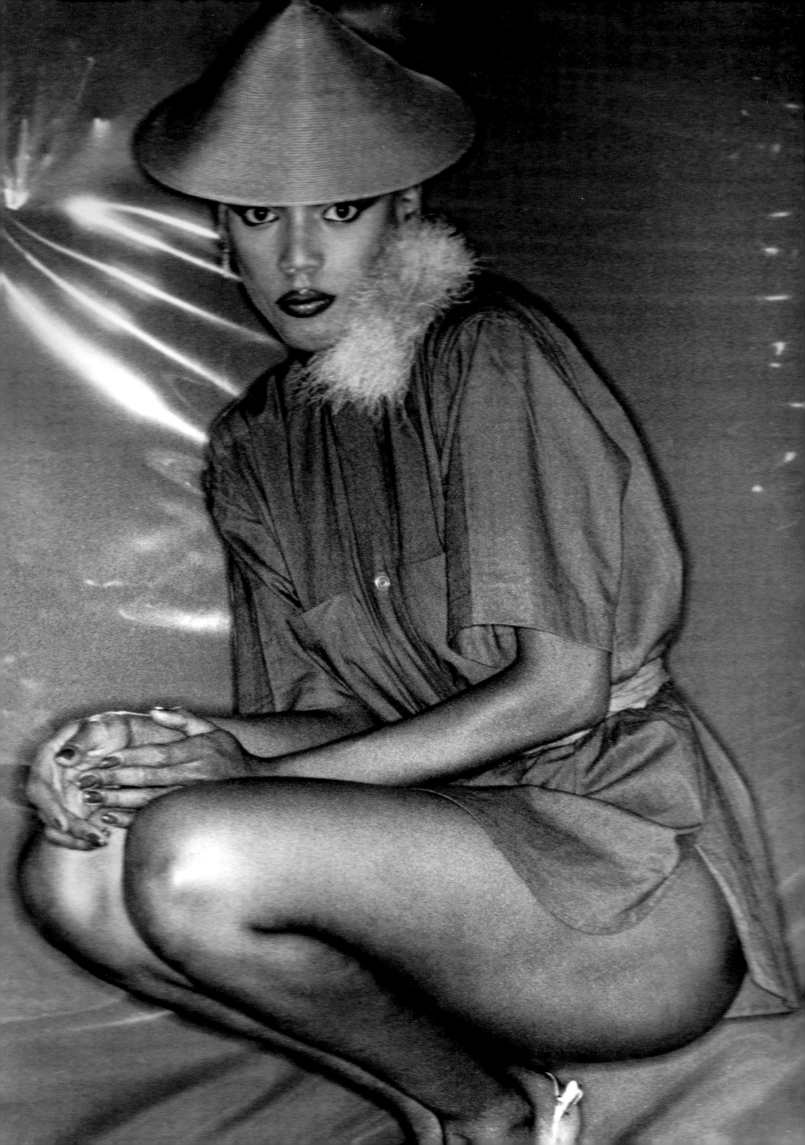

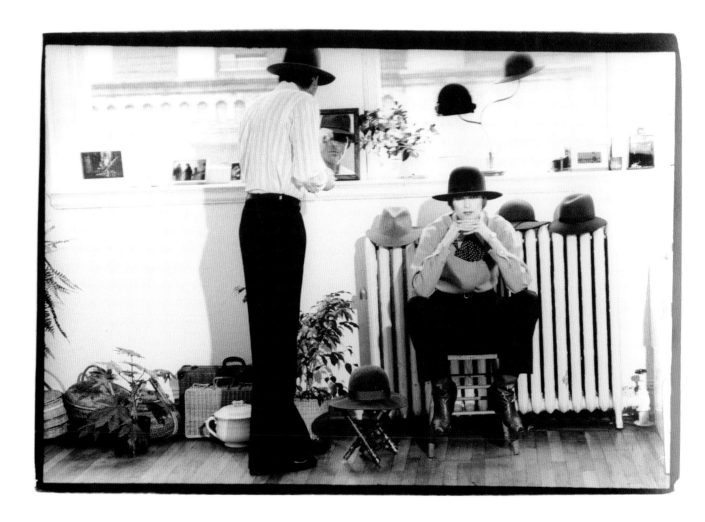

Above: Model in bowler hat (pre–*Annie Hall*) in the studio

Right: Early in her career when Underwood was short on cash, she agreed to have a buzz cut and be photographed for a German magazine in exchange for $150, which she used to help fund her new business.

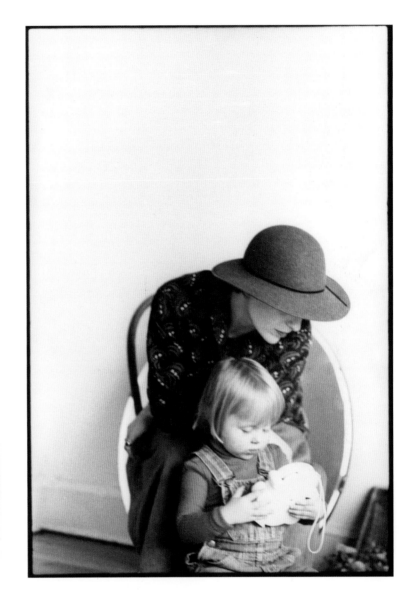

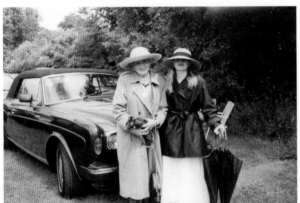

Underwood's daughter, Vivecca, at various ages. Clockwise from top left: As a teenager with her grandmother; as a small child with her mother; and as a young woman with her mother

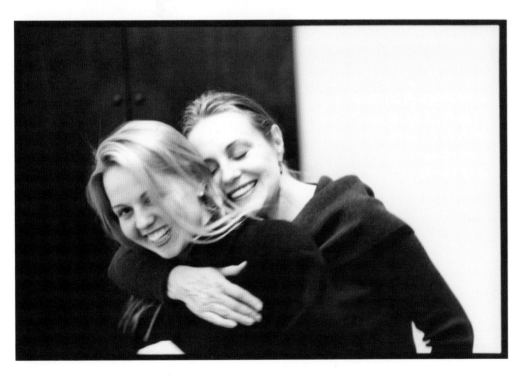

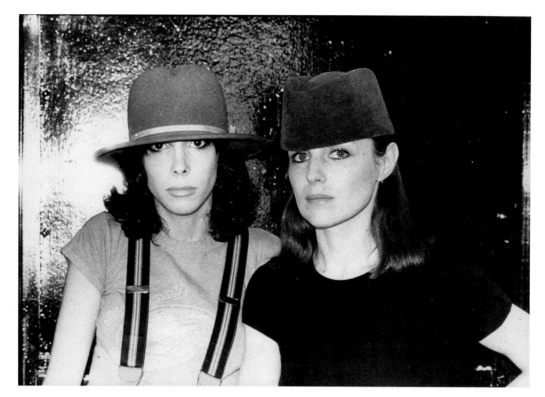

As Underwood became more and more intrigued by the actual process of hat-making, which most definitely appealed to the geometric side of her brain, Holmfeld returned to Denmark to take care of some family affairs. While there, she started a small, knit-hat business, working with cashmere, chenille, and fine wool, which later became a warmly welcomed addition to their New York millinery. After Holmfeld returned, she and Underwood were asked to make hats for the runway shows of hot '70s designers Pinky and Dianne, and later created elegant, understated toques for Donna Karan's catwalk. It was the first time the hat designers had a chance to view their millinery in the context of a fashion show and they were thrilled: "Seeing our hats complement these designers' clothes really sparked us. Hats really did have relevance. Hats should go with clothes."

The two young milliners continued to build their fledgling hat business for another couple of years when Holmfeld decided that she needed to return to Denmark for a longer period, and in 1976, the name of the company was changed to "Patricia Underwood." Now operating on her own, Underwood ran into money problems and at times, found herself afraid to pick up the phone. Jay Gerish, her supplier of felt and straw said, "Patricia, I know you are having a tough time. As long as I hear from you it will be fine. Pay us what you can when you can, but *always* return

calls." It was a lesson she took to heart: Relationships work and the people in the hat industry in New York know how to work together and support each other.

A while thereafter, Underwood joined forces with the equally young milliner, Eileen Carson, sharing a loft/workspace with her. Together they created three separate hat lines: Patricia Underwood, Eileen Carson, and Carson/Underwood, the latter a lower-priced line. Carson, a RISD graduate, was an extremely talented designer who contributed many wonderful and whimsical ideas, but she was pulled in many directions; eventually she left the company to focus on her greatest passion: disco roller-skating (this *was* the '70s). Underwood, on her own again, began to attract the serious attention and respect of the fashion community. Designer Perry Ellis, in particular, was a huge fan, and became so enamored of her and her work that he dubbed her "La Underwood," an honorific denoting his deep respect. Ellis was then the fast-rising designer of a cool new kind of relaxed American sportswear, and by asking Underwood to make hats for him, he accorded her his "seal of approval."

Now a divorced single parent, Underwood in 1979 met business advisor Jon Moynihan over Thanksgiving dinner at a friend's home in Washington, DC, and they began to date. His job required extensive travel, but each time he was able to, he stopped in New York. Underwood would pick him up in her battered old VW at the airport so they could spend some time together, then drive him back so he could catch yet another plane. A month or so after their first meeting, Moynihan and a friend threw a party at the former's house. Underwood was there and as the party went on toward midnight, she overheard an uninvited guest making a less than complimentary remark about Moynihan, whom he'd never met. Underwood, taking umbrage, quickly crossed the room and told the fellow in no uncertain words, "I'm sorry, you'll have to leave. You have behaved badly," and escorted him to the door. "I think that was the clincher for me," says Moynihan smilingly, years later. "She was really determined."

In October 1980, Underwood met up with Moynihan in Paris and over champagne at the Ritz, he asked her to marry him. After tying the knot

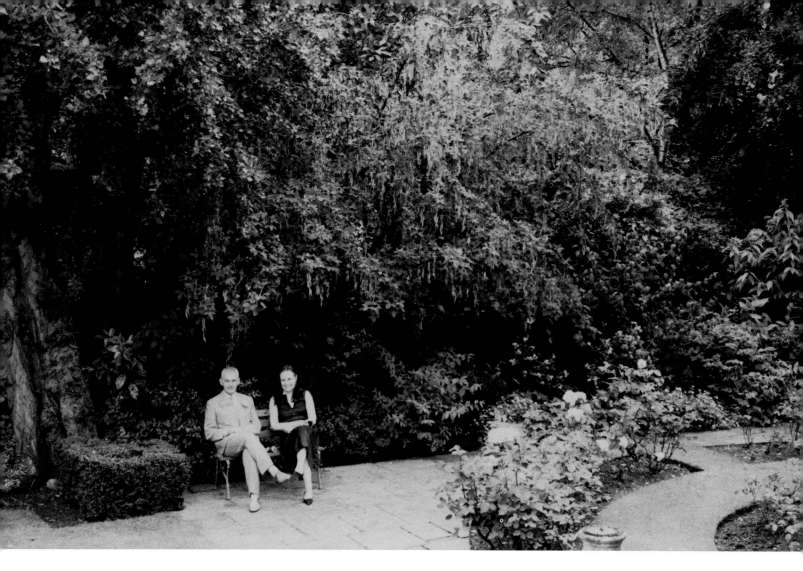

in December, Underwood moved to Chevy Chase, Maryland, to live with Moynihan, bringing her young daughter Vivecca and her hat-making materials with her. She set up a mini–millinery workroom in the basement, where one had to navigate the rivulets of water on the floor each time there was a heavy rain. Undaunted, she continued to work with a full-scale production line. Once she "finished" the hats, she would charge to the airport, hop on the Eastern shuttle to New York, and hand-deliver her wares to the stores. Then she would fly back to DC to repeat the process. After a year of shuttle-deliveries and subterranean hat-making, the exhausted Underwood realized that commuting between New York and Washington was taking an enormous toll on her, and explained to her husband that they would have to move back to New York for her business to continue. So, the very understanding Moynihan gave up his job, started his own company in New York, and together, they purchased a townhouse in then-unfashionable Chelsea. The house was in such a total state of disrepair that it required two years of renovating before they could move in.

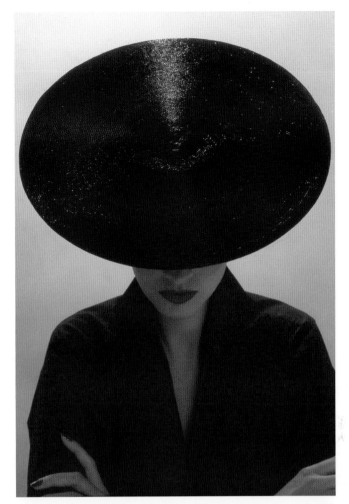

Opposite: Patricia and her husband, Jon Moynihan, in their tree- and rose-filled garden

Above: Hat tree in showroom

Above right: A "receiver hat" for extraterrestrial communication, designed by Underwood and Holmfeld in the futuristic-minded 1970s

Right: Underwood's stand at the *Premiere Classe* trade show in Paris

Left: Editorial photographs hang in Underwood's studio, one of seven workspaces the hat-maker has had, 1978.

Below left: Wendy Anderson, production manager, and Ray Lao, shipping head, in front of wood blocks on which hats are formed, at 498 Seventh Avenue

Opposite: Calvin Klein's first Japanese show in Tokyo featured hats by Underwood, dramatically photographed by John Calcagno.

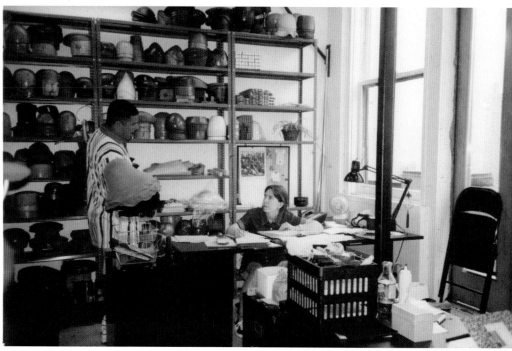

But for Underwood, the return to business in New York City paid off; it was the right time and the right thing to do. Within a year, she had won a Coty Award (the equivalent of an Oscar in the fashion world) and then a special CFDA award for her work. Suddenly she and her hats were garnering major headlines. "She had matured, had a good organization and new people working for her," said Moynihan, "and she hit her moment." Underwood was also thrilled to have her hats documented by some of the most respected photographers in the world—Richard Avedon, Irving

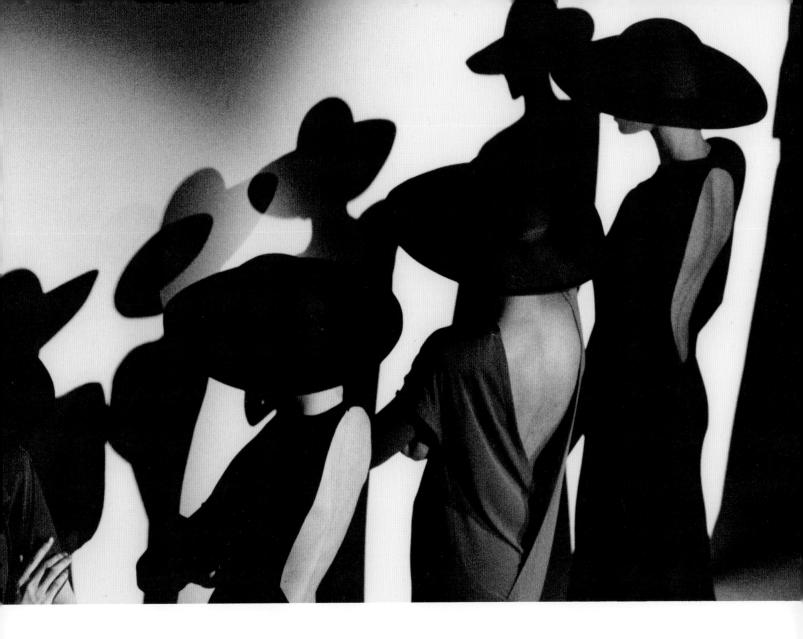

Penn, Horst, Bill King, Annie Leibovitz, Barry Lategan, and others, all of whom loved lensing her pure, graphic creations.

Once she had re-established the core of her business in Manhattan, Underwood's reputation as a top-flight couture milliner began to soar. Designer clothing had become more sophisticated and tailored in the 1980s, with beautifully cut suits that begged for modern, unadorned hats to "finish" them. No one was doing hats like that as well as Underwood. The best fashion designers in America—Ralph Lauren, Perry Ellis, Donna Karan, Calvin Klein, Oscar de la Renta, and Bill Blass—chose to collaborate with her on hats to show with their clothes on the runway. Even Karl Lagerfeld tapped Underwood to collaborate with him on hats for his New York runway presentations. He was enormously intrigued by her ingenious stripped leather hats, which are among Underwood's much-prized trademarks.

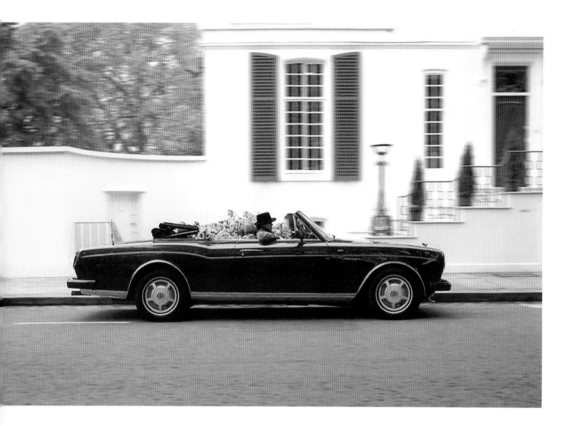

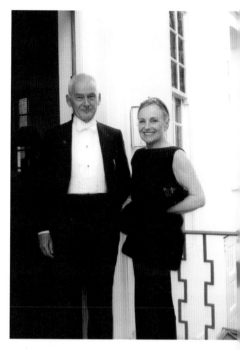

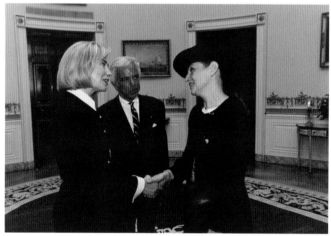

Clockwise from upper left: Underwood pulling up in front of her London house in her husband's Bentley Continental; Underwood and Moynihan dressed for a white-tie evening; Underwood in her garden, which she designed; and Hillary Clinton greeting Underwood at a White House event, with Ralph Lauren looking on

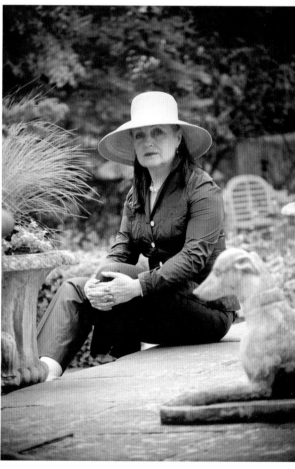

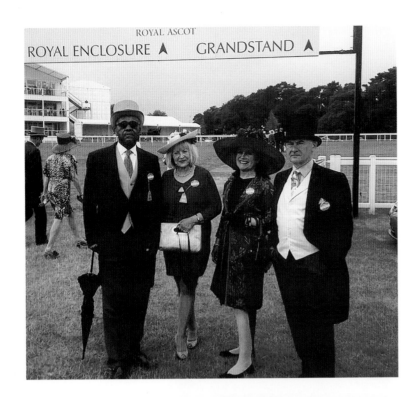

Clockwise from left: Oliver Franklin and his wife, Pat, with Patricia and Jon Moynihan at Ascot; Jon Moynihan with his godson, Thomas Crosthwaite, Underwood, and her daughter, Vivecca, before Moynihan's OBE ceremony; the Moynihans snowshoeing in Beaver Creek; and Underwood heading out to the Royal Academy gala in 2014

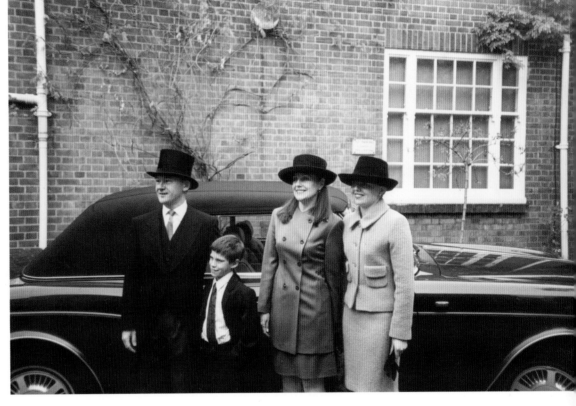

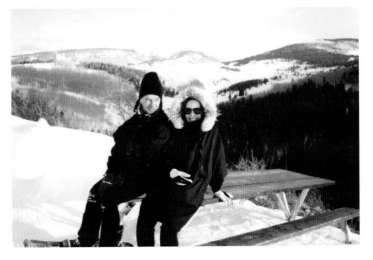

By virtue of having established a consistent reputation for some of the most desirable, subtle, and sophisticated hats anywhere, Underwood was besieged by the stores. Hip retailers at the forefront of fashion like Geraldine Stutz of Henri Bendel, Joan Weinstein of Ultimo in Chicago, Joan Burstein of Browns in London, and Charles Gallay in Los Angeles were among her early supporters, and in 1982 she began to sell to Bergdorf Goodman—a relationship that has lasted over thirty years. Her ever-rising sales at BG resulted in the creation of her own epony-mous department, under the watchful guidance of Ira Neimark and Dawn Mello. Other famed stores carrying the Patricia Underwood brand included Saks Fifth Avenue, Neiman Marcus, I. Magnin, and select carriage trade stores as Martha in Palm Beach and New York; Nan Duskin and Sophy Curson in Philadelphia; Saks Jandel and Rizik's in Washington, DC; and Gold's and Debbi Safran in the New York area.

Ever the consummate problem solver, Underwood never wants to sell more hats to a store than it can handle, using her version of "just in time" production—therefore keeping hat-selling profitable. Just like her prede-cessors Coco Chanel and Lilly Daché did years ago, she has opened her studio to sell directly to her devoted hat-wearing and hat-loving clientele.

Wearing a hat takes confidence because it is a choice. Society says we have to wear clothes, life says we have to wear shoes, but YOU have to choose to wear a hat. So the fact that somebody could choose a hat that I made and feel that it enhances her life in some way, is a gift to me!

—Patricia Underwood

Underwood, who with her husband is an automobile enthusiast, fills the Bentley with fresh flowers—the couple have in their collection three Bentleys and two Aston Martins. She wears a burgundy velour hat of her own design.

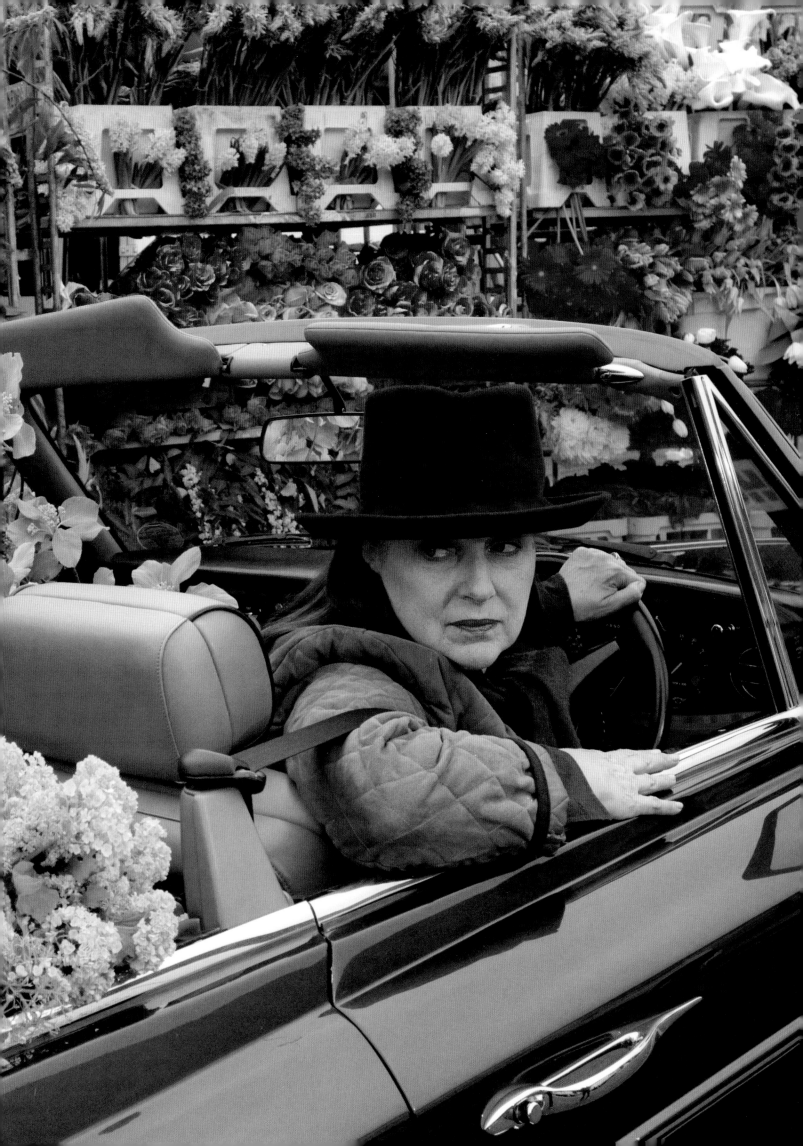

INSPIRATION

All hats can endow the wearer with the tools for flirtation, self-confidence, drama, frivolity, panache, authority, elegance and mystery … the list goes on. But each of these qualities is enhanced by the inner life of the wearer: the thinking woman's hat is an accomplice to the character the wearer wants to project. Otherwise, a hat is just a "thing on a head."

— Patricia Underwood

Like other gifted designers, Patricia Underwood has a talent for plucking ideas out of the ether, drawing inspiration for her hats from her surroundings—especially art, nature, history, fashion and cinema. In her Spring 1982 collection when "embellished" hats were all the rage, instead of piling on roses, Underwood channeled Chanel, employing the idea of simple color blocks from her clothing and Chanel-style bows from her iconic flats. (Let us not forget that Chanel, herself, was once a milliner.) Underwood combined colors like pink and red and "engineered" a large, symmetrical bow by sewing a big loop into the hat, making it an integral part of the design. The result: boldly chic hats done with Underwood understatement in lieu of over-the-top adornment.

After spending a wonderful "Sunday in the museum with Georges," Underwood was smitten by Georges Seurat's paintings and conjured up an unforgettable collection of straw hats using some of the pointillist's colors, not in the form of dots but in stripes. After analyzing the blues, turquoises, and creams of the artist, she used them in color bands— merging one into another, providing the illusion of motion in beautifully tonal stripes. Another color combination—composed of vivid orange, red, and purple stripes—was stacked together, blending beautifully, but at the same time, standing out in relief. No one had seen hats like this before!

Sometimes an idea just appears full-blown in a designer's mind. In 1977, Underwood felt the time was right for bowler hats for women. She had

Right: Georges
Seurat's famous
pointillist work *A
Sunday Afternoon
on the Island of La
Grande Jatte* (1884)
served as inspiration
for Underwood
when she was
experimenting with
tonalities.

Below: Underwood's
hats inspired by
Seurat's palette

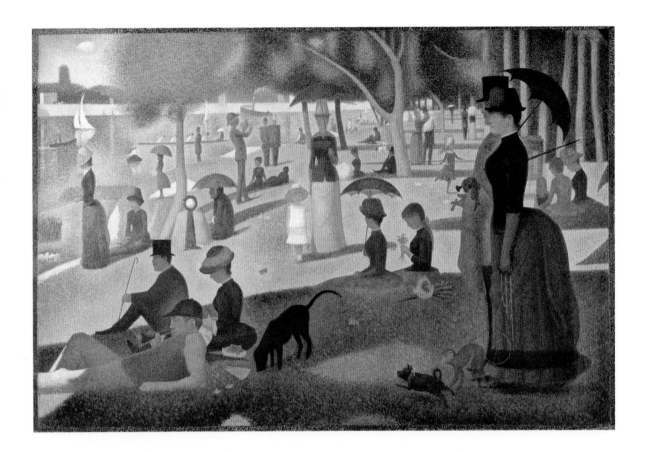

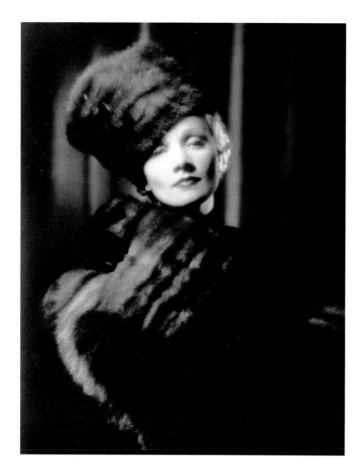

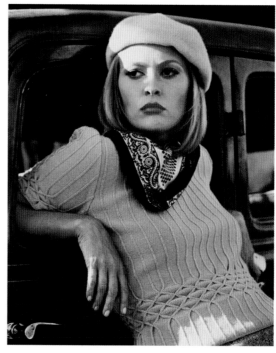

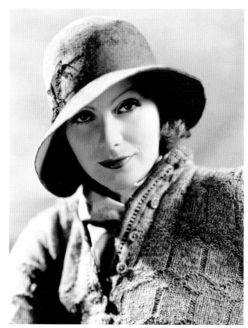

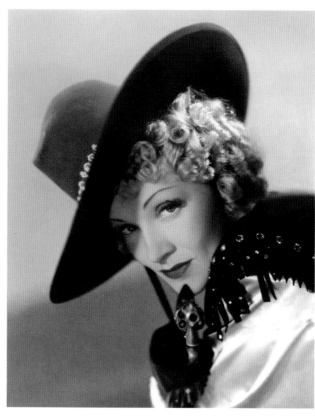

Underwood is inspired not only by the hats worn by movie actresses on and off screen but also by the attitudes with which they wore them: a confidence, a flirtatiousness, an allure. Clockwise from top left: Marlene Dietrich looking dangerous in mink in *The Scarlet Empress* (1934); Faye Dunaway as Miss Bonnie Parker in *Bonnie and Clyde* (1967), wearing a "killer" beret; *Destry Rides Again* (1939) with Dietrich, her cowboy hat pitched at a rakish angle; and Greta Garbo in *The Kiss* (1929), in a brimmed felt cloche angled to show off the curve of a cheek

always loved the shape of the traditional man's hat, so she adapted and "sculpted" a slightly softer, more feminine version of a bowler with a bigger brim. Shortly thereafter, Woody Allen's movie *Annie Hall* was released to great acclaim, and people found themselves particularly drawn to the title character, as played by Diane Keaton, who often sported a quirky brimmed hat that was somewhat similar to the bowler Patricia had already designed. Buyers and press started to refer to Underwood's hat as the "Annie Hall" and soon Underwood received a lawyer's cease-and-desist letter, warning her to stop using the "Annie Hall" name. Underwood never had used the name, but everyone else had!

Frequently, it's the magic of the cinema, its images of sultry Silver Screen beauties wearing (and knowing *how* to wear) mysterious and face-flattering hats that suggest new possibilities. Thus, according to Patricia Underwood, "Any movie with Greta Garbo in a hat is always a source of pleasure … and inspiration."

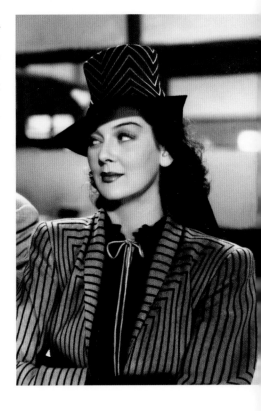

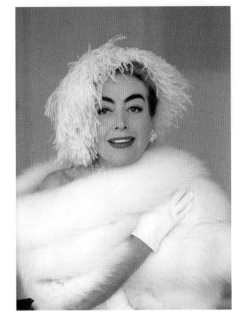

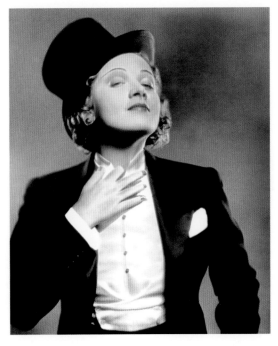

From left to right: Joan Crawford in a snow-white ostrich confection, circa 1960; Dietrich in *Morocco* (1930) in classic top hat and tails—sexy and sophisticated in stark black and white; and Rosalind Russell in a high-crowned fedora in *His Girl Friday* (1940)

portfolio

THE CLOCHE

An oversized version
of the close-fitting
cloche, in ivory felt—
the perfect finish to a
bouclé suit

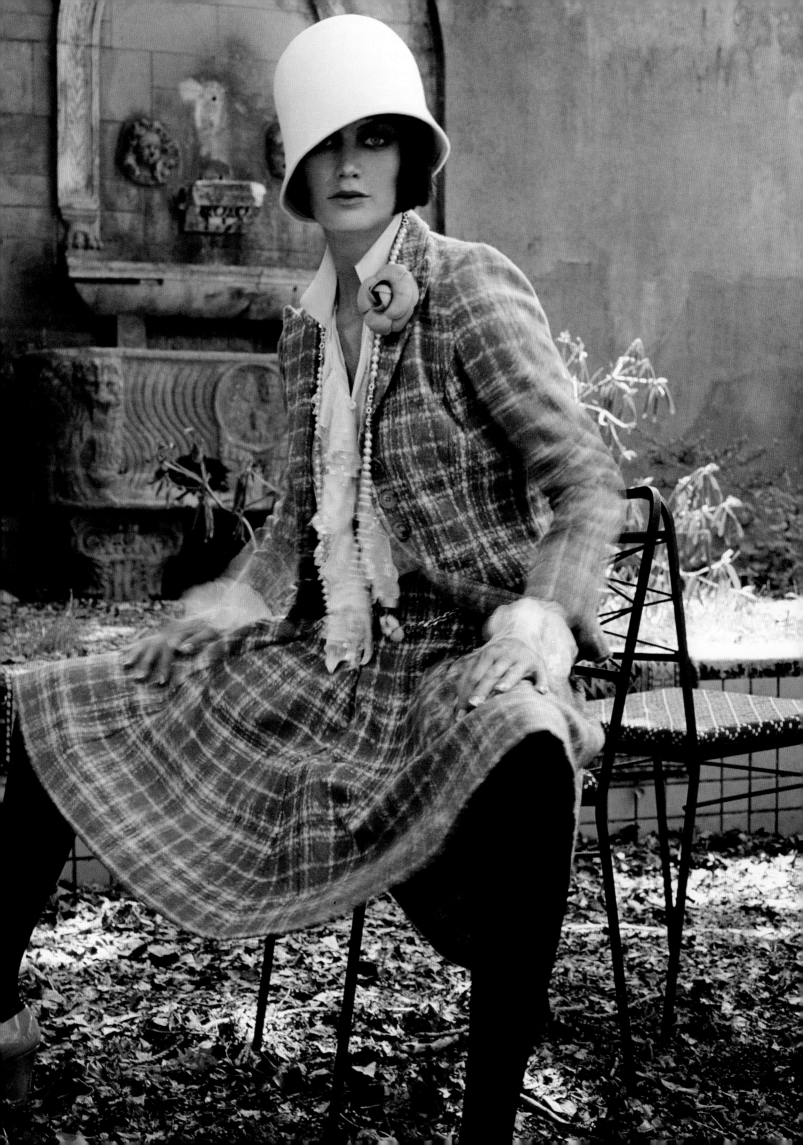

When one of Lipp
Holmfeld's and Patricia
Underwood's clients
mispronounced
the name of the
"Vendôme" hat as
VEND-O-MAY, the
milliners couldn't resist
changing the name to
"Vendomay." Inspired
by one of Paris's most
beloved landmarks,
Lipp Holmfeld
designed this hat for
her shared line with
Underwood. Model
Ramona Saunders
wears a version in
taupe velour felt with
sculpted felt trim on
the side.

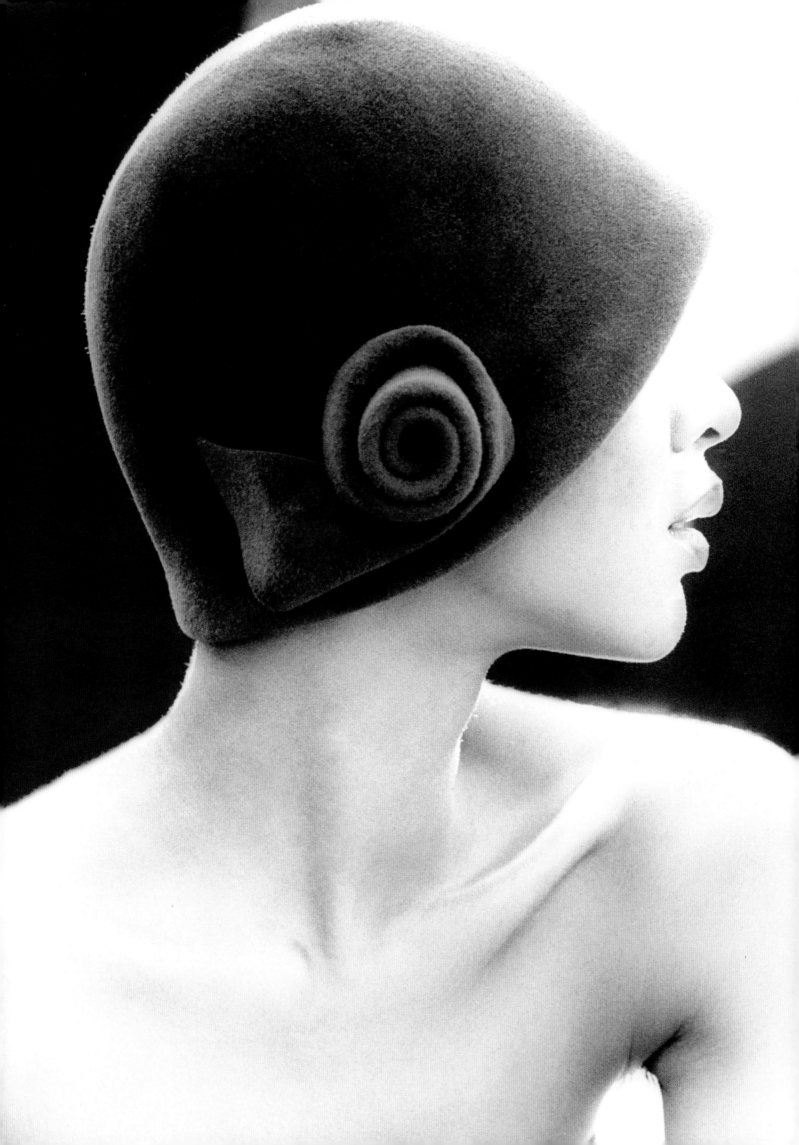

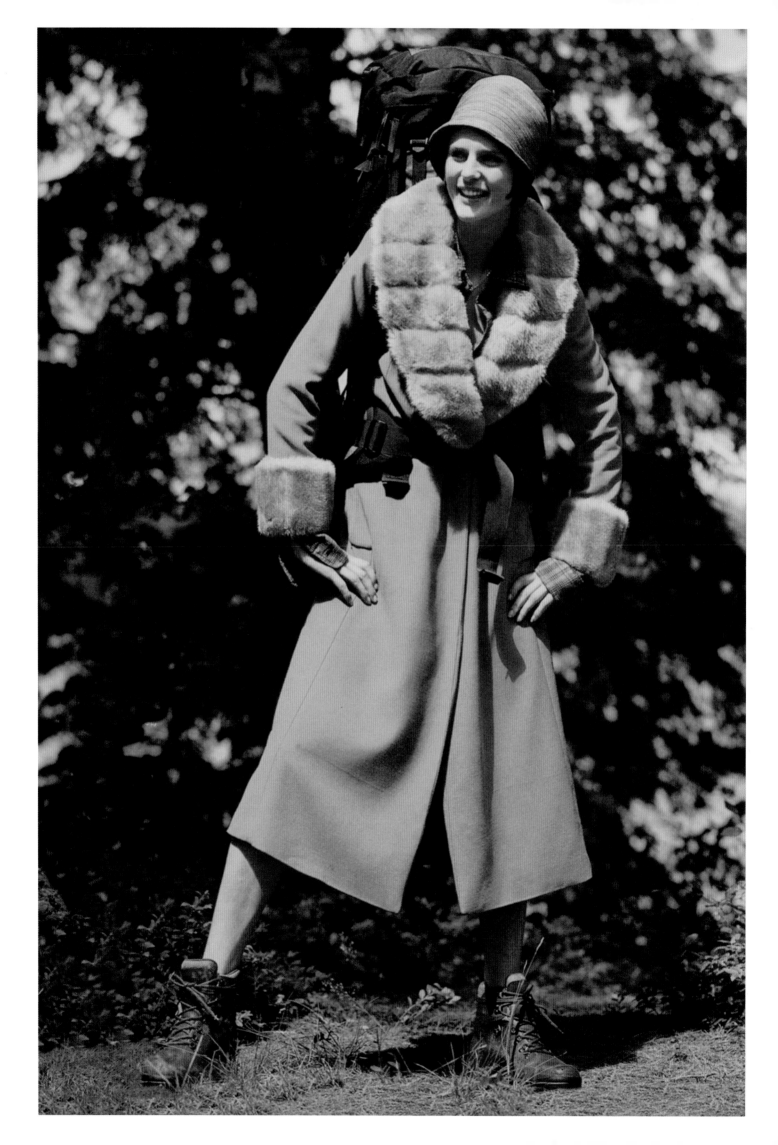

Opposite: Stella
Tennant wears a
stitched-suede
bonnet, a close
cousin of the cloche
but a little more
casual

Above: The "Pippa"
cloche, black felt
with a sprinkling of
buttons, and a bit of
magic

Following spread:
Ralph Lauren
Collection for Fall
2012: Underwood's
variations on the
classic bell-shaped
cloche with a small
roll, a tiny brim, a
larger brim, and
a squarer shape;
plus a cheeky news-
boy cap.

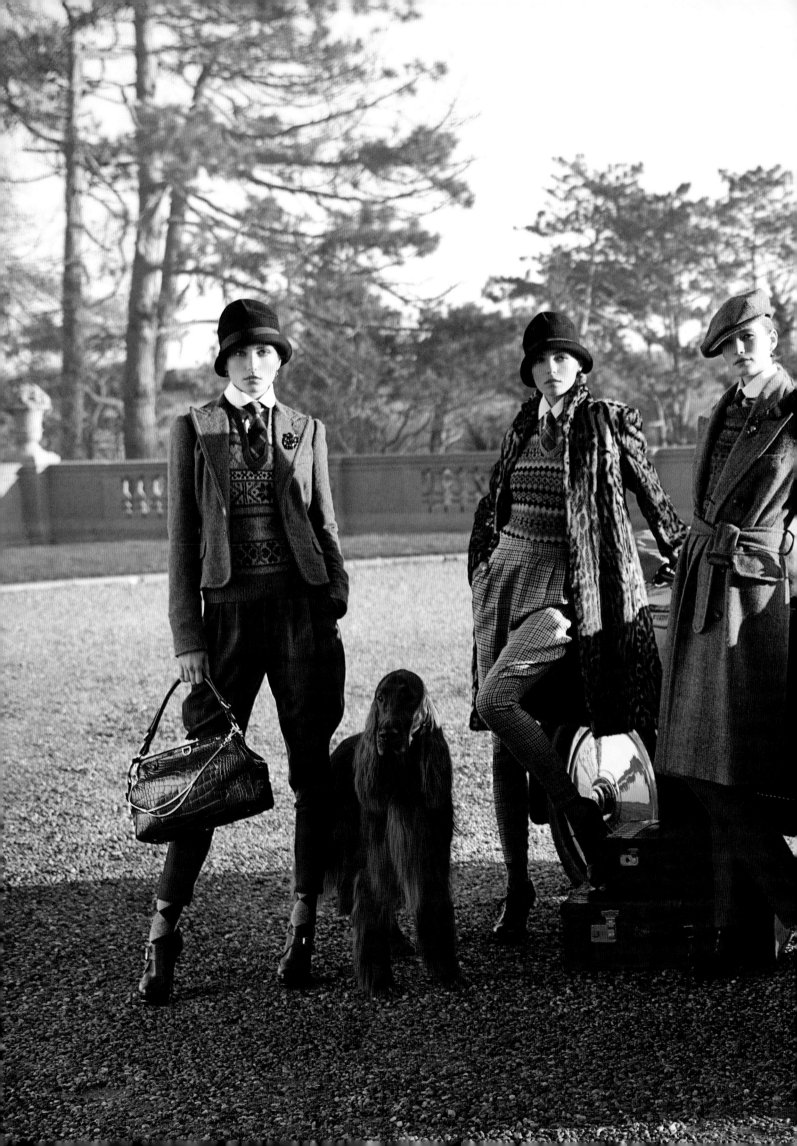

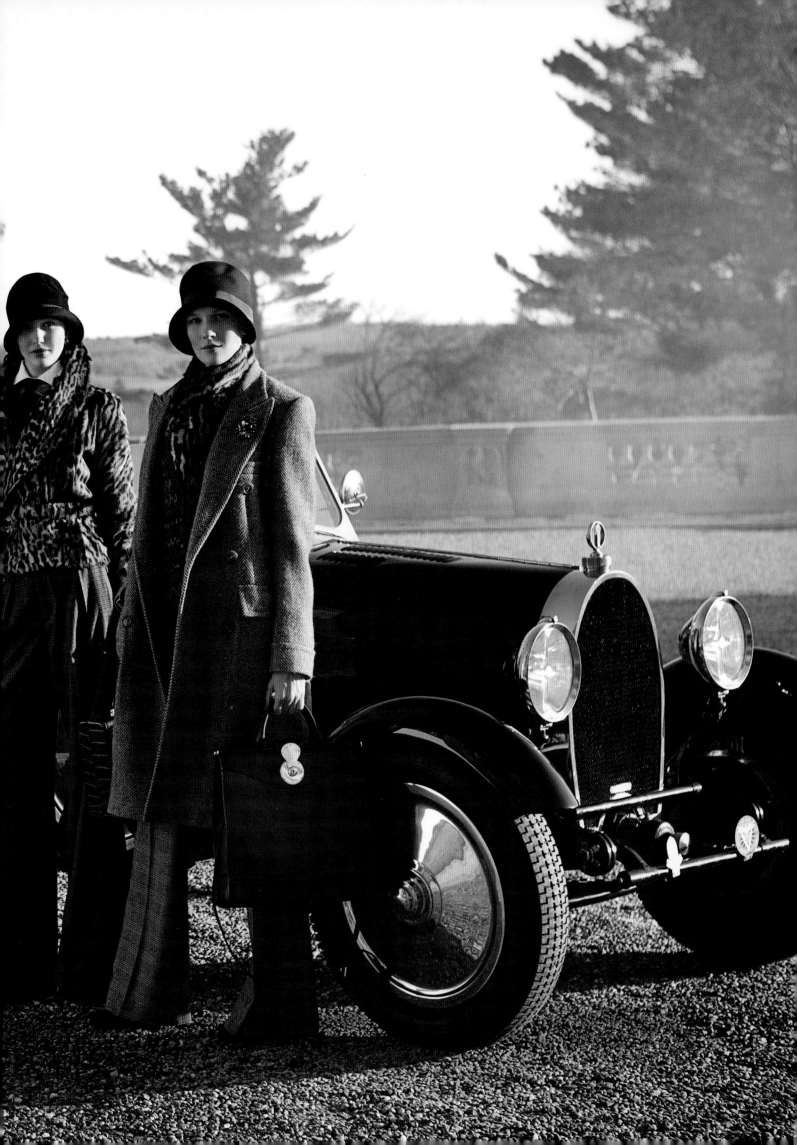

THE TOP HAT *and* THE BOWLER

Right: Towering
over all other hats,
the top hat, worn
by everyone from
statesmen to circus
ringmasters, has a
whiff of authority.
And on women, it
has a particularly
devastating charm.

Following spread:
Backstage: Bowlers
and newsboy caps
top off menswear
looks for women.
Patricia Underwood
for Ralph Lauren
Collection

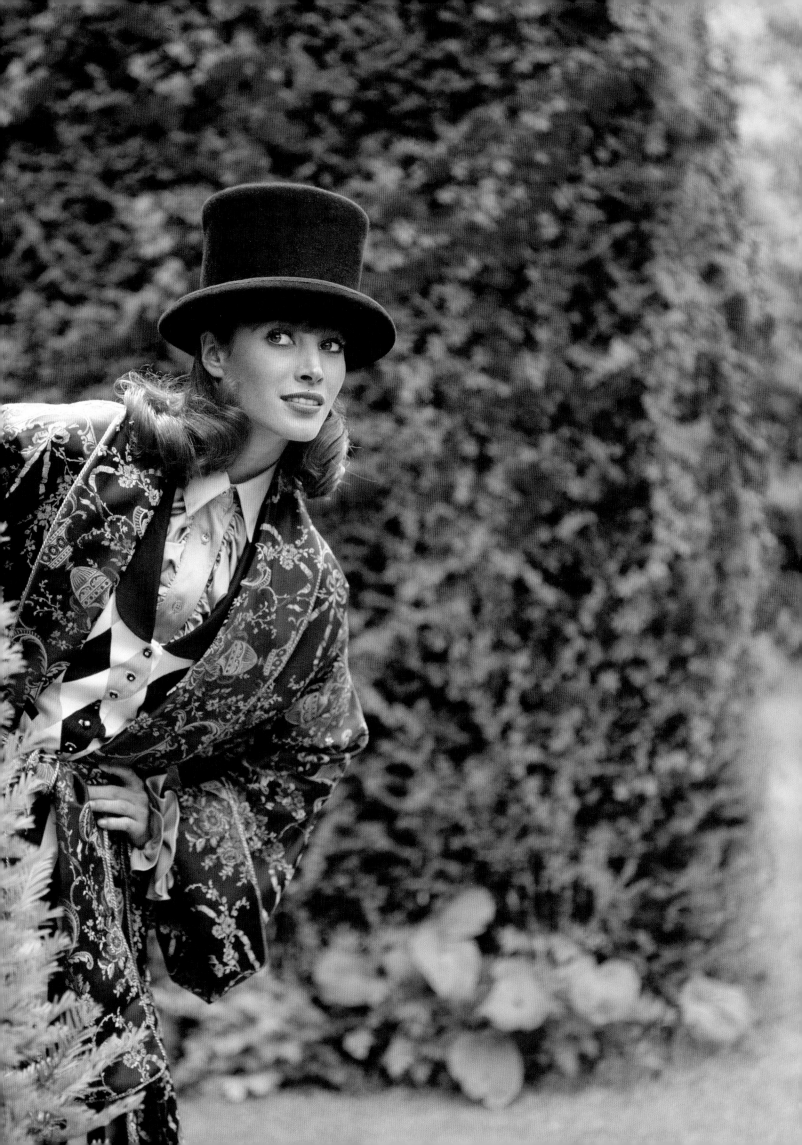

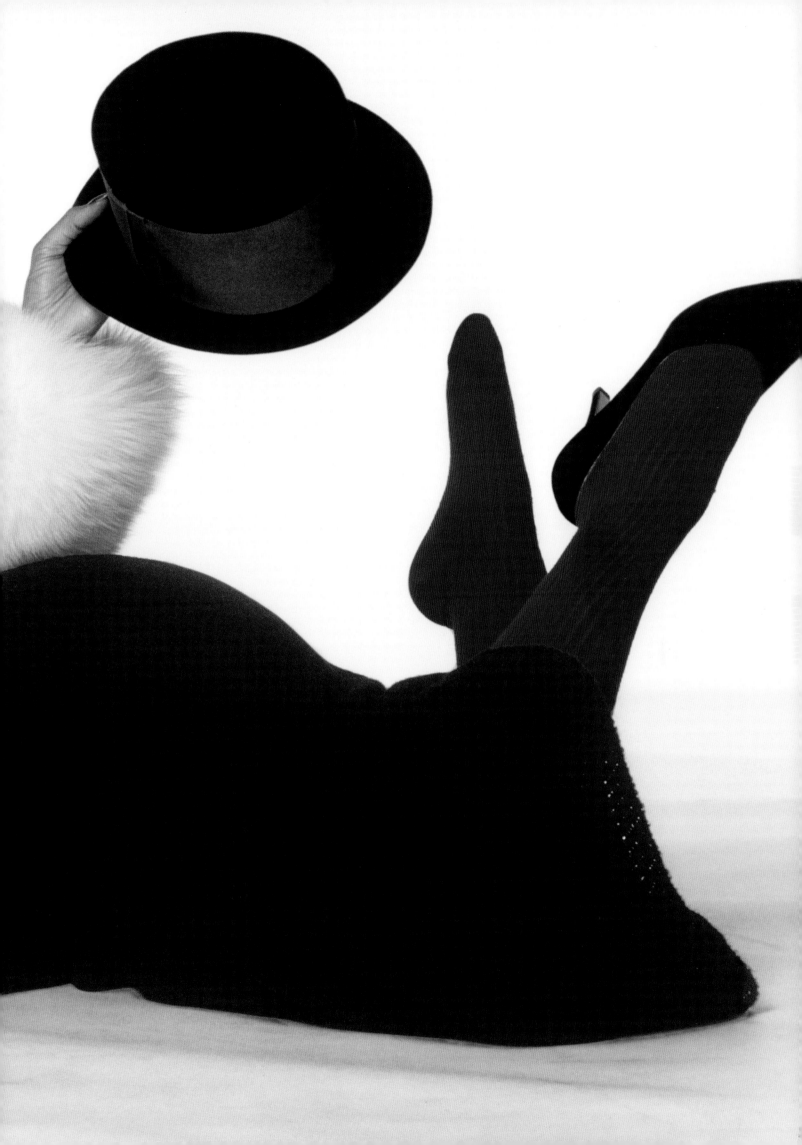

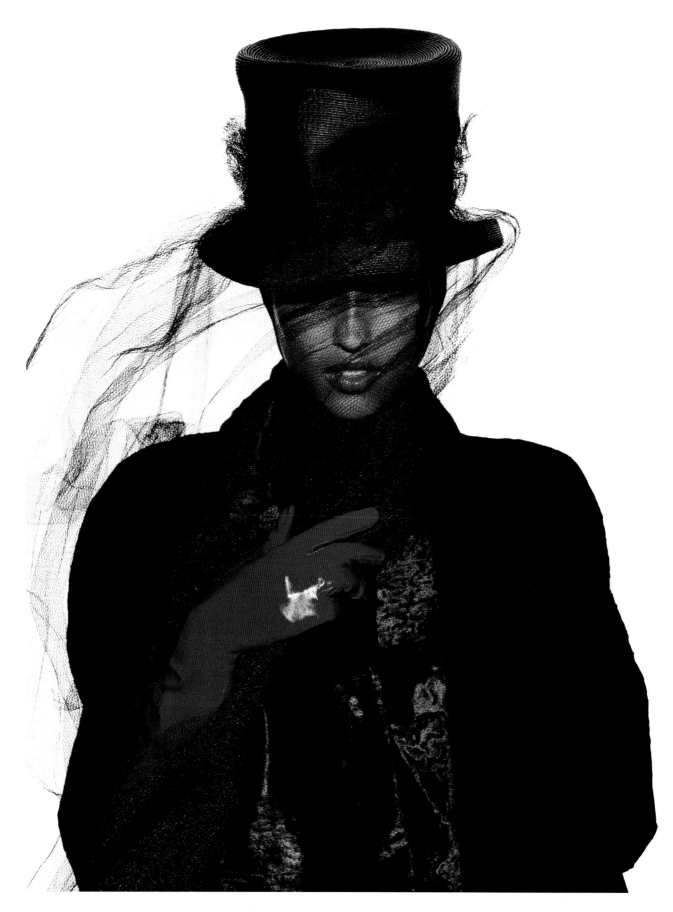

Preceding spread:
Shari Belafonte
glams it up in a
Perry Ellis slinky black
dress, white fox
sleeves, red stock-
ings, and a playful
coachman topper.

Above: The ultra-
chic and mysterious
veiled top hat in
paglina straw

Opposite: Stars
and stripes on
white felt, worn by
Helena Christensen
for a Kenar
advertisement

Following spread:
Nadja Auermann
in white evening
clothes and top hat

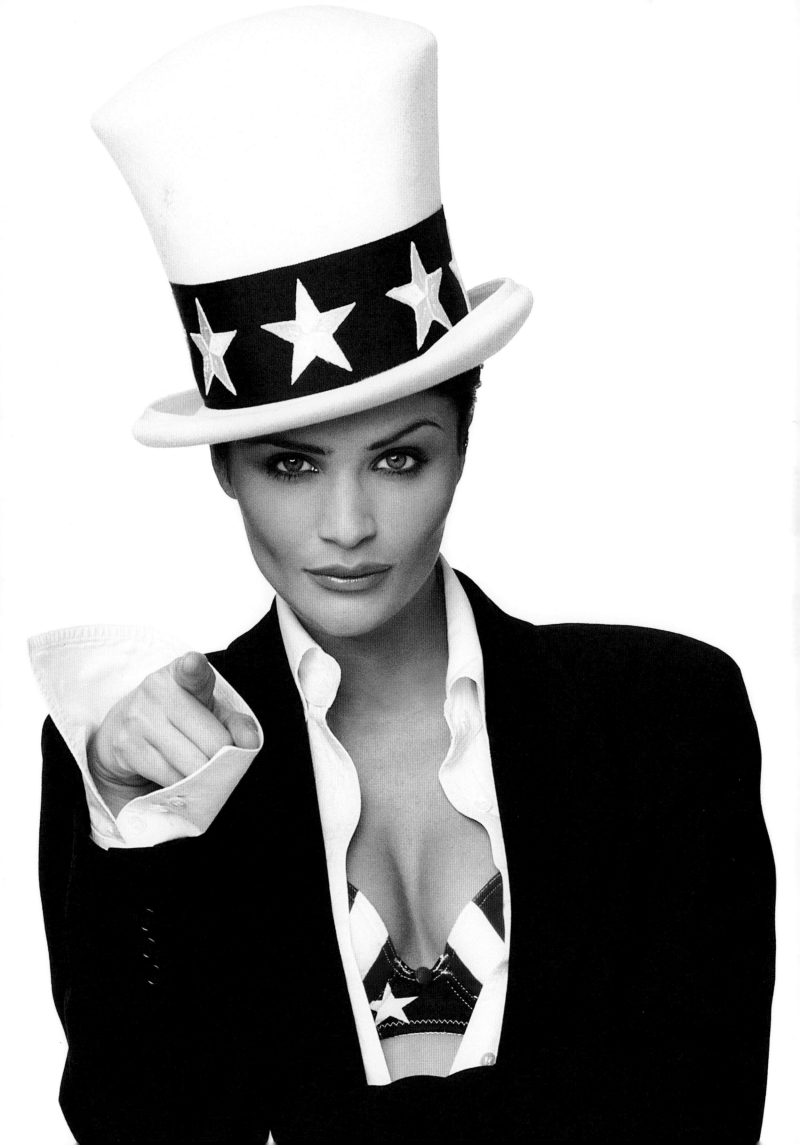

THE FEDORA

Fedoras are dapper
on men, but doubly
alluring on women.
Ramona Saunders
wears a gray felt
fedora at just the
right angle.

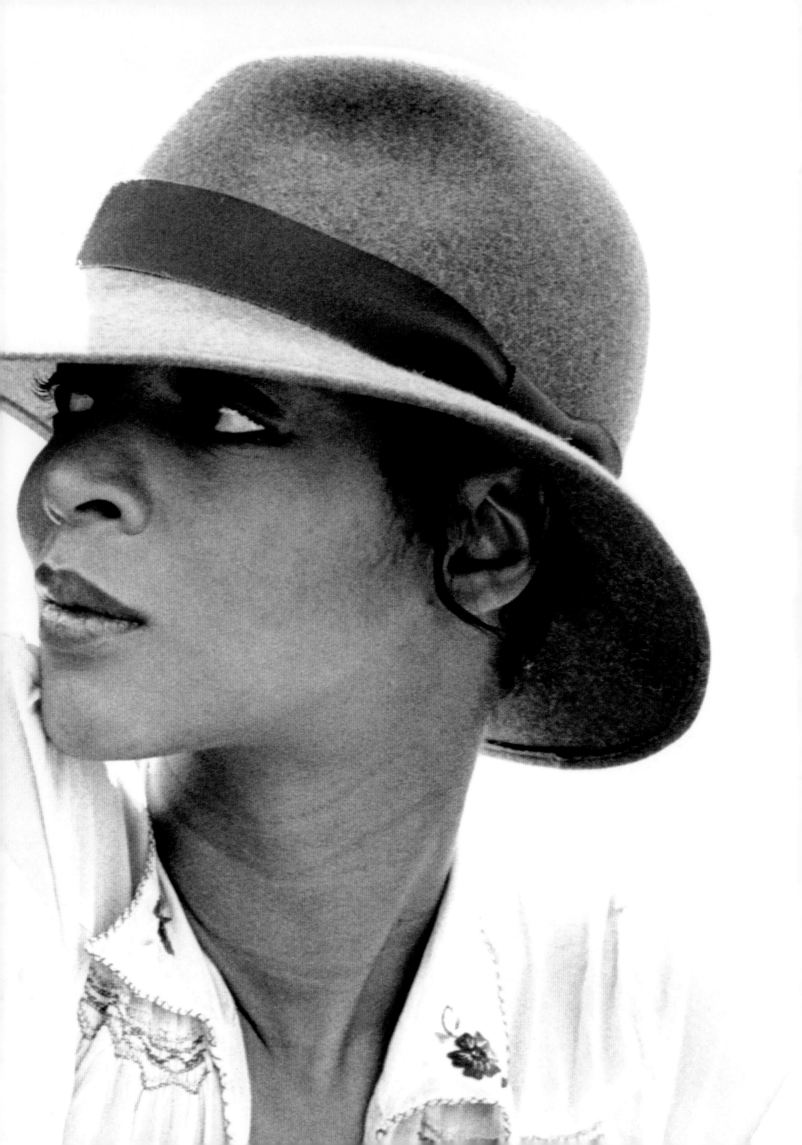

Underwood's signature
super-cool, stitched
black leather fedora

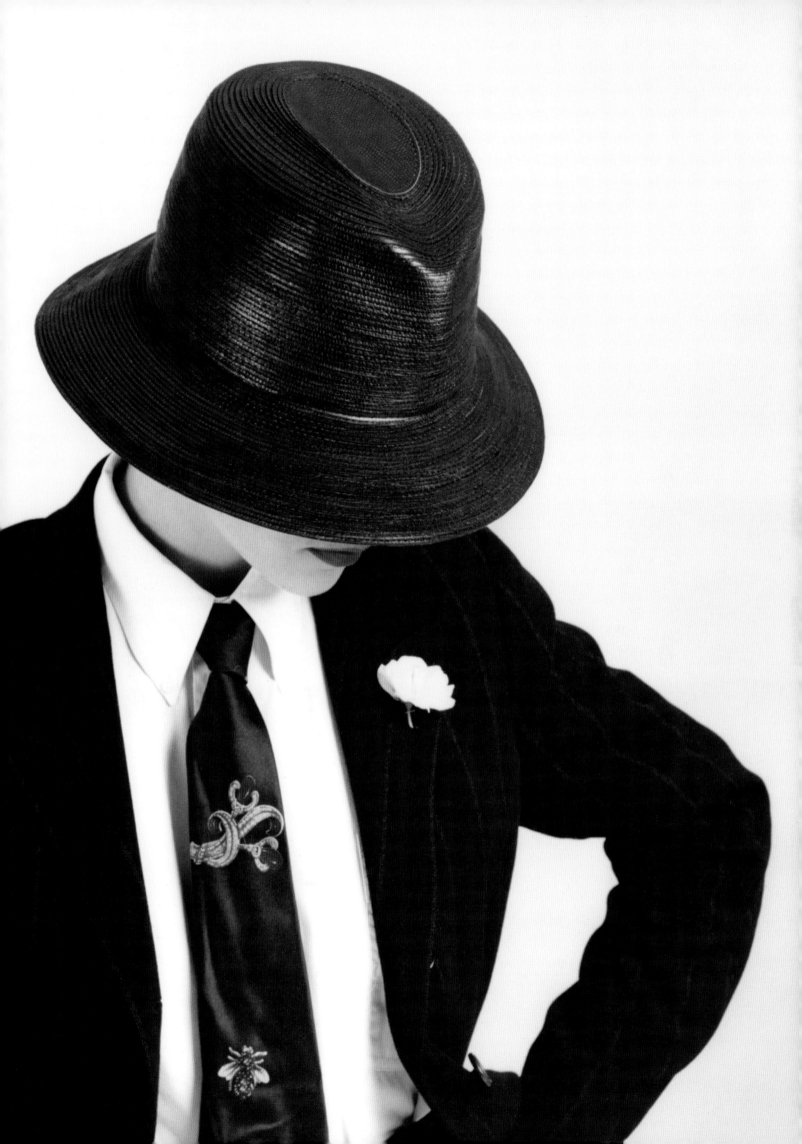

Keira Knightley,
fetching in her
black felt fedora

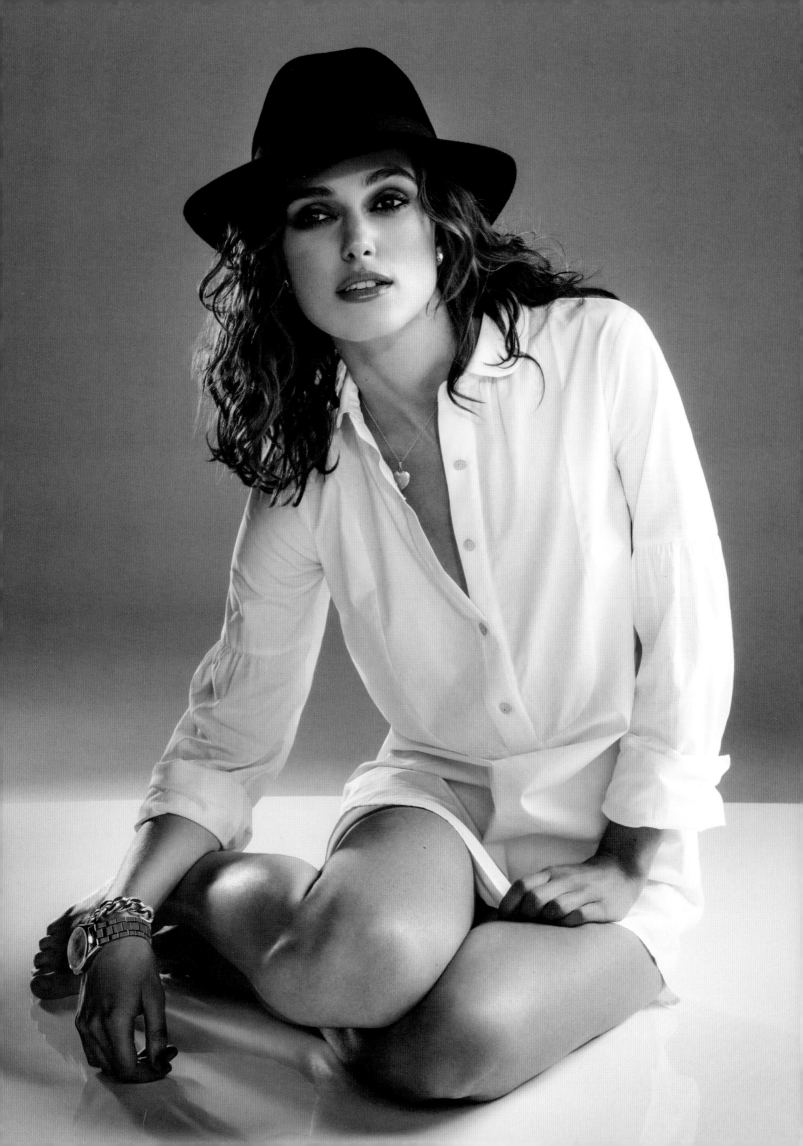

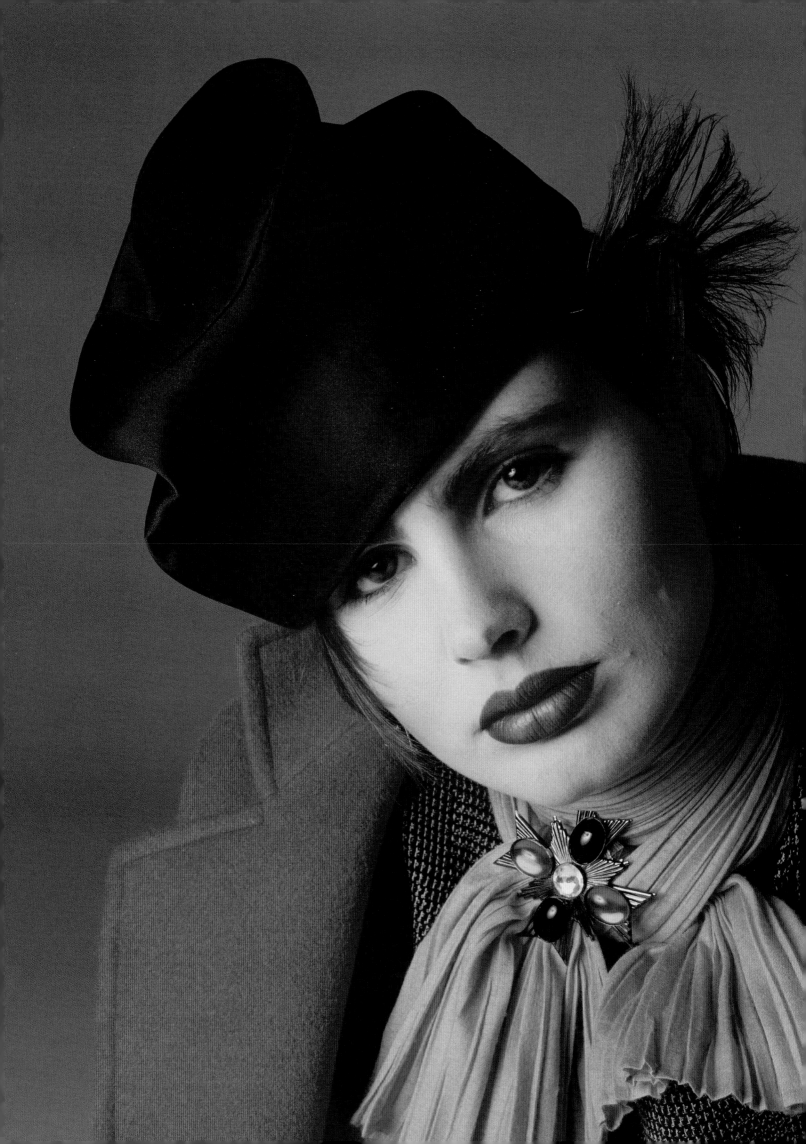

THE TOQUE

Small, slightly crushed,
black silk satin toque

Licorice-colored
pillbox of turkey and
burnt ostrich feathers

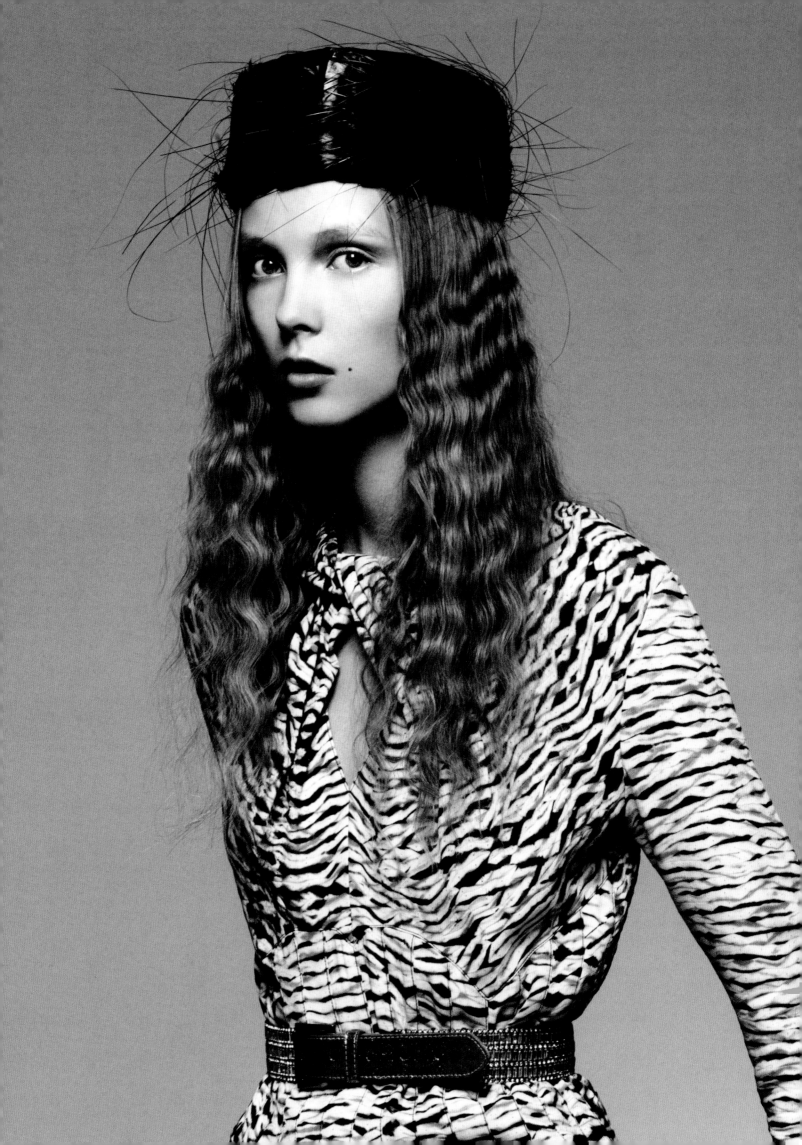

Toque in textured
chenille, wool, and
spandex knit, with
matching fringed scarf

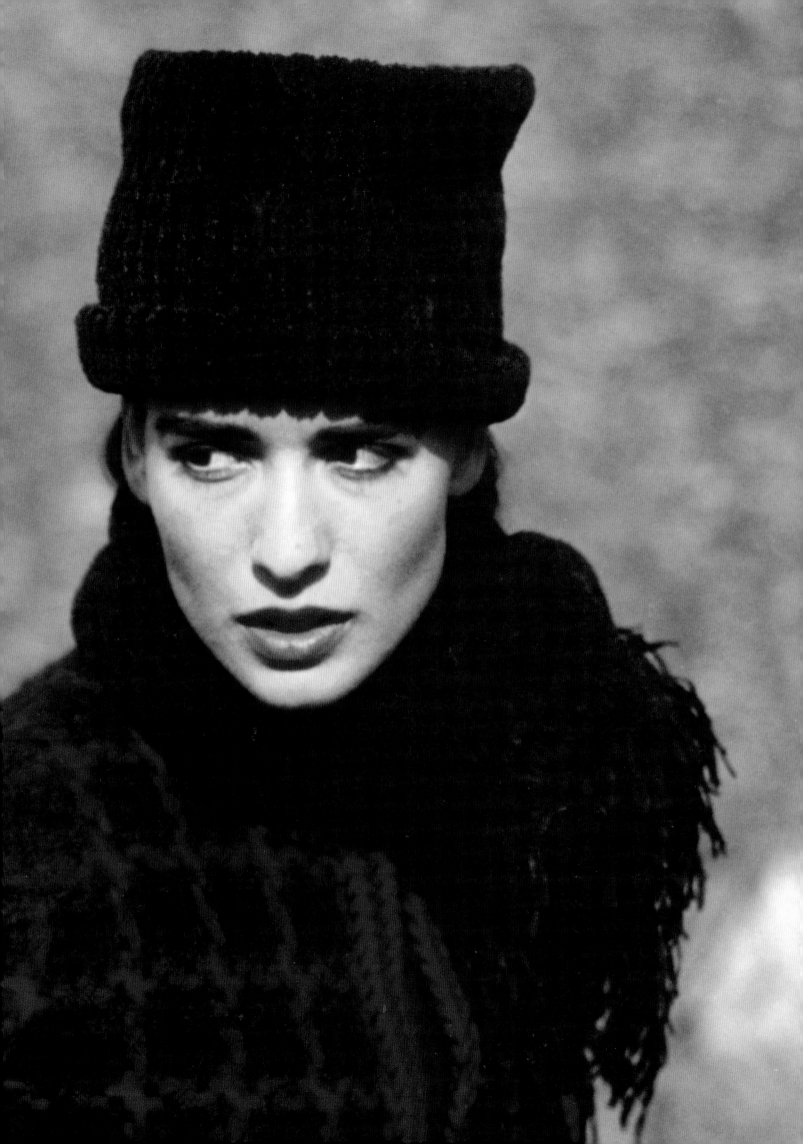

Simplicity of shape
and luxuriousness of
texture: the tall, sleek,
buttery leather toque

THE WIDE-BRIMMED HAT

Jennifer Lopez is spot
on in Underwood's
leopard-print, beaver-
felt "eyeline" brimmed
hat, worn with coordi-
nating coat and bag.

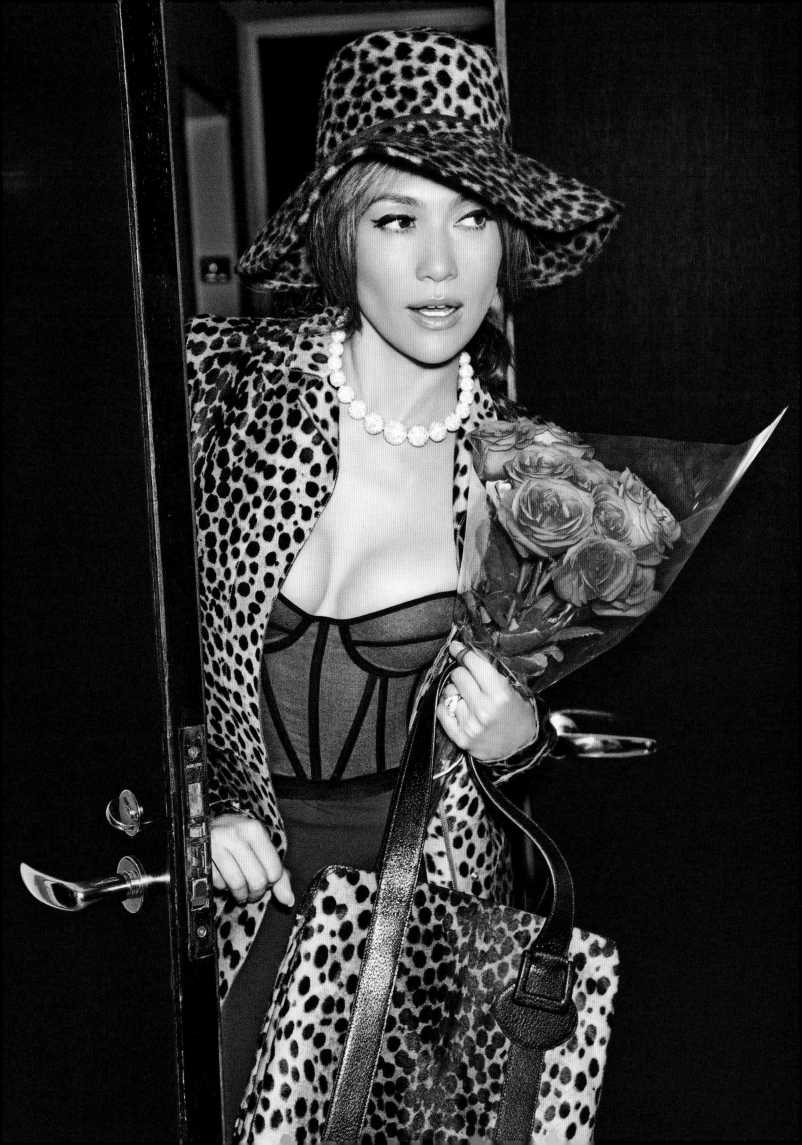

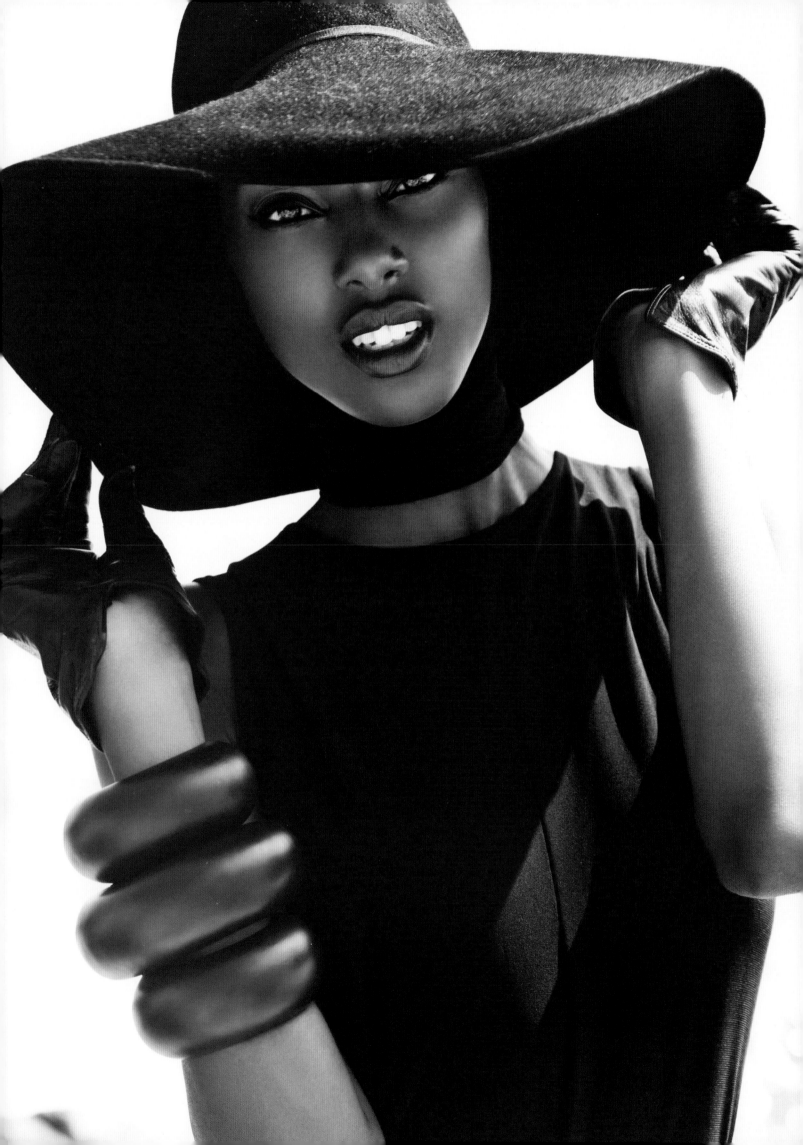

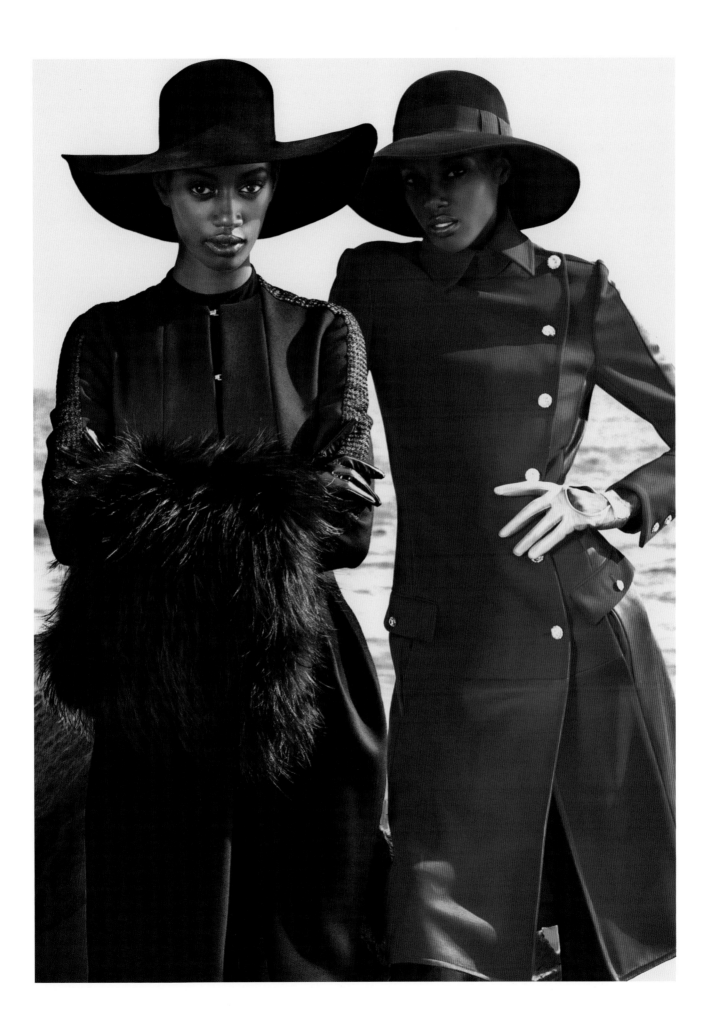

Previous spread (left):
Flattering black fur-felt,
large-brimmed hat

Previous spread (right):
Black high-crowned
wide-brimmed hat,
and round-crowned
red velour, bowed, and
brimmed hat—both
adding drama to
strong, tailored coat
shapes

Opposite: Actress
Annette Bening in a
face-framing soft felt
hat for a dramatic
studio portrait

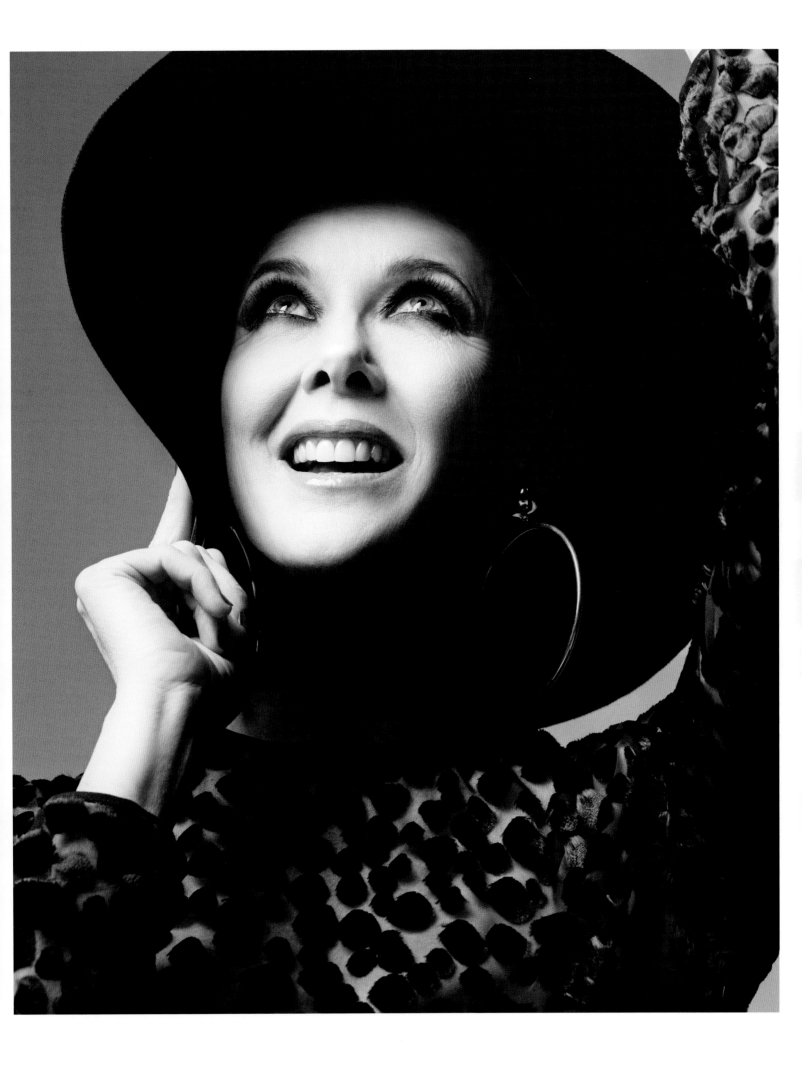

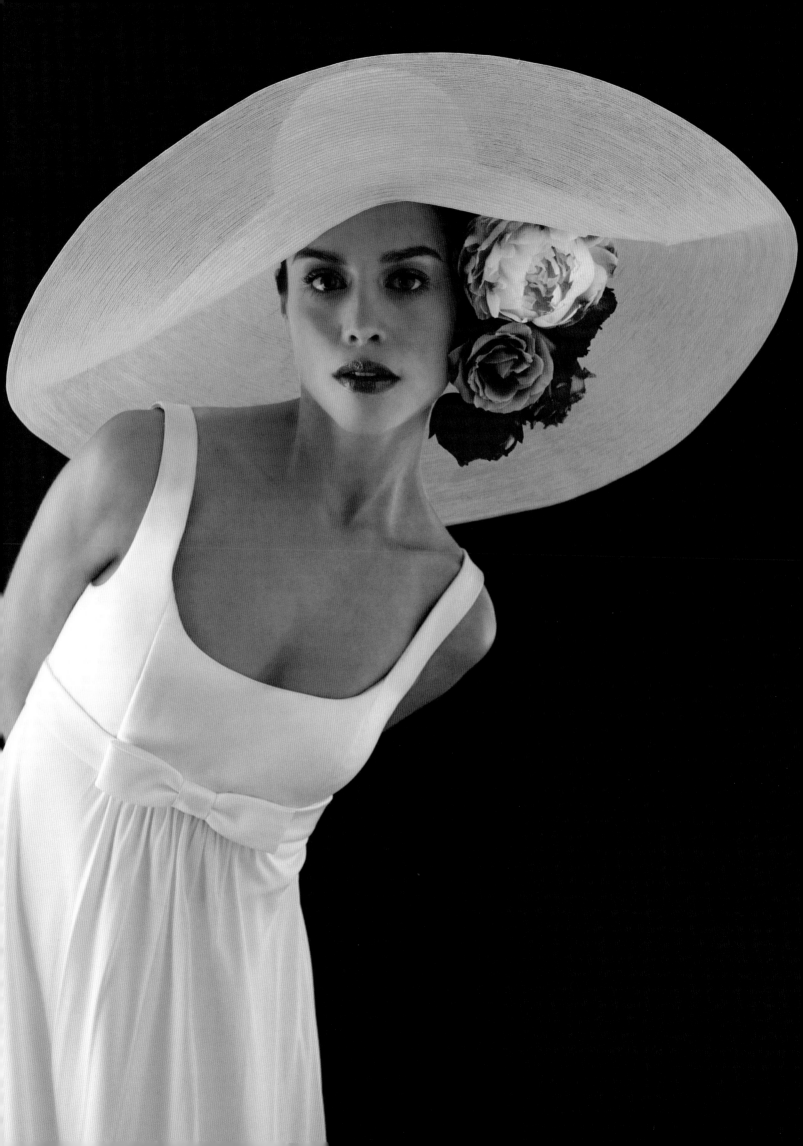

LIGHT AND SHADE

Instead of piling
roses on top of
an upturned fine-
horsehair hat,
Underwood tucks
them under the brim,
where they bloom,
charmingly, next to
the model's cheek.

A giant swoop of
finest horsehair braid
both flatters the face
and creates an air of
mystery.

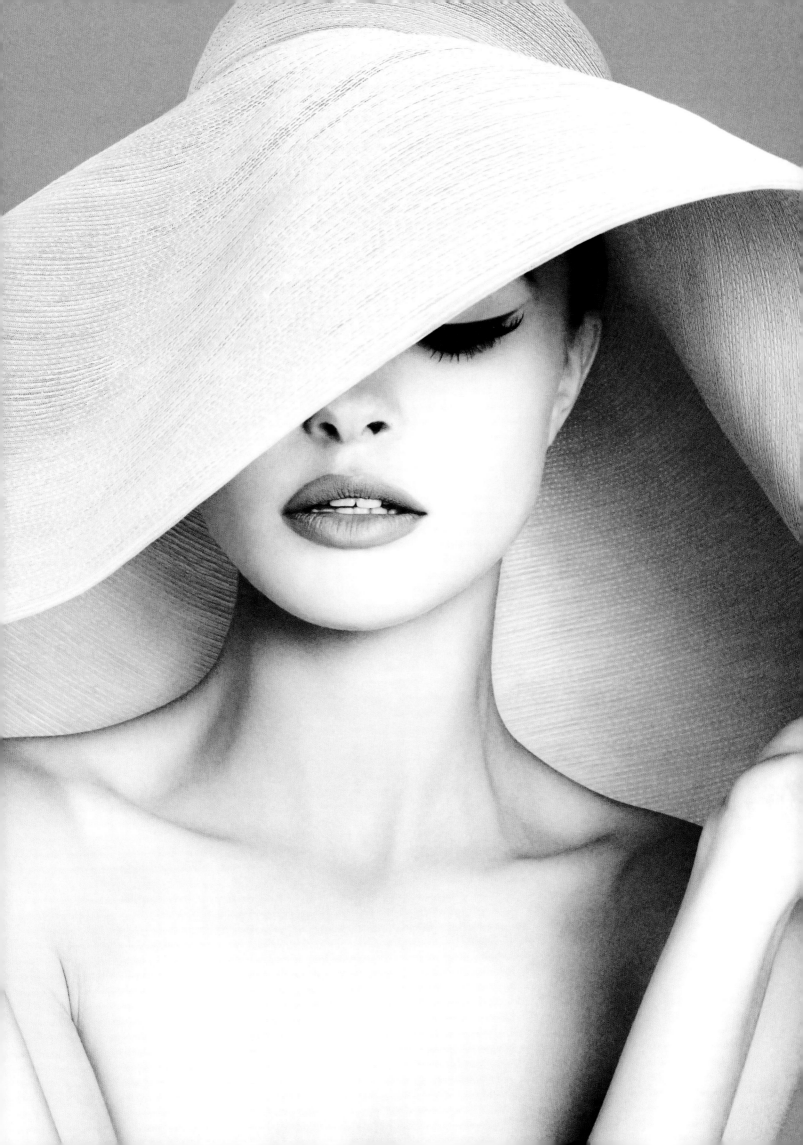

Opposite: Giant
"Arcadia" hat with
a different slant, a
round crown, and
big upturned brim.
Of fine horsehair (very
narrow nylon crinoline
braid), which allows
enough light in to
illuminate the face

Following spread:
Black paglina straw
"Celeste" hat, edged
in white on Lydia
Hearst

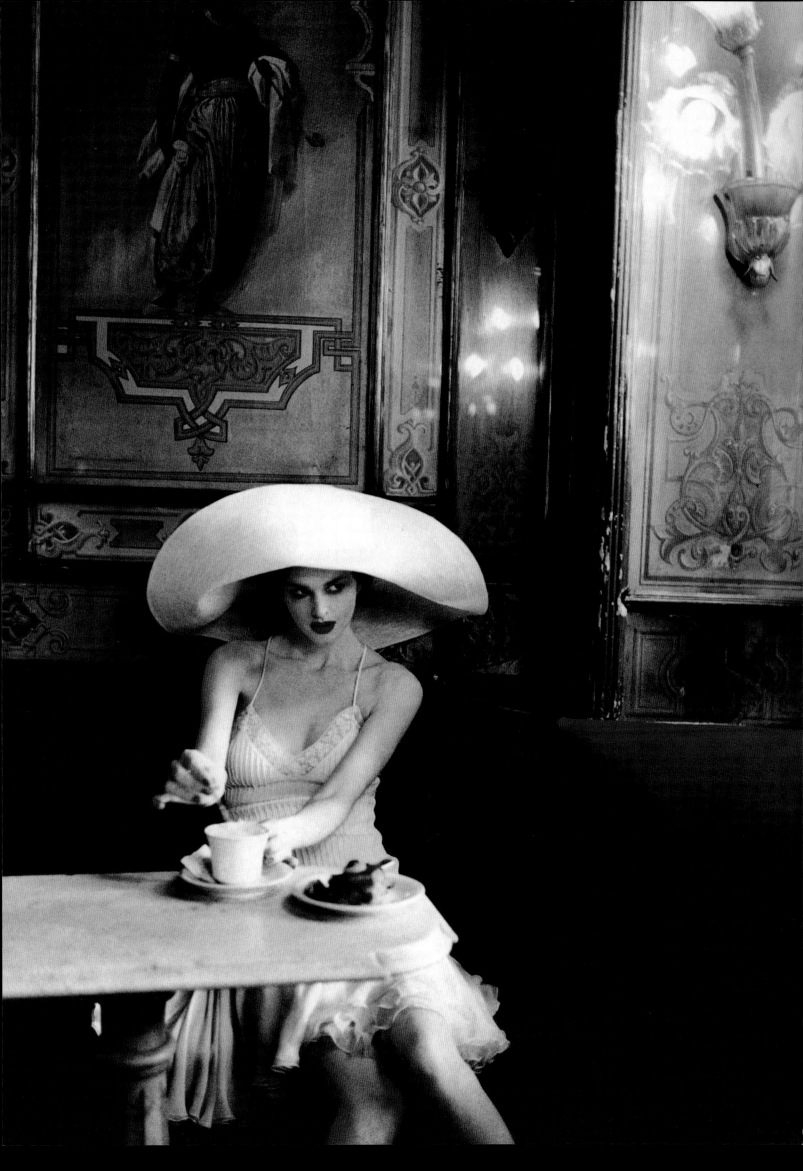

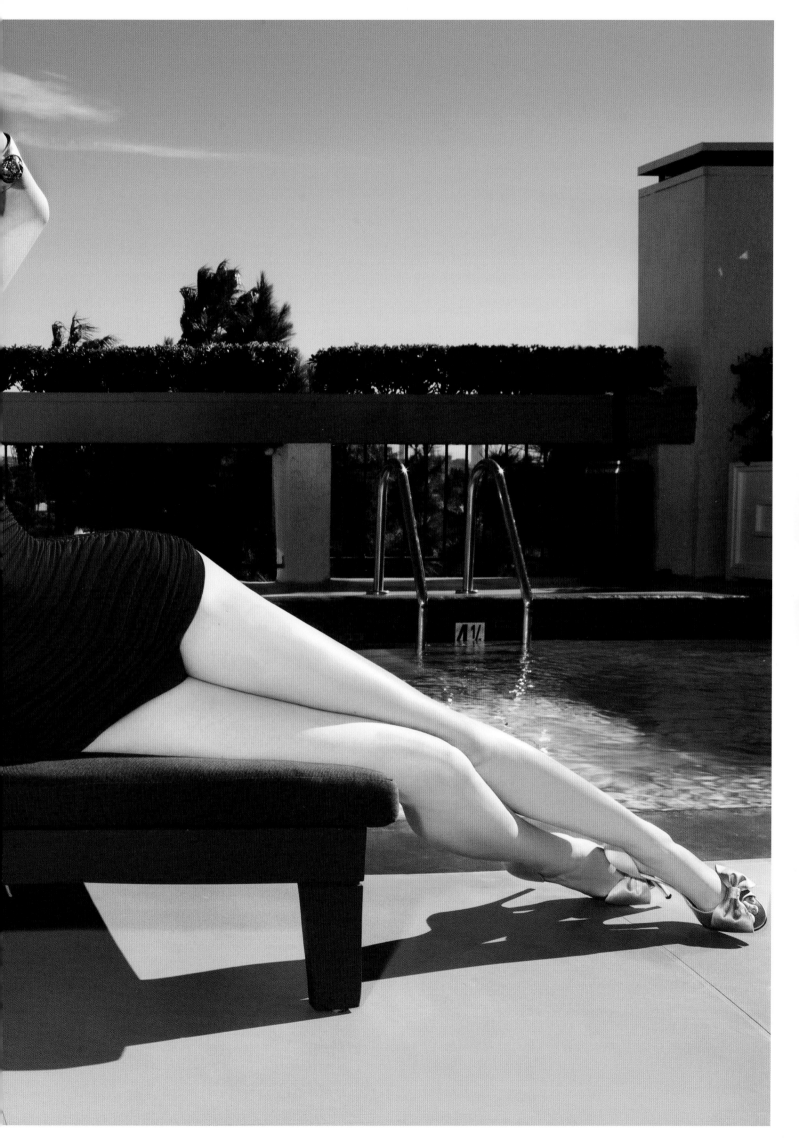

Oversized "beach
umbrella" hat of
Pontova braid,
providing shade for
Elle Macpherson
and her sons

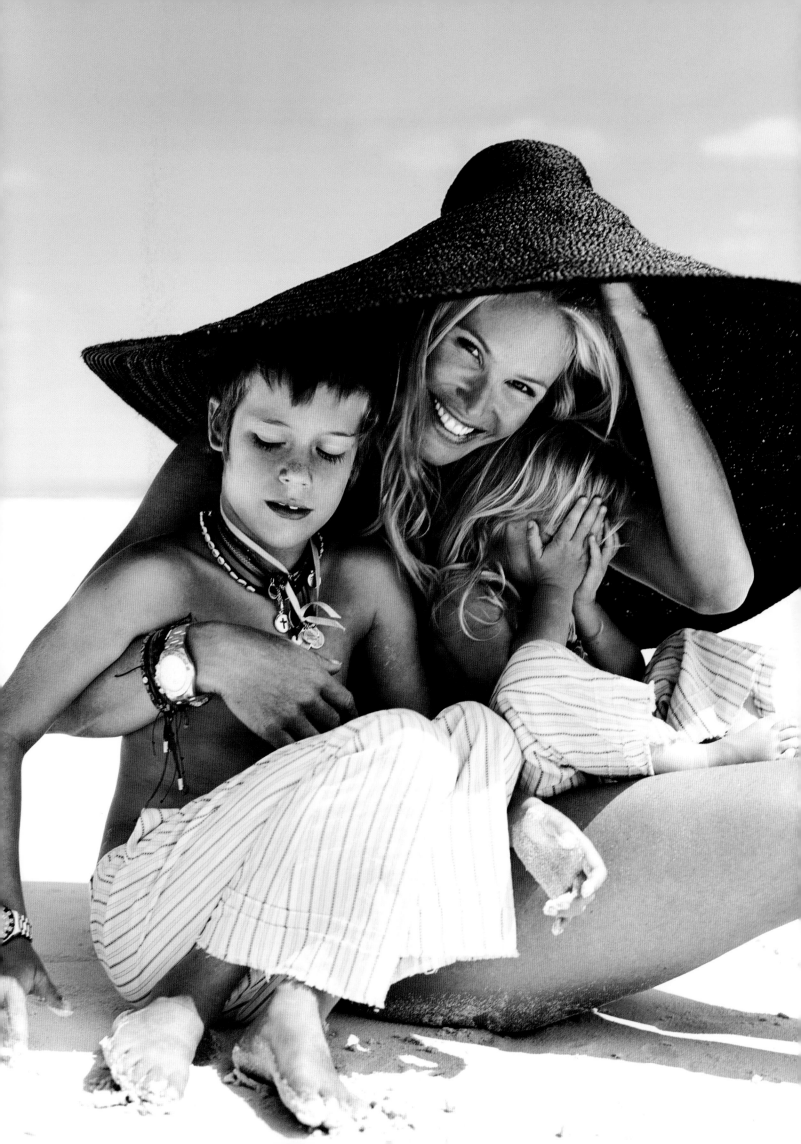

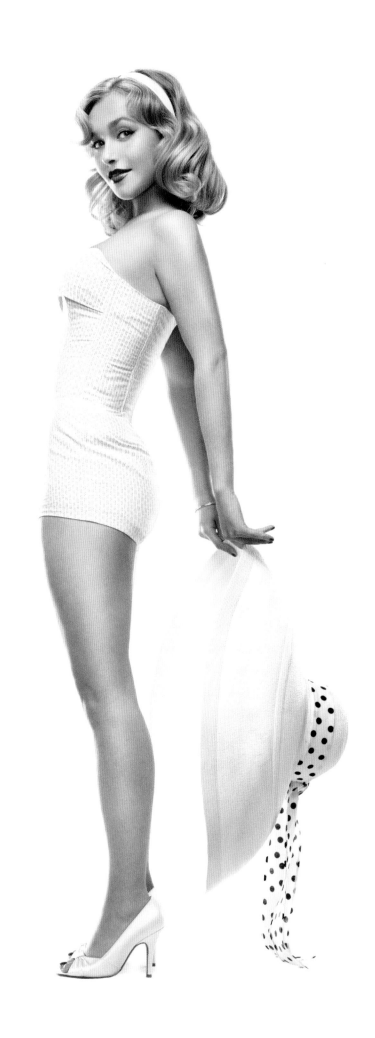

This page: Hayden Panettiere in a vintage-inspired bathing costume with large paglina hat trimmed in polka dots

Opposite: Super-sized, shredded coconut straw shading model Michelle Behennah on the beach during a *Sports Illustrated* Swimsuit Issue shoot

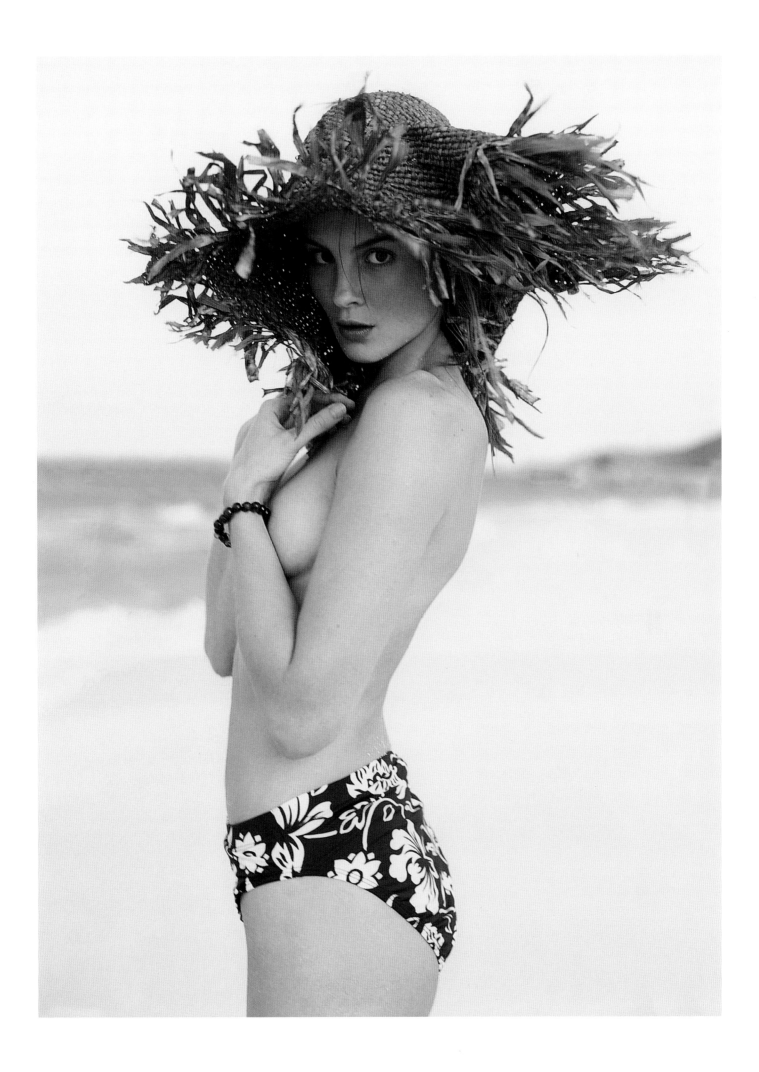

Opposite: "Lea" hat
in white horsehair,
perfect for chasing
butterflies or floating
down the aisle

Following spread:
Taking shelter in a
fine Milan straw wide-
brimmed hat

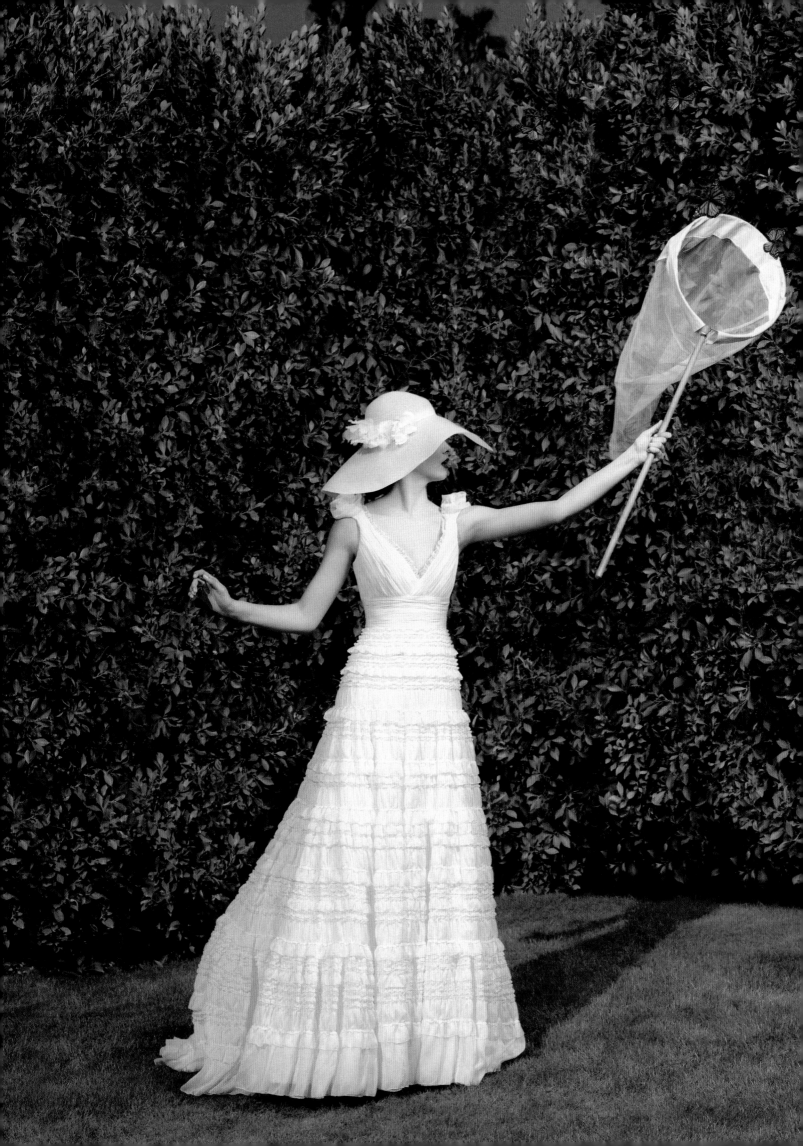

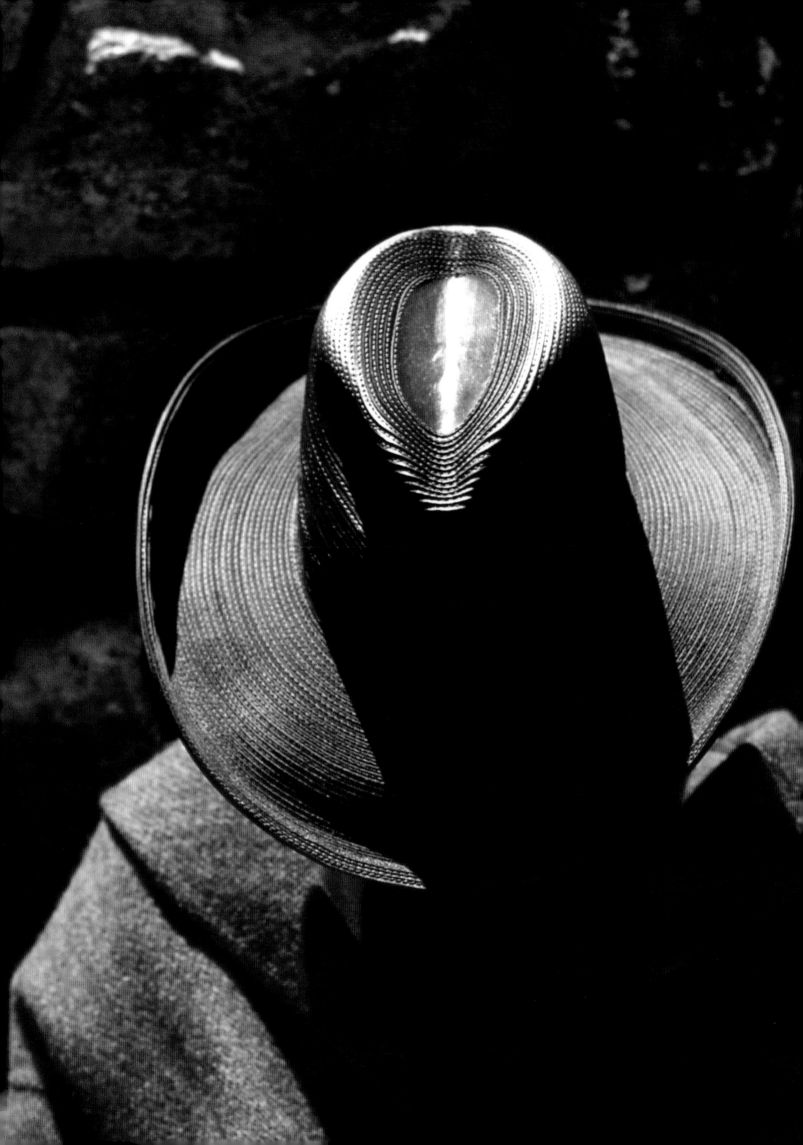

THE COWBOY HAT *and* THE GAUCHO HAT

Underwood's signature
stitched-leather cow-
boy hat

Opposite: Backstage
at a Ralph Lauren
show for Spring
2013, which featured
Patricia Underwood
for Ralph Lauren
Collection silk flat-
brimmed gaucho
hats

Following spread:
Patricia Underwood
for Ralph Lauren
gaucho up close

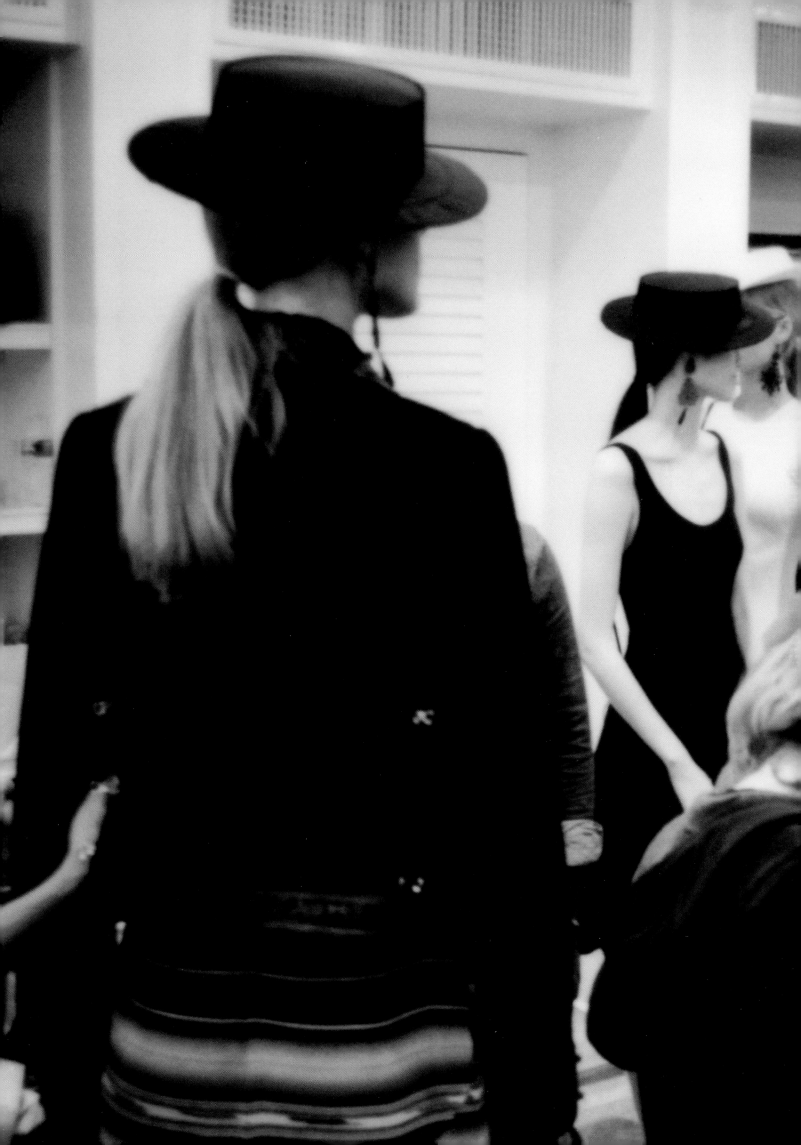

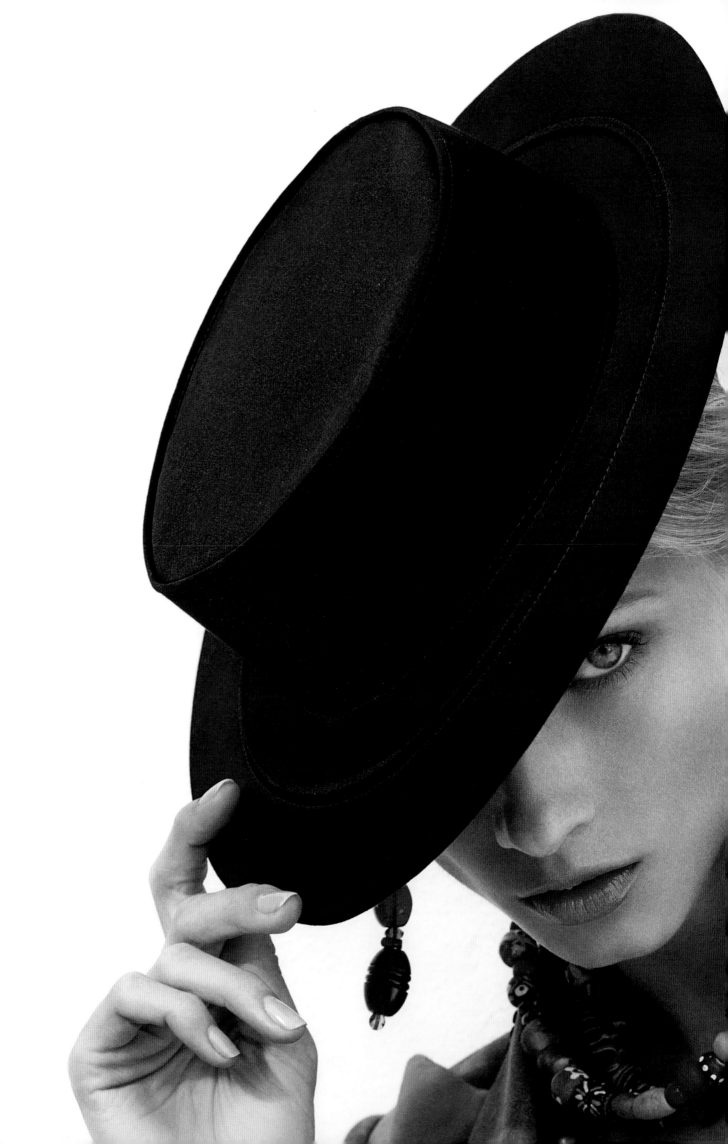

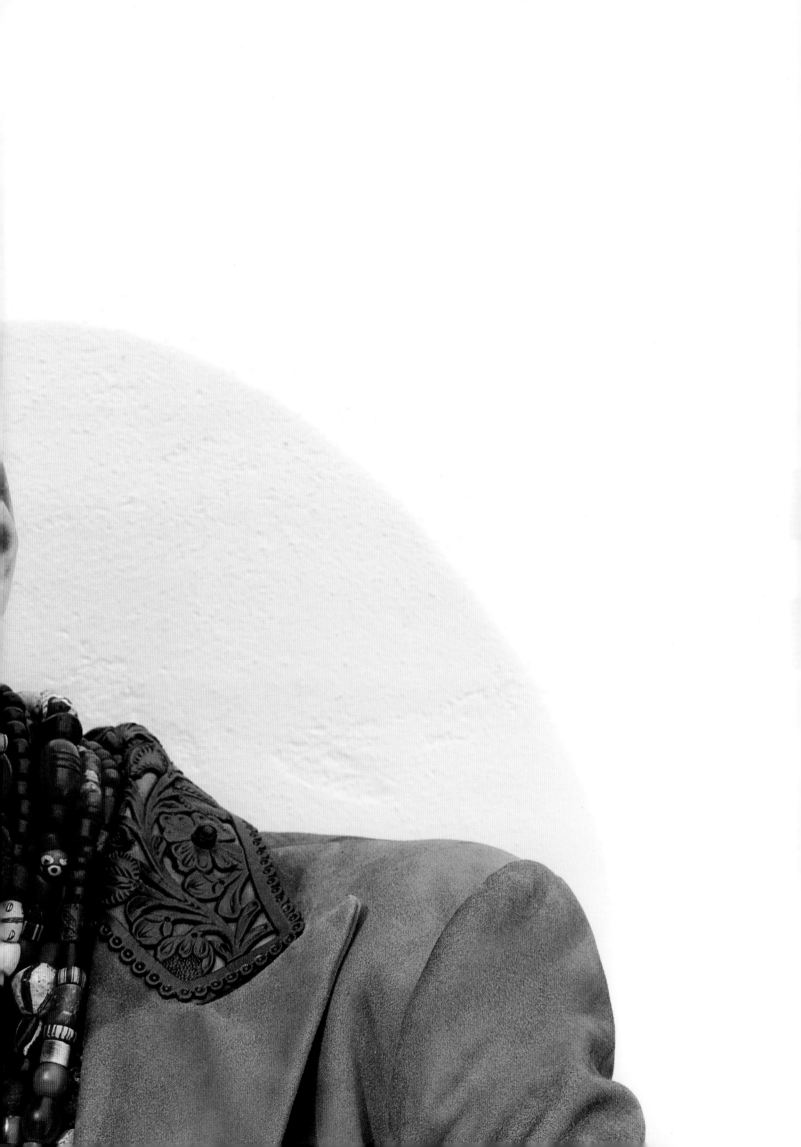

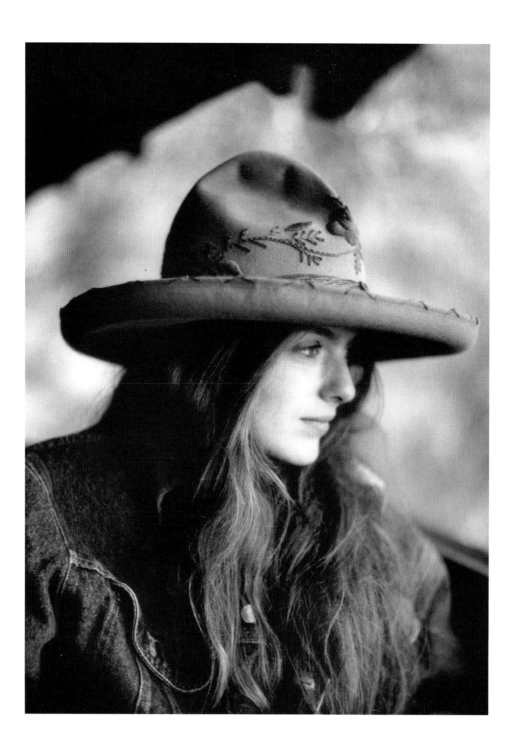

Above: Handsome
hand-embroidered
felt "Tom Mix" cowboy
hat. Commissioned
and photographed by
Monty Montgomery.

Opposite: Deeply
dented, white paglina
straw cowboy hat
with curved brim on
model Carré Otis

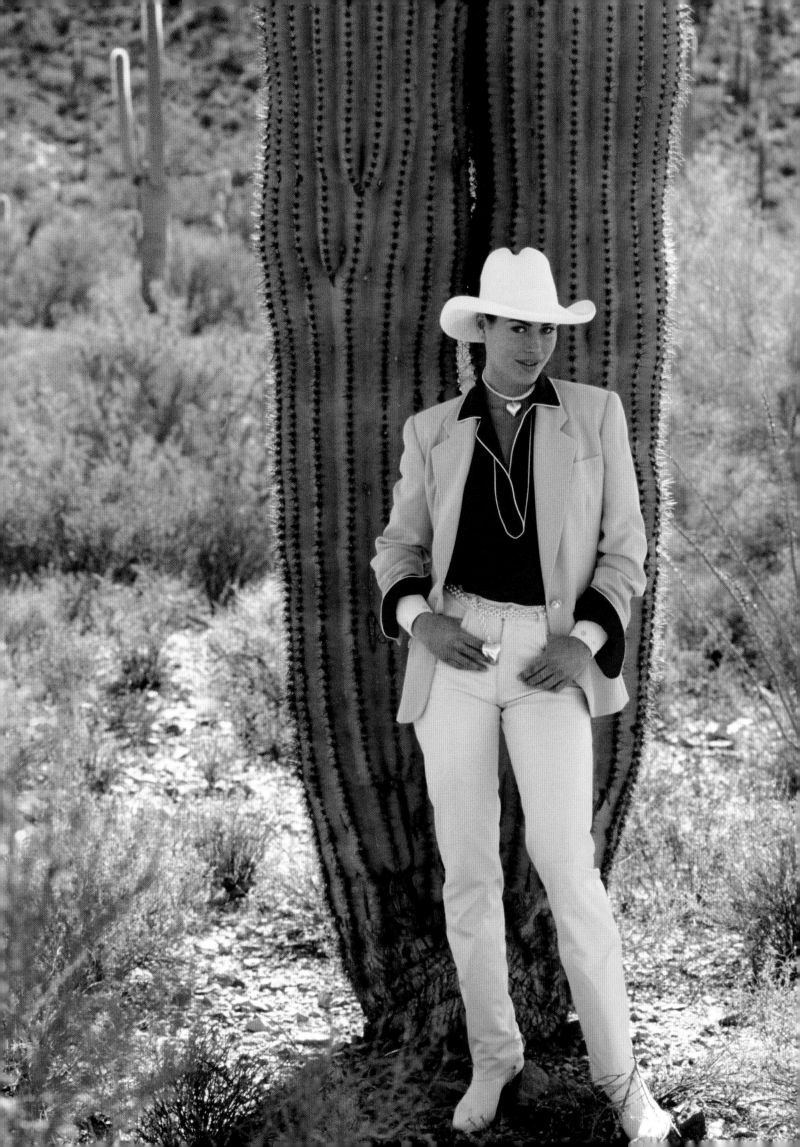

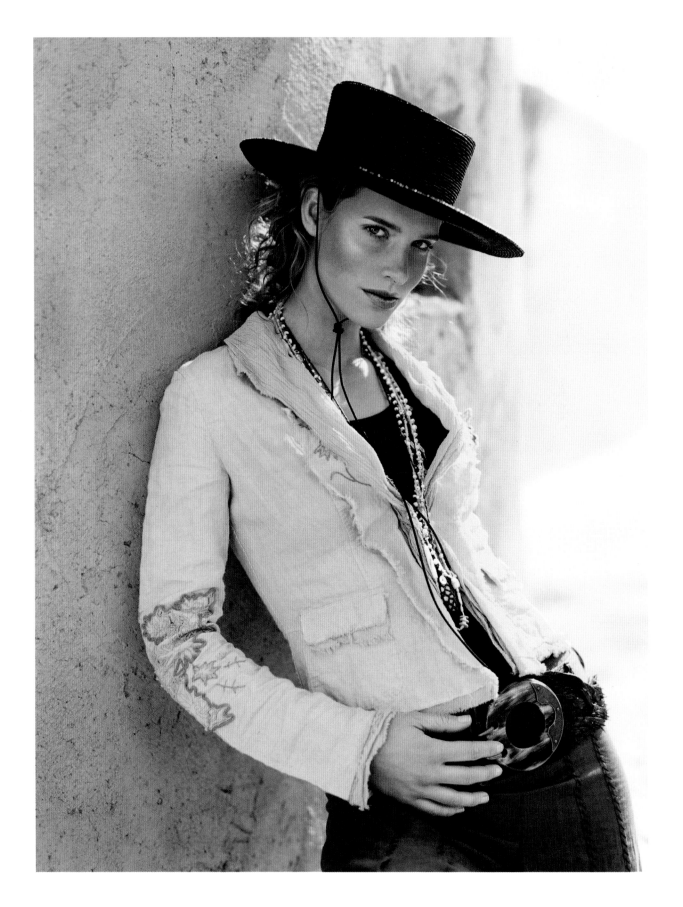

Above: Flat-brimmed
black Milan braid
gaucho hat with a
slightly taller crown

Opposite: The same
shape, slung to the
back

THE BERET *and* THE TURBAN

Leopard-spotted
beaver berets on
models Patricia van
der Vliet and Ylonka
Verheul

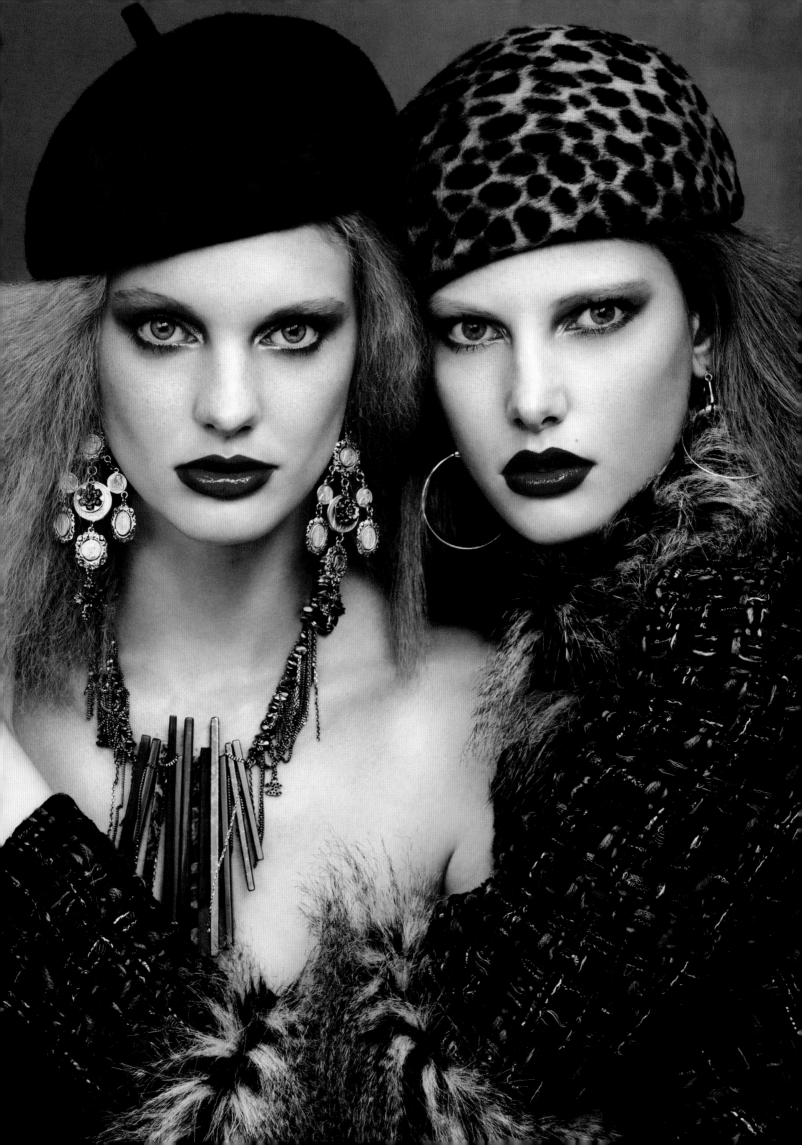

Small jade-colored
paglina straw beret
on Anais Mali

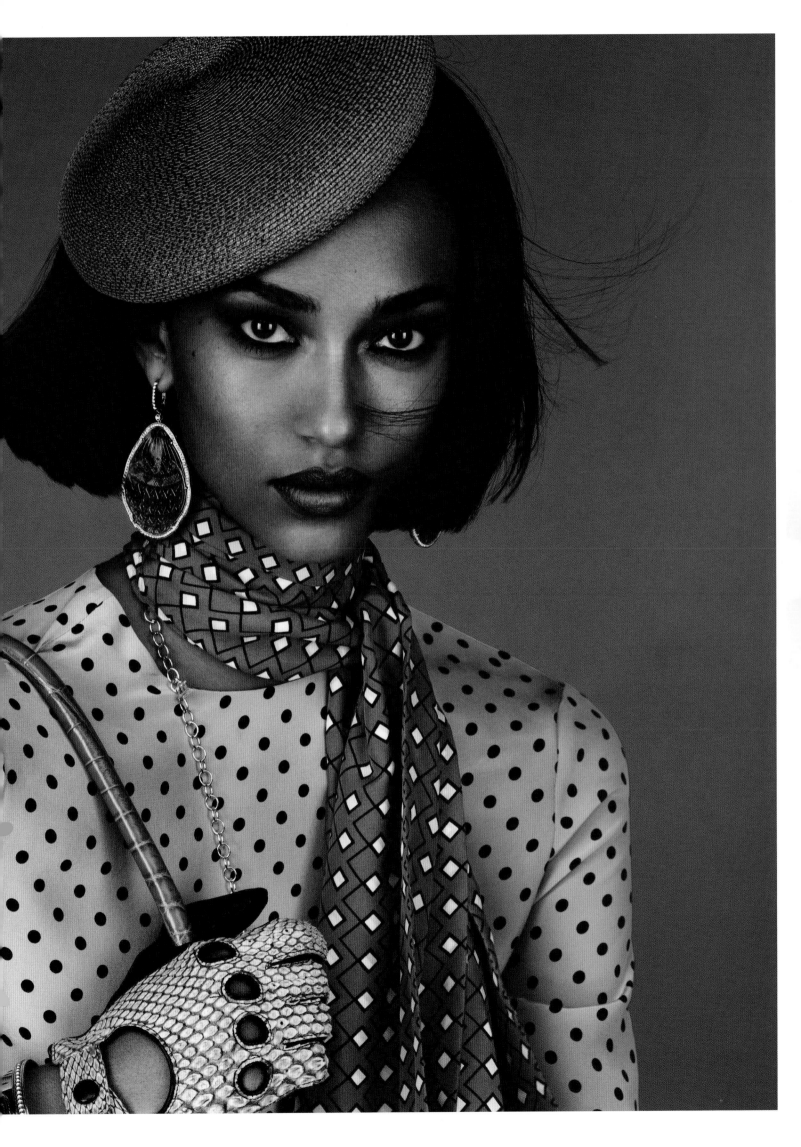

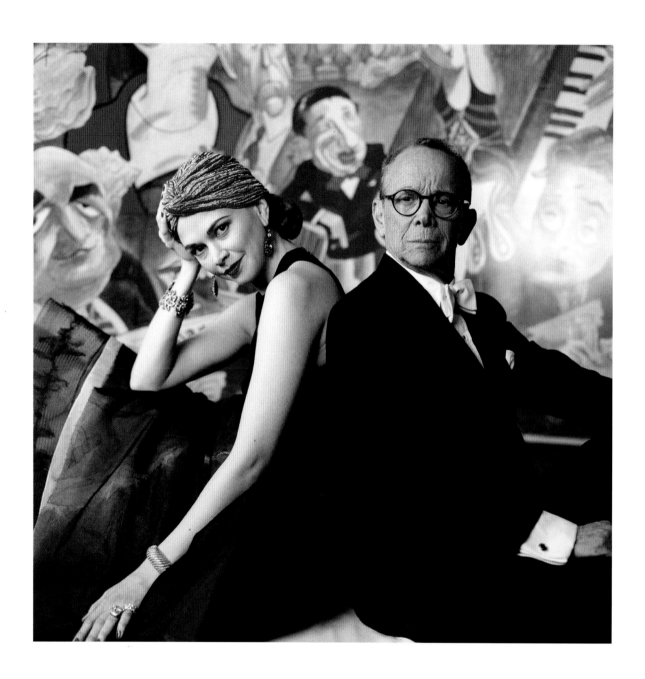

Above: Lurex and silk,
pleated and draped
turban on actress
Sutton Foster, with
Joel Grey

Opposite: Petrol-blue
cotton-ribbed knit
turban

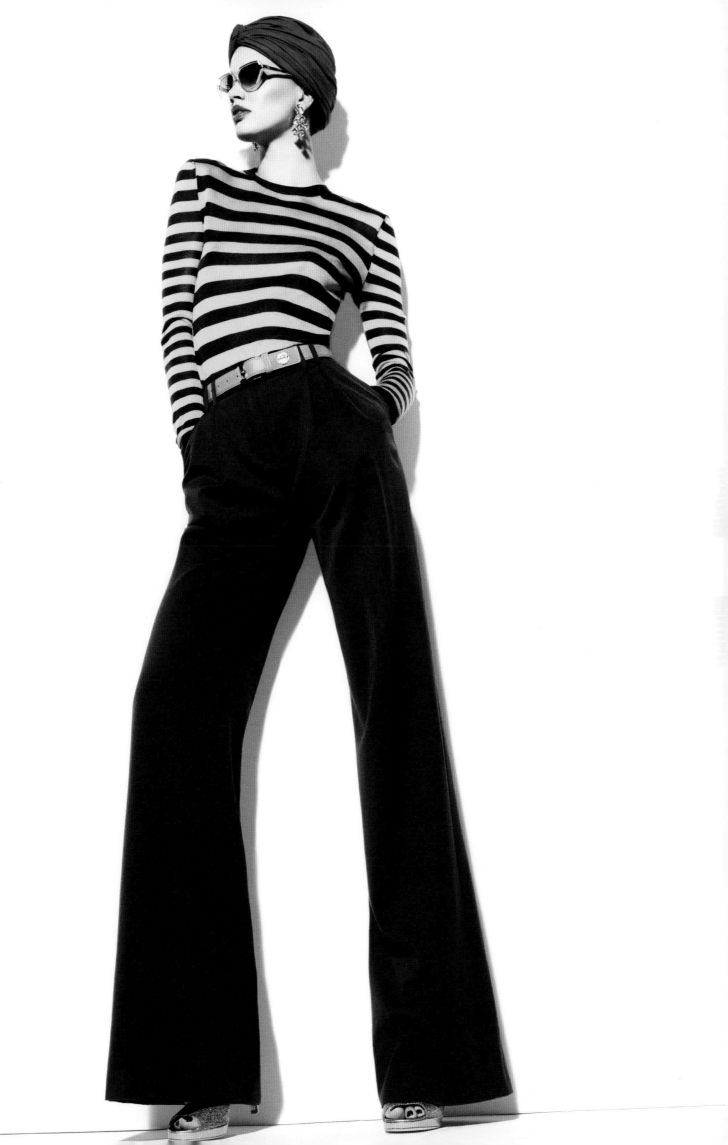

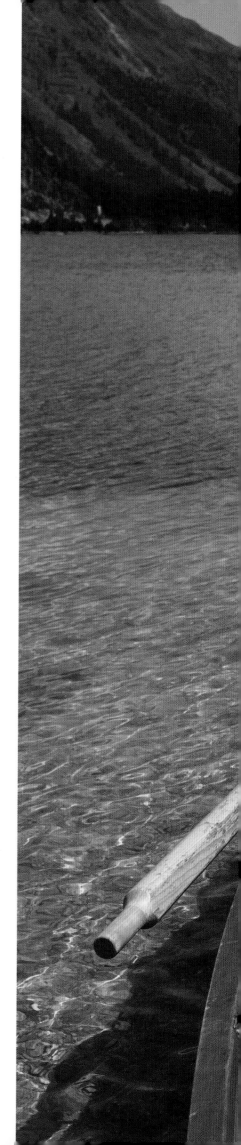

THE SOU'WESTER *and* THE BOATER

A flattering, face-
framing hat, whose
brim is longer in back
than in front to keep
the neck covered,
the sou'wester was
originally designed as
foul-weather gear.

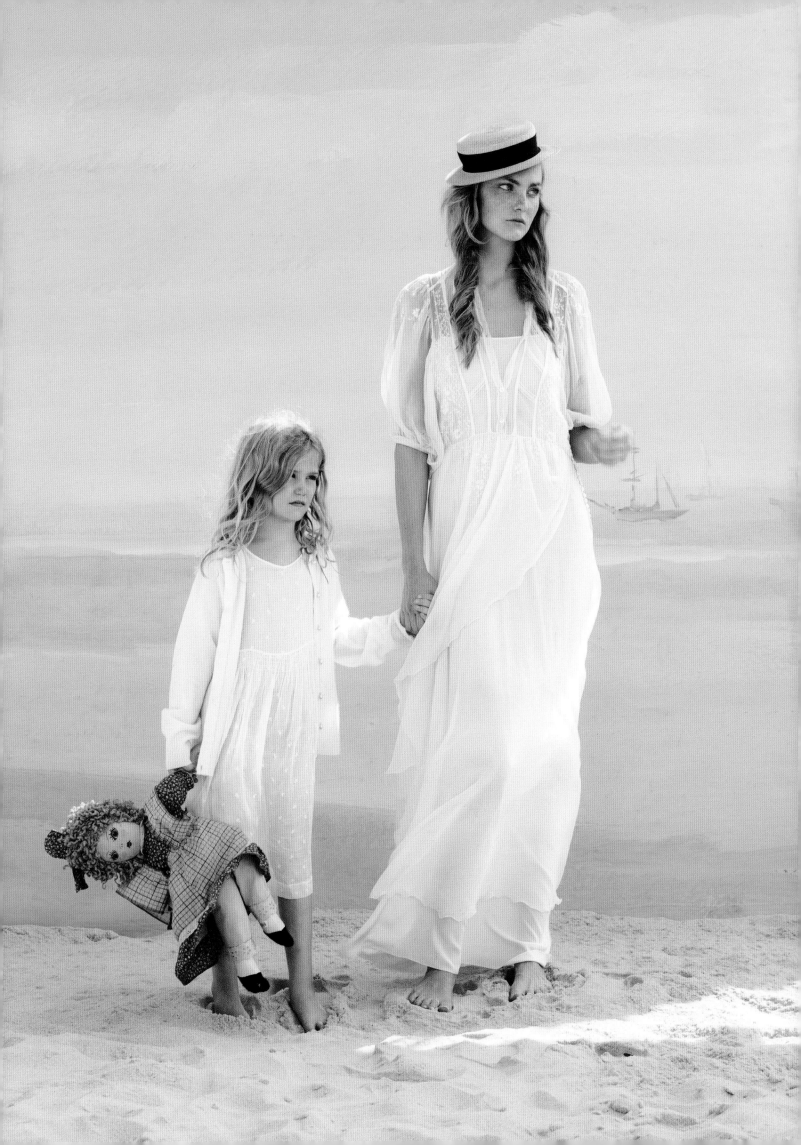

Previous spread (left):
A slightly higher-
crowned boater in
fine Starbrite braid,
perfect for gliding
down the Grand
Canal

Previous spread
(right): First made for
the British Royal Navy
to shade the faces
and necks of mid-
shipmen, the straw
boater has been a
stylish summer hat for
men and a charmer
on women in long
white dresses and just
about anything else.

Opposite: The
sou'wester, as worn
by Audrey Smaltz,
is smashing with a
bright slicker.

THE FUR HAT *and* THE KNIT HAT

Brimming with fur, a
statement in mink on
Stella Tennant

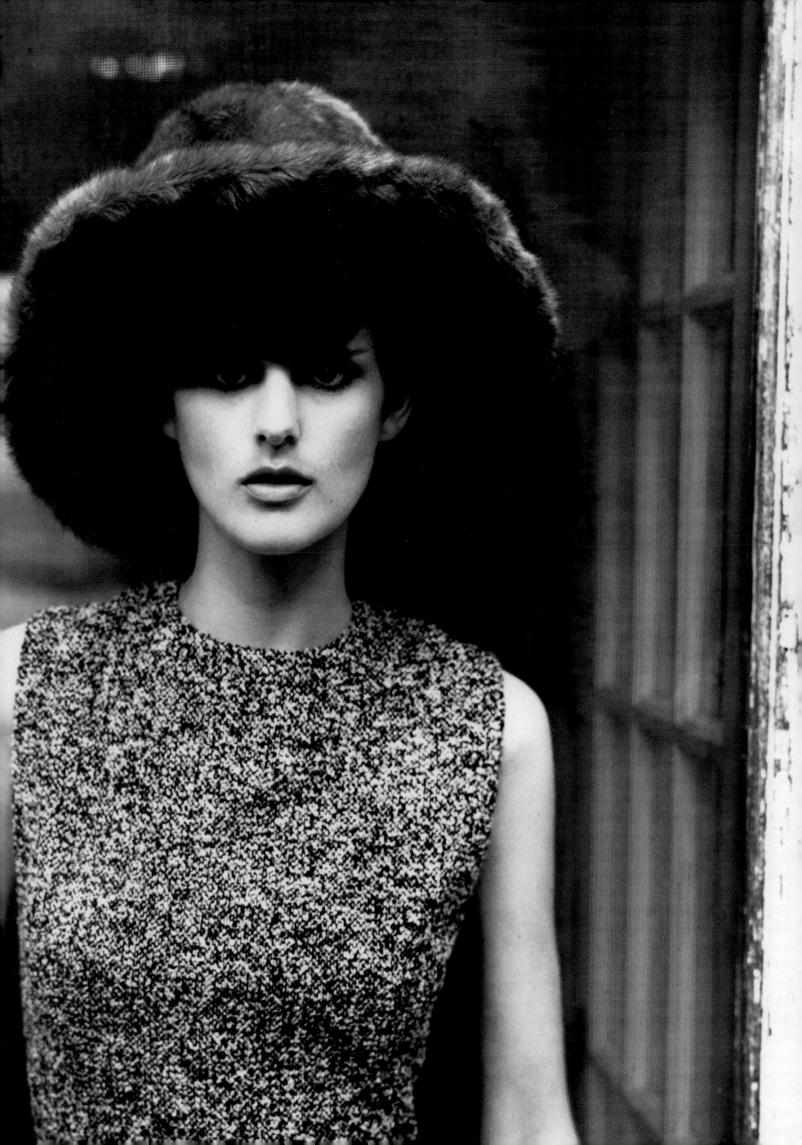

Luxurious, oversized
fox fur beret

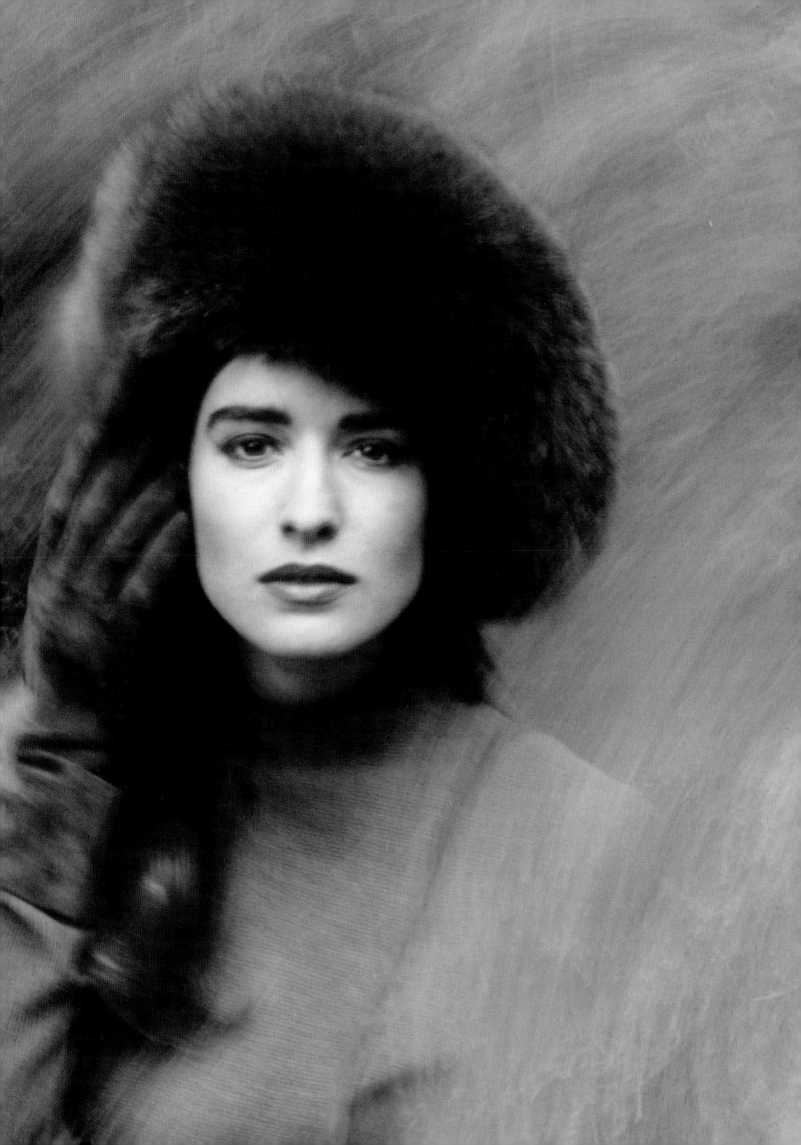

The "Ice Boater,"
worn by Kristen
McMenamy, is a
winter version of the
classic straw boater,
with a taller crown in
soft white fur.

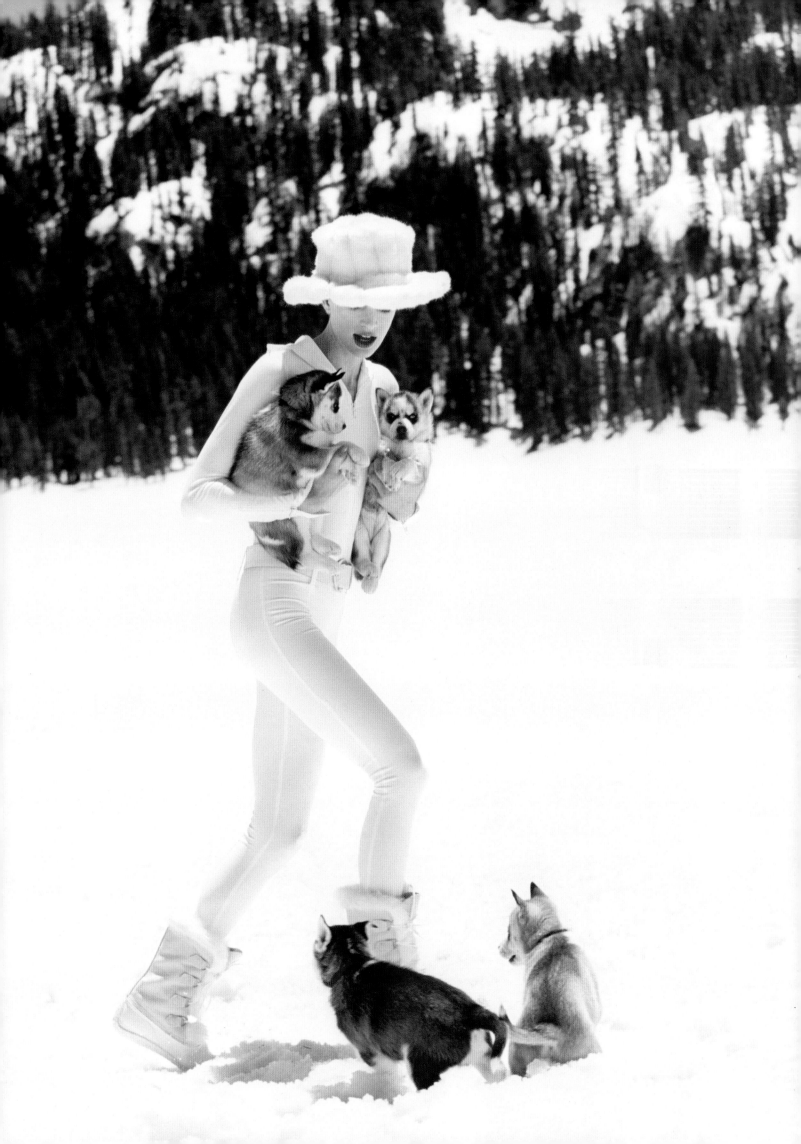

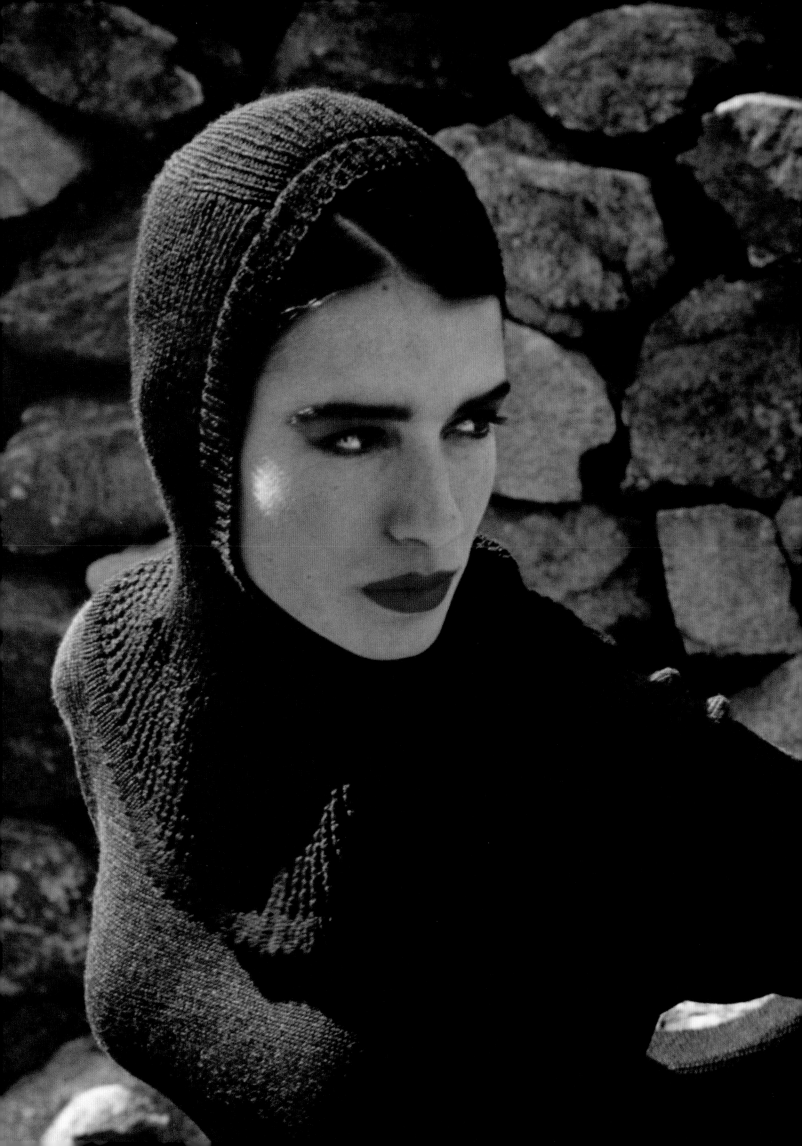

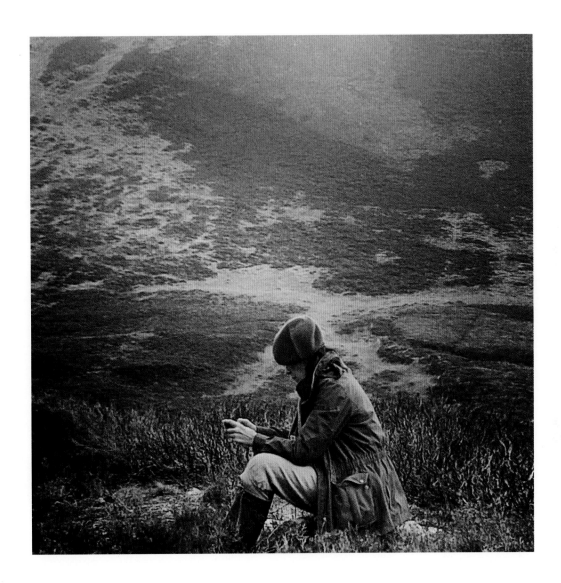

Opposite: Crusading
against the cold, a
face-framing carbon
cashmere and wool
knit hood

Above: Artist Bridget
Lansley tones into the
Scottish landscape
wearing a cashmere
beret.

Oatmeal-colored,
oversized ribbed
cashmere toque
with cashmere
lace-knit shawl

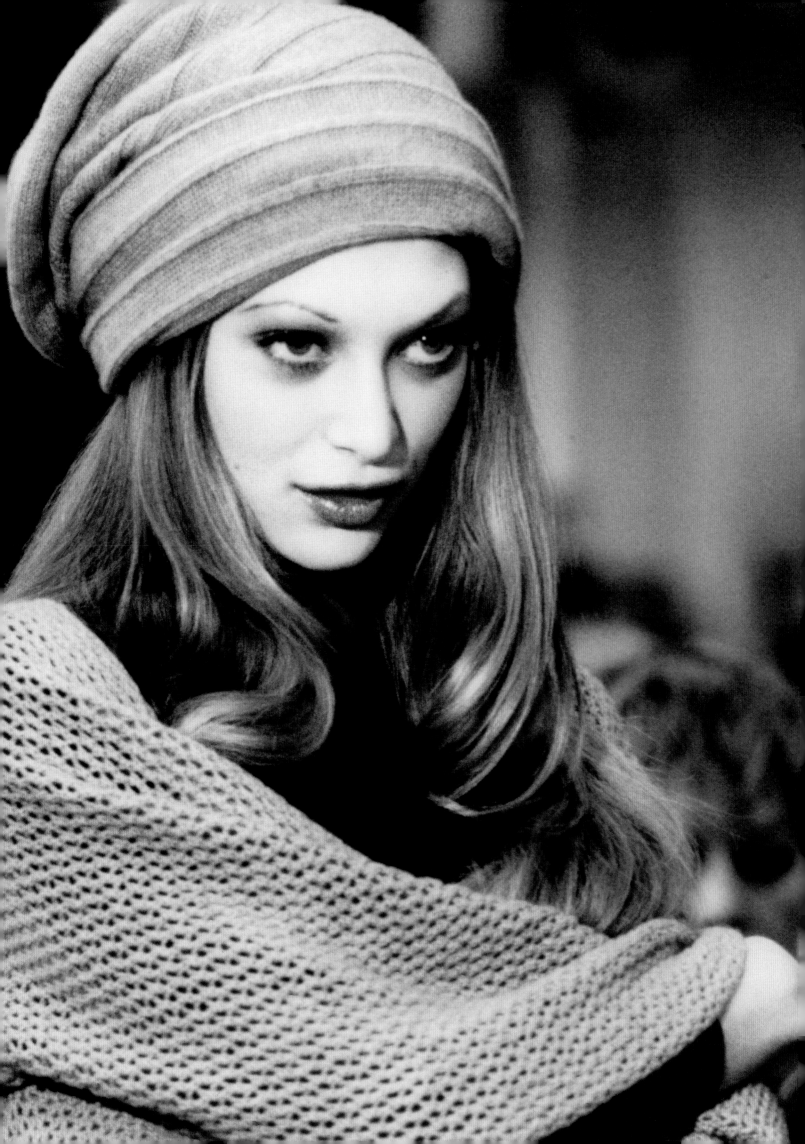

THE NEWSBOY CAP *and* THE DOO'LANDER

Patricia Underwood
for Ralph Lauren
Collection menswear-
fabric newsboy caps
for Spring 2010

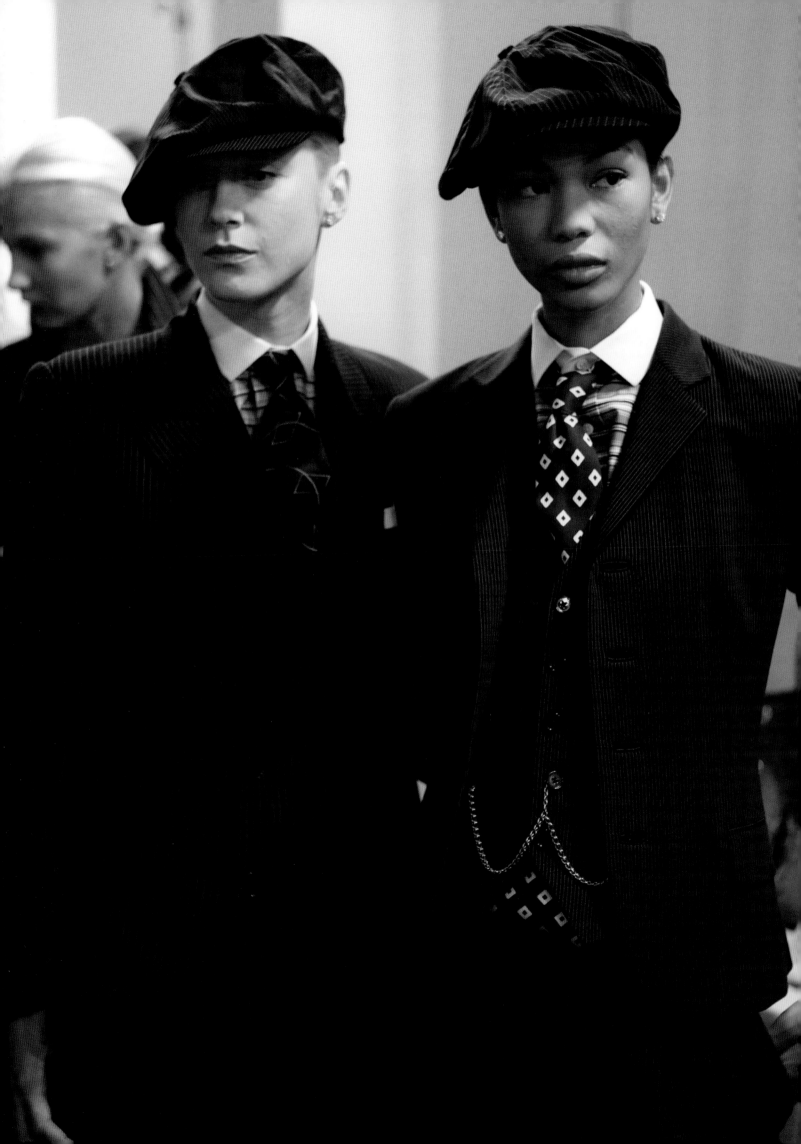

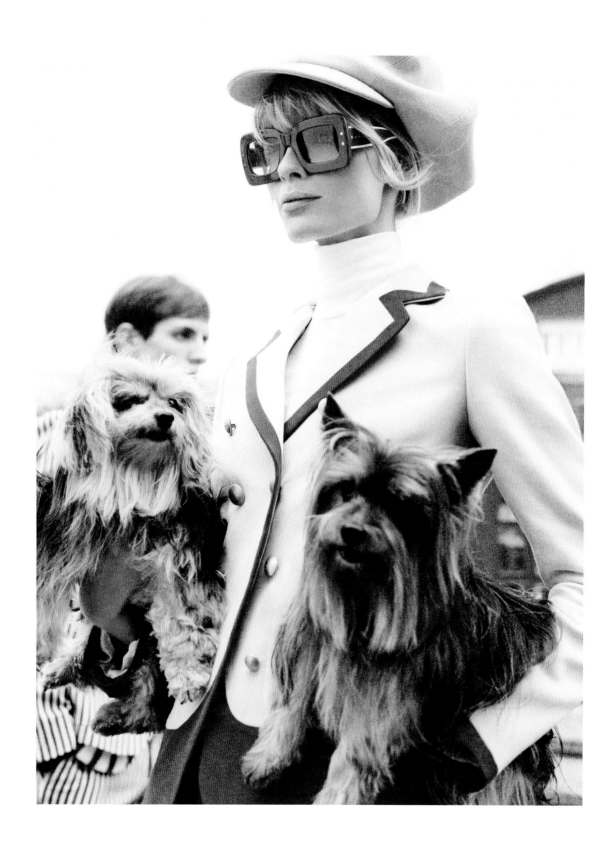

Applejack caps—
oversized versions of
the newsboy cap

Above: In ivory wool
melton

Opposite: In dark
chocolate-colored
velvet

FANTASY HATS

Close-fitting cap with
finely crocheted and
beaded soutache

Above: Pheasant-
feathered wig-hat

Opposite: A pale
Norwegian fox hood

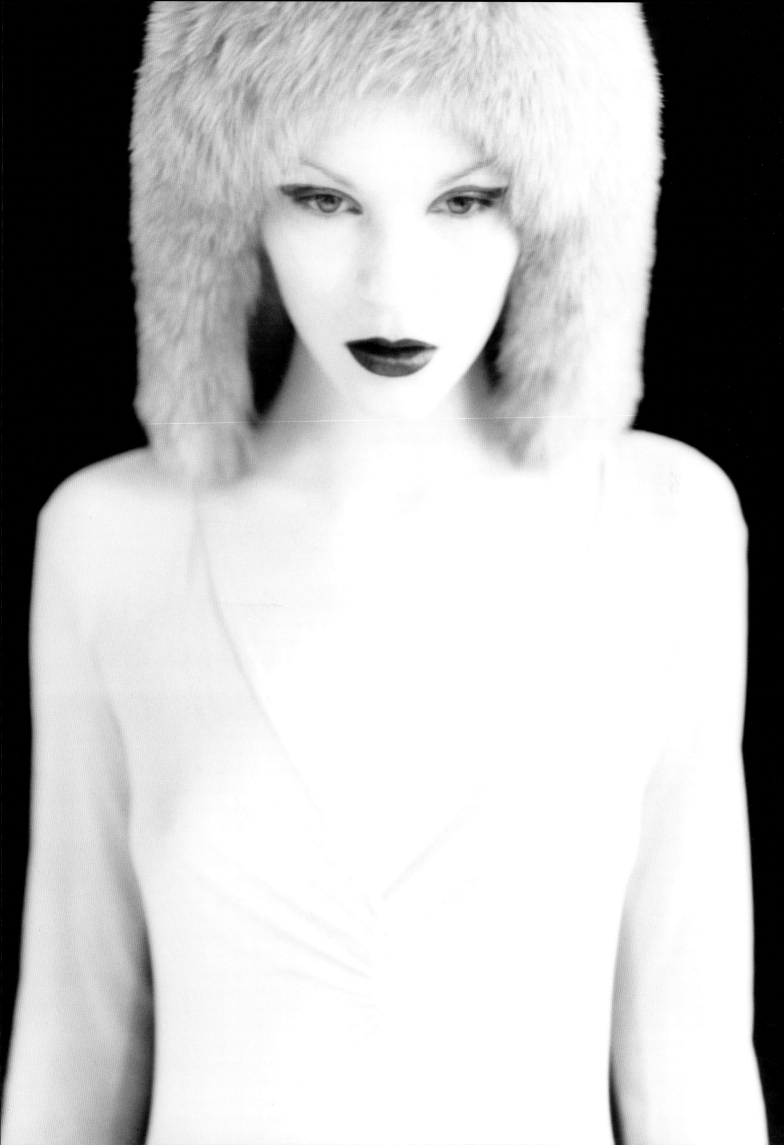

Opposite: Vase-
shaped straw toque
erupting with poppies

Following spread:
Underwood's
towering striped
paglina straw hats for
Custo Barcelona

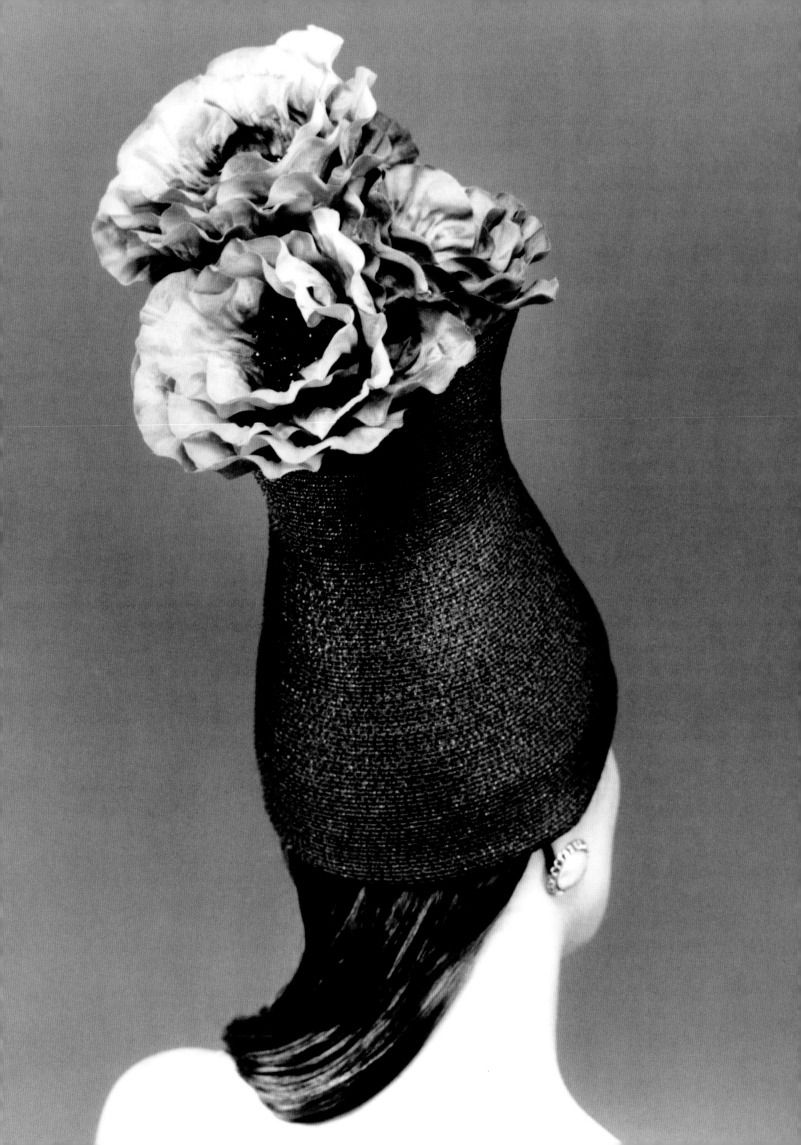

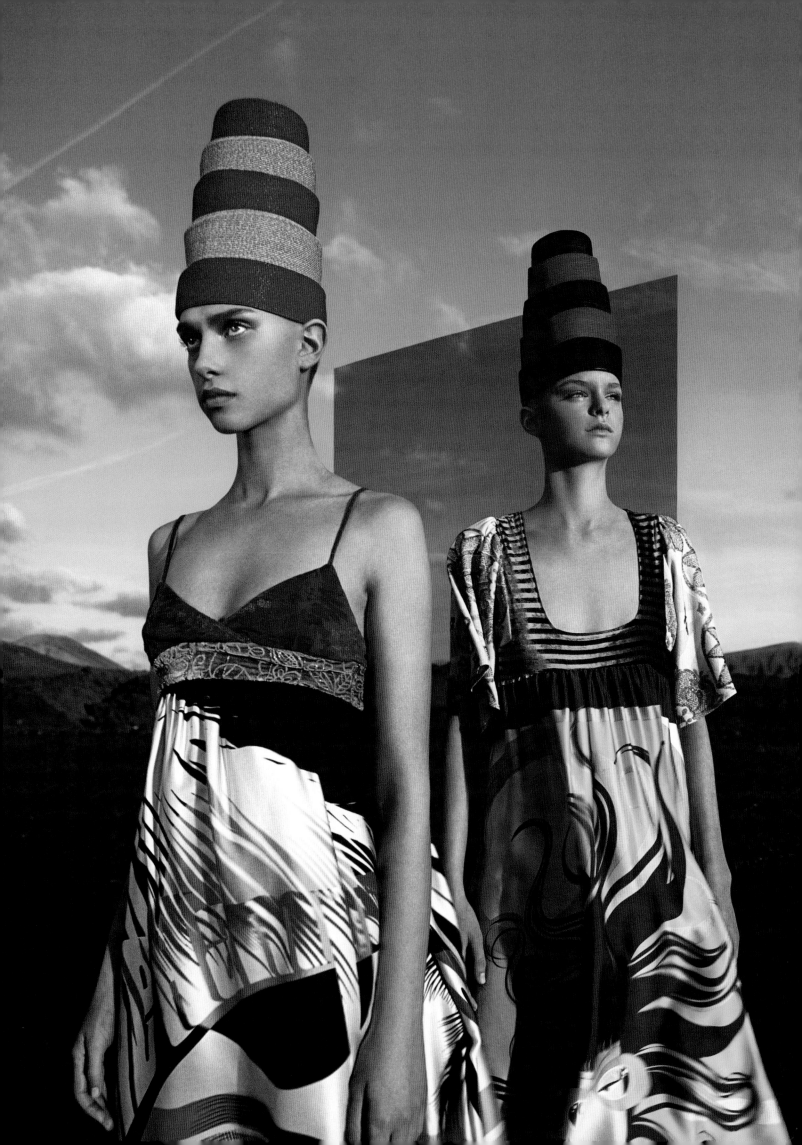

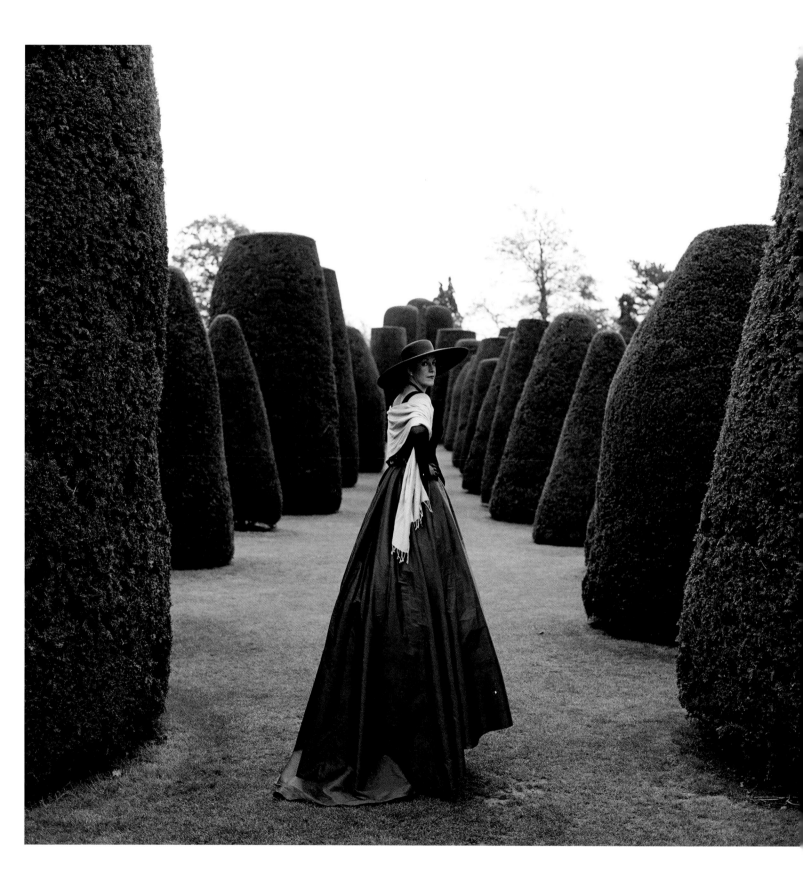

Above: "JeeJee" hat
of paglina straw

Opposite: Giant
shade-loving
mushroom-brimmed
paglina straw
"Salisbury" hat

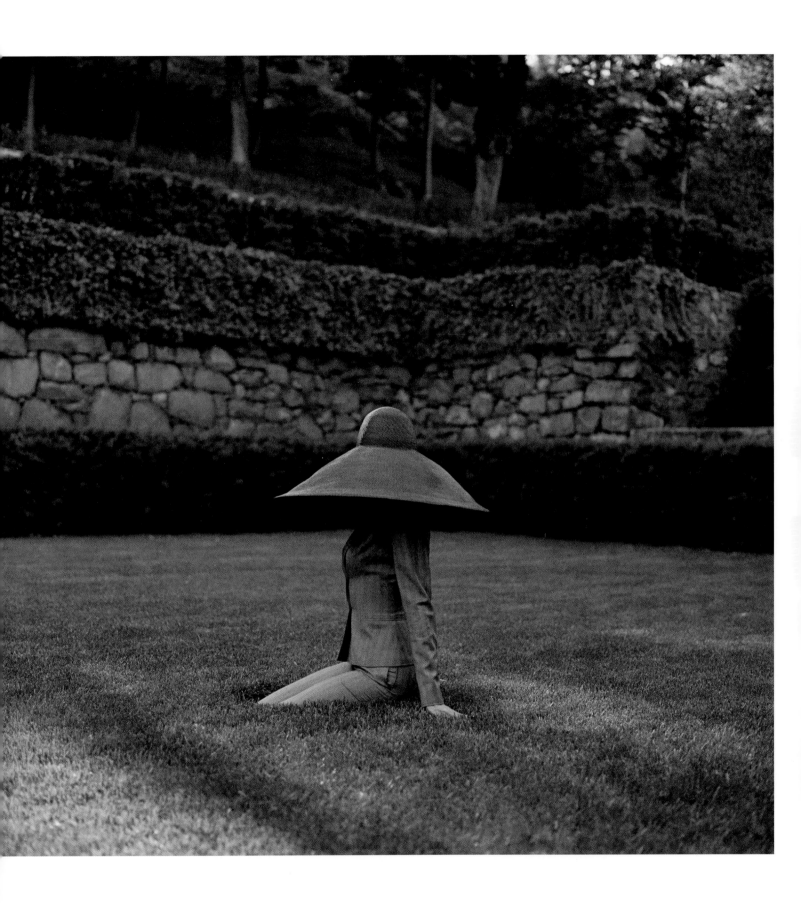

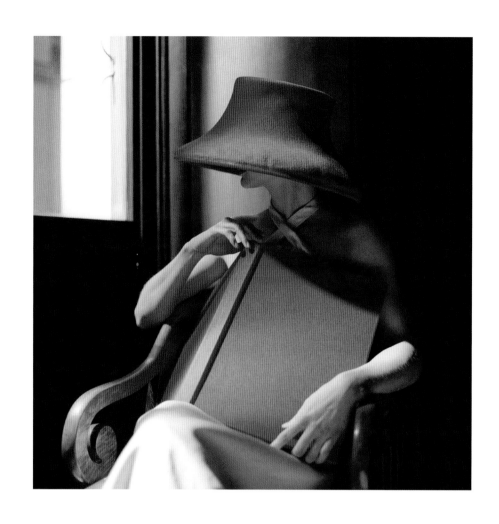
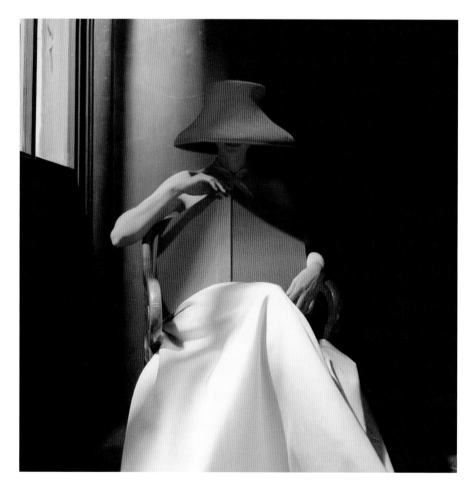

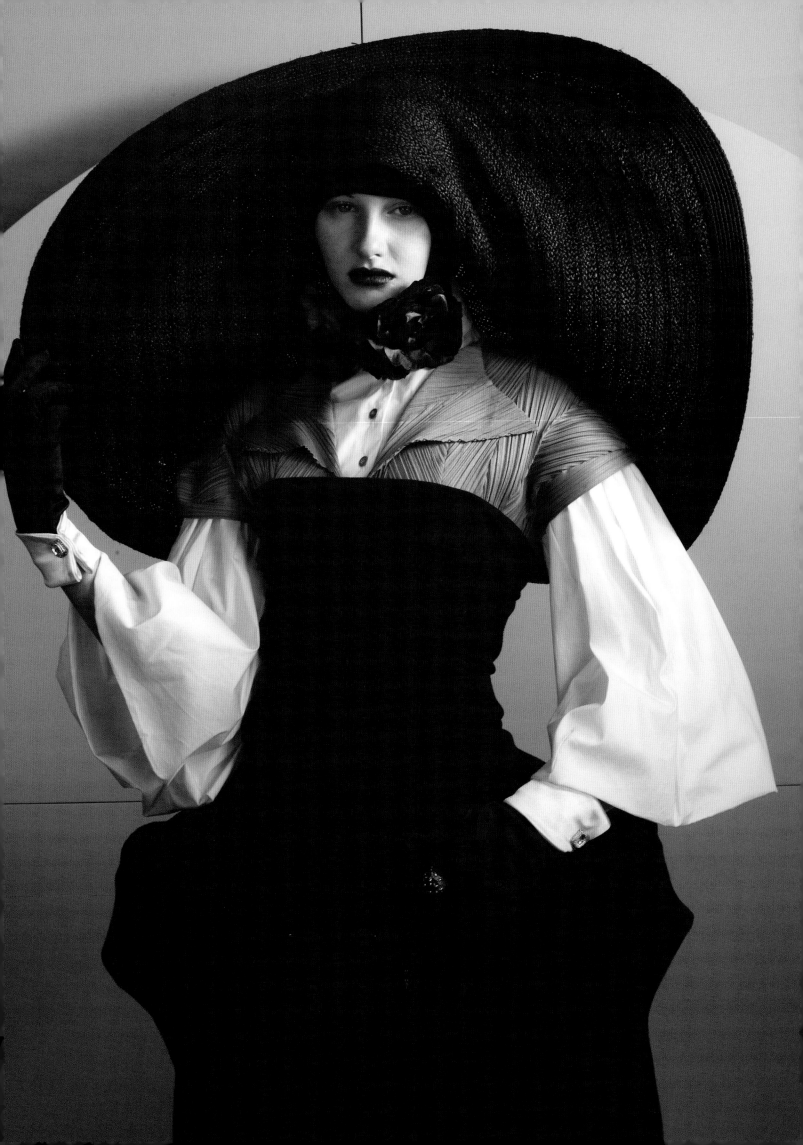

Previous spread (left):
An elegantly shaped
hat to shed a little
light on the subject

Previous spread
(right): Taking cover
in an outrageously
brimmed cartwheel
hat of Pontova braid

Opposite: From
William Wegman's
book *Fashion
Photographs*:
"The Reader" in
Underwood's
pheasant-feathered
cloche

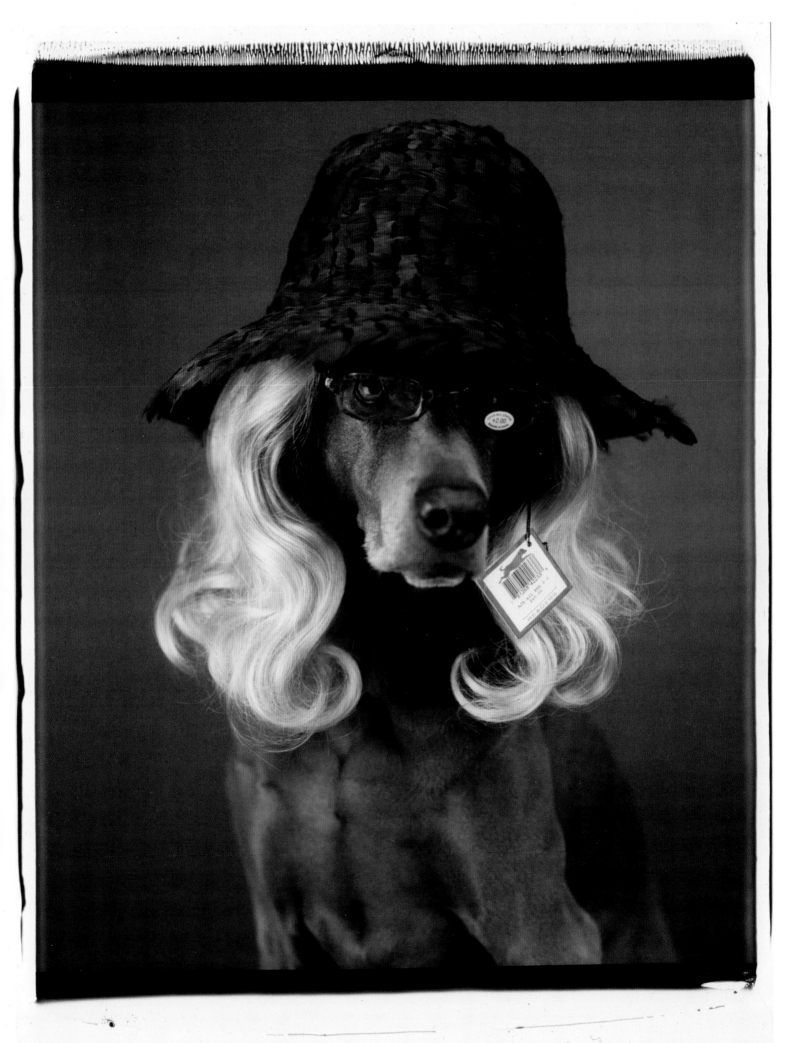

fashion designer
collaborations

PATRICIA UNDERWOOD HAS CREATED myriads of enchantingly subtle and sophisticated hats during the last four decades under her own elegant hand-sewn label. But she is also well known for the hats she designs in collaboration with the elite list of fashion designers who largely define American style. Among them: Bill Blass, Oscar de la Renta, Calvin Klein, Ralph Lauren, Donna Karan, Cathy Hardwick, Perry Ellis, Mary McFadden, Marc Jacobs, Isaac Mizrahi, and Michael Kors; all of whom have understood, and understand still, the significant role that hats can play in "finishing off" the silhouettes of their clothes on the runway. Innovative European designers, like Karl Lagerfeld and John Galliano for Oscar de la Renta, also engaged Underwood to collaborate on *chapeaux* for their New York catwalk presentations.

PERRY ELLIS

Perry Ellis was Underwood's first big-deal collaboration. When his assistant designer Patricia Pastor wore one of Underwood's porkpie hats to work one day, eagle-eyed Perry noticed it at once and asked to meet the hat designer.

Pastor and Jed Krascella, Perry's two top assistant designers, describe their *modus operandi* and what is was like to collaborate with Underwood: "It was lovely working with her. In most cases, we had a concept and would ask her how she could execute it for us, make it better, complete the outfit. Perry invited her to fittings so she could observe the process. She brought her own take to everything, reshaping hats, treating structured hats as though they were soft berets. We all shared a point of view about hats: we understood *angles* and *mystery* and *drama*, things that were pure and tweedy at the same time.

"We always made a point of showing her hats worn in a casual way—offhandedly, almost like they were knitted caps, which of course contributed to the uniqueness of her work. There was a strong link between Perry's look and the hats, but it never seemed forced: It just looked like the outfit 'needed' the hat! With Perry's clothes, the hat provided the finish; it was never a case of the hat walking into the room first."

Page 154: Underwood collaborated with Perry Ellis on his Fall 1982 "Ladies Who Lunch" collection (and all of his collections thereafter). This was the first season Ellis created a more sophisticated, "ladylike" show and Underwood's coachman hats with grosgrain ribbon were an integral part of it.

Opposite: Underwood's coachman hat with pheasant feather, topping Ellis's oversized fox stole and beaver coat

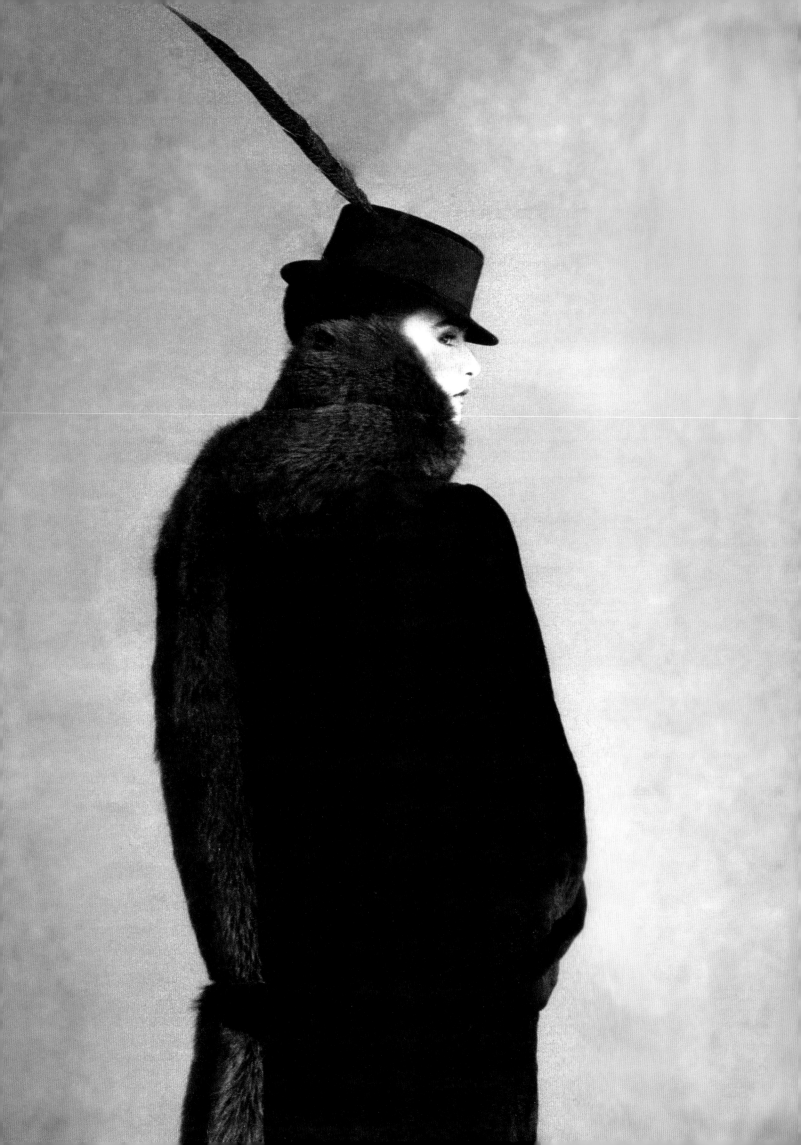

Perry was a total perfectionist, but so was Underwood. When he designed his brilliant "Espana" collection of 1983, Patricia had to create twenty-something different samples of an exquisite flat-brimmed lacquered straw Basque hat before Perry was satisfied with its proportions. Her response: "Perry was right. A scintilla of difference made the difference." Says Jed, "With Patricia, it was always about the work, never the ego."

Left: Bill Blass and Underwood worked together on an elegant navy-and-white fine-straw pillbox to top Blass's simply elegant navy suit.

Page 160: Pale pink cloche in Visca with small rolled brim was fashioned by Underwood to work with a pale chiffon chemise from Ralph Lauren's Gatsby Collection for Spring 2012.

Page 161: Seated model on left in Patricia Underwood for Ralph Lauren Collection "Robin Hood" hat

BILL BLASS

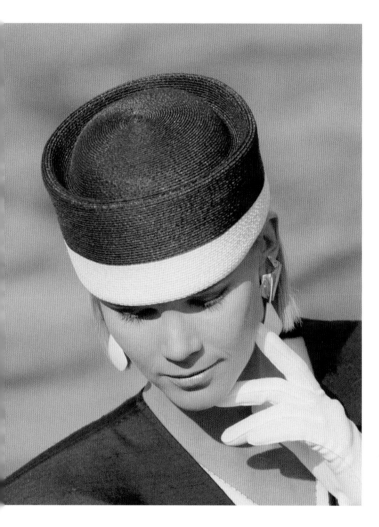

Designer Bill Blass was another early fan of Patricia's work. Tom Fallon, Bill's longtime principal assistant, had worked for then-hat-designer Halston in the late 1960s and when he joined Blass, both of them became aware of Patricia's work. Fallon says, "We loved her clean, unencumbered shapes, her big brims and her dramatic sense of scale—all of which were eminently suited to Bill's clothes. I remember Bill once gave Patricia a Hershey's Kisses chocolate and asked her to make a hat in the same shape. She produced a lovely twisted velvet cocktail hat that we showed with several outfits. But generally, we relied on her ideas. She could do anything; even if it was not her thing, it always came off in such a sophisticated way. Patricia's hats gave Bill Blass clothes a certain elegant finish. It was very logical that Patricia and Bill worked together: they both had a perfect sense of luxurious understatement and proportion."

RALPH LAUREN

Buffy Birritella, executive vice president of women's design and advertising at Polo Ralph Lauren, relates some details about the firm's longtime collaboration with Underwood: "We hired Patricia to collaborate with us on hats as she had a reputation for doing fine custom work and she was

one of very few designers making hats for runway. She had an approach to hats that dovetailed with ours, because the emphasis was on shape and proportion and that seemed to us very American, like Ralph.

"Hats were totally inspirational for Ralph—something he could build a whole collection around. One season, he found a vintage Panama straw hat that he loved and it became the beginning of an entire concept. Patricia made a copy of the hat and we went on from there. She kept refining it, reshaping the brim and changing details, and Ralph would say, 'It's still not quite right.' Patricia persevered. Finally, after an infinite number of tiny adjustments, Ralph saw what he was looking for. Ralph's perfectionism is legendary, but Patricia is a perfectionist, too. That's the genius of it—never being satisfied until it looks perfect to your eye.

"Another season, Patricia worked on creating a perfectly proportioned, flat-brimmed gaucho hat for us. We asked the model to put it on and practice walking. It was only then that we discovered that the hat wouldn't retain its angle on her head as she moved down the runway. Patricia had the ingenious idea of sewing tiny plastic tubing inside the crown to anchor the hat. This time, the hat didn't move, but the tubes in the hats started to squeak. Ultimately, she solved the problem by sewing tiny sections of fabric into the hat to silence the tubes.

"Patricia has astonishing resources and technical knowledge and can do almost anything. She is a terrific problem solver. If we wanted a certain kind of straw hat that's no longer made, she would figure out a way to simulate it by dyeing different types of straw or manipulating it in some way. So much of hat-making is magic. On the evening before our runway show, Ralph decided we needed ten more hats. Patricia explained that she didn't have any left. We must have driven her crazy, but she and her team worked all night to make them, then delivered them in person to the show.

"She is delightful to work with, a lovely person, almost like a throwback to the days of couture. It's a different world now—couture is a dying art, but working with Patricia presents that same quality of art, craftsmanship, and joy. She is like that in her work and like that in her person."

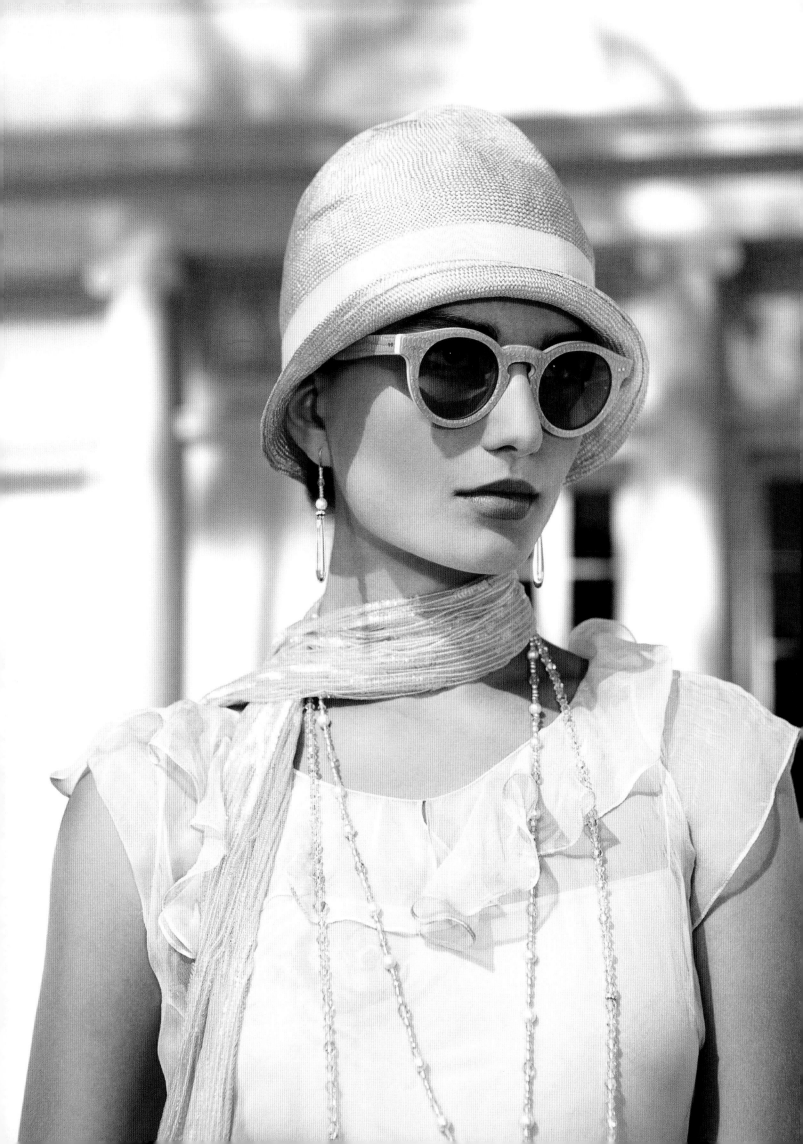

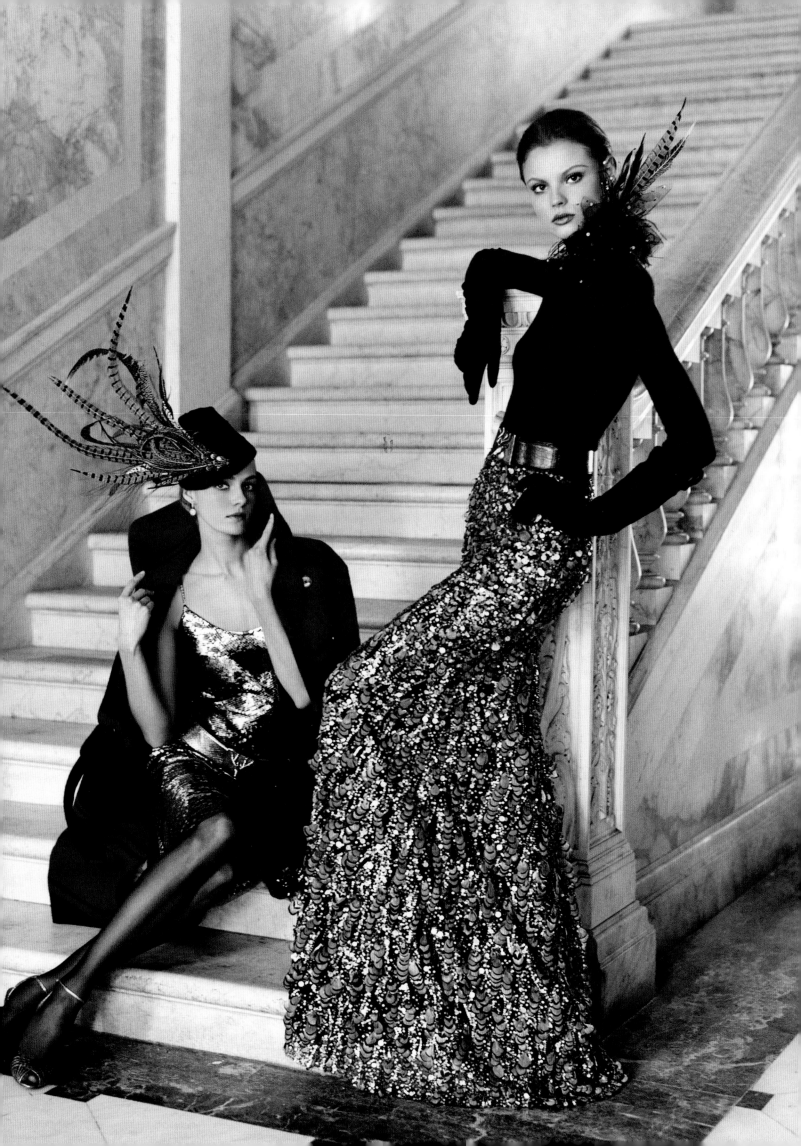

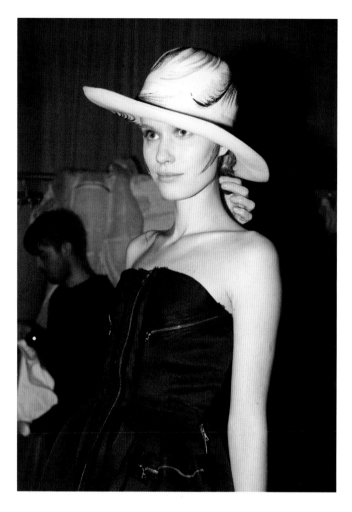

Above: For Isabel
Toledo, a round-
crowned brimmed
straw hat, painted by
Ruben Toledo

Right: Underwood's
"off sailor" hat for
Calvin Klein

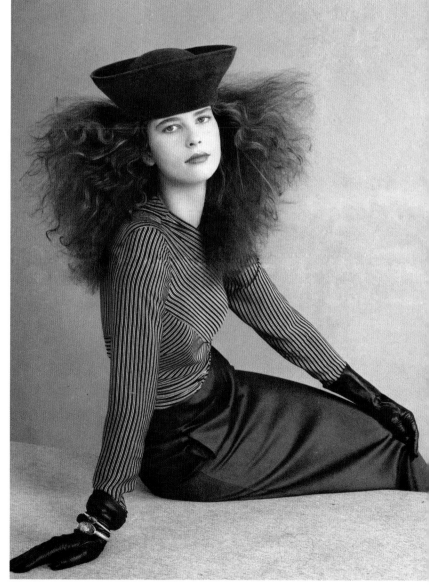

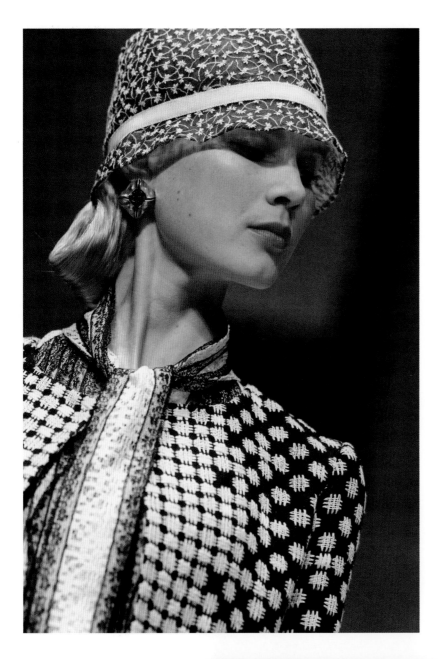

Left: Lacy tulle cloche
with grosgrain band
for an Oscar de la
Renta pre-Fall 2012
collection

Below: Wide-brimmed,
tricolor, and bowed
hat designed for Bill
Blass

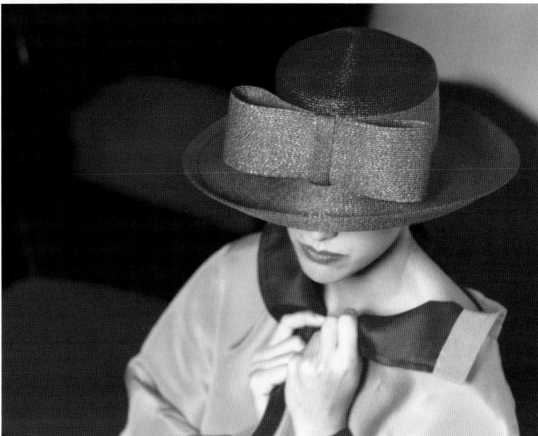

stage and screen collaborations

FASHION DESIGNERS CHOOSE HATS to complement their clothes on the runway, but costume designers must go a step further, using hats to create character, texture, and individuality. Hats can serve as an exclamation point—an emphatic "Voila!" moment when an actor enters the stage or appears on screen: They add interest and drama to a set and work wonderfully as props. The difference between designing hats for a fashion show and hats for the theater or cinema is that the latter requires a good deal more technical work, particularly onstage. Theater is a live art and the characters, particularly in a musical, might have to dance, jump, and do backflips, while their hats have to magically stay in place.

ISABEL AND RUBEN TOLEDO

Isabel and Ruben Toledo were given a scant three months to design over 150 costumes for *After Midnight*, a Broadway musical that featured a succession of great artists like k.d. lang and Patti LaBelle and centered around a collective memory of jazz, the Cotton Club, and the melding of eras into the Harlem Renaissance. The Toledos immediately asked Patricia Underwood to collaborate on the hats. Ruben and Isabel recall, "The show was hat-heavy from the start: we had our work cut out for us. There were times when we had to change the shape of a hat because of a mike or allow for an actor's wig, which affects the proportion of the hat. Patricia had to tweak those looks but stay in the timeframe of the story. She designed top hats for two guys and then found out they needed to perform somersaults so the hats were eliminated. Another actress had to lose her hat because it cast a shadow onto her face. As designers, we had to work in tandem with technicians and the people who put all the elements together—we were not in control of the whole thing. Throughout it all, Patricia was amazing—her work never feels frivolous, it is no-nonsense and strong. She has no ego as a collaborator—it's all about making the hat perfect and the woman beautiful."

WILLIAM IVEY LONG

William Ivey Long, the six-time Tony Award–winning theatrical costume designer, was chosen to design 1920s and 1930s Jazz Age–inspired costumes for Woody Allen's *Bullets Over Broadway: The Musical*, and although he had already pinned a photograph of Kate Moss in a green beret by

Page 164: Ruben Toledo's watercolor of Underwood's design for Isabel Toledo's headpieces with giant transparent blooms, worn by the nightclub dancers in the Broadway play *After Midnight* (2013)

Opposite, from top to bottom: Vivid transparent plastic tropical blooms; felt cloche with geometric appliques; and Underwood's "Arcadia" hat in fine horsehair braid for the "widows"—all made for *After Midnight*

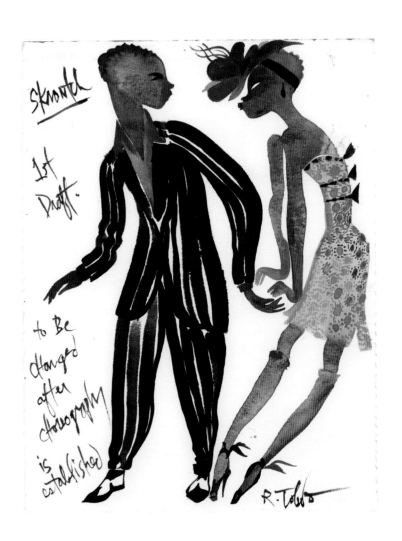

Sknowtd

1st
Draft.

to Be
changed
after
choreography
is
established

R. Toledo

R. Toledo

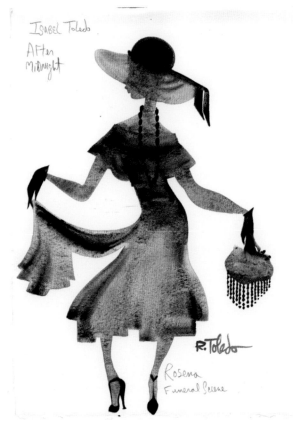

Isabel Toledo
After
Midnight

R. Toledo

Rosena
Funeral Scene

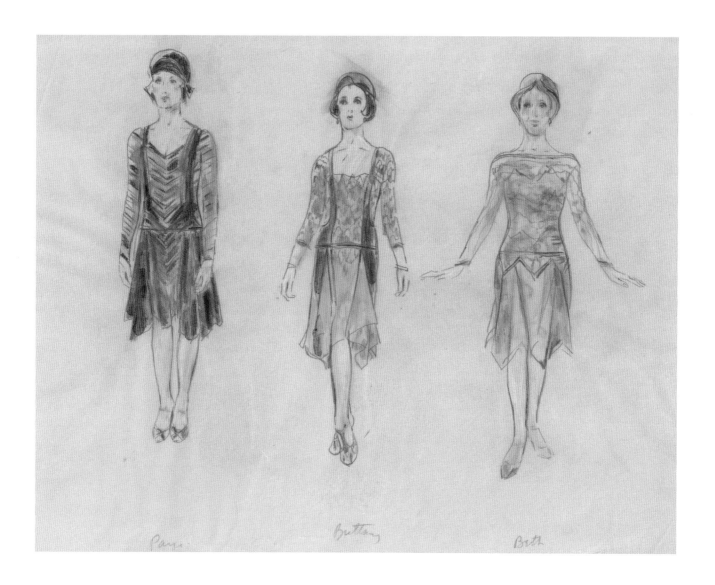

Pari Brittany Beth

Patricia Underwood to his idea board, he hadn't taken it any further. It wasn't until his friend Isabel Toledo showed him the hats Underwood had collaborated on for *After Midnight* that he thought to call her. When they finally spoke, she said, "Please send me the research ahead." Long was impressed that she was so well prepared: no one else had done that. They met and hit it off then agreed to collaborate on hats for the show.

Long says, "Patricia is very picky, and so are we, and hats aren't made of cement. She has mastered the ability to make things that last. A hat in a Broadway show gets a lot of abuse. Much of the millinery is worn in a spritely way for a moment in time. And then the mood changes and the seasons change and the outfits. We have to capture on Broadway that moment in time.

Above: William Ivey Long's costume sketches for Woody Allen's *Bullets Over Broadway: The Musical* (2014)

Opposite: Underwood's hats working with the costumes: a deep-squared toque with cut-out brim; a red-faced dark brown cloche; and a tricolor beret in dark brown, red, and silver

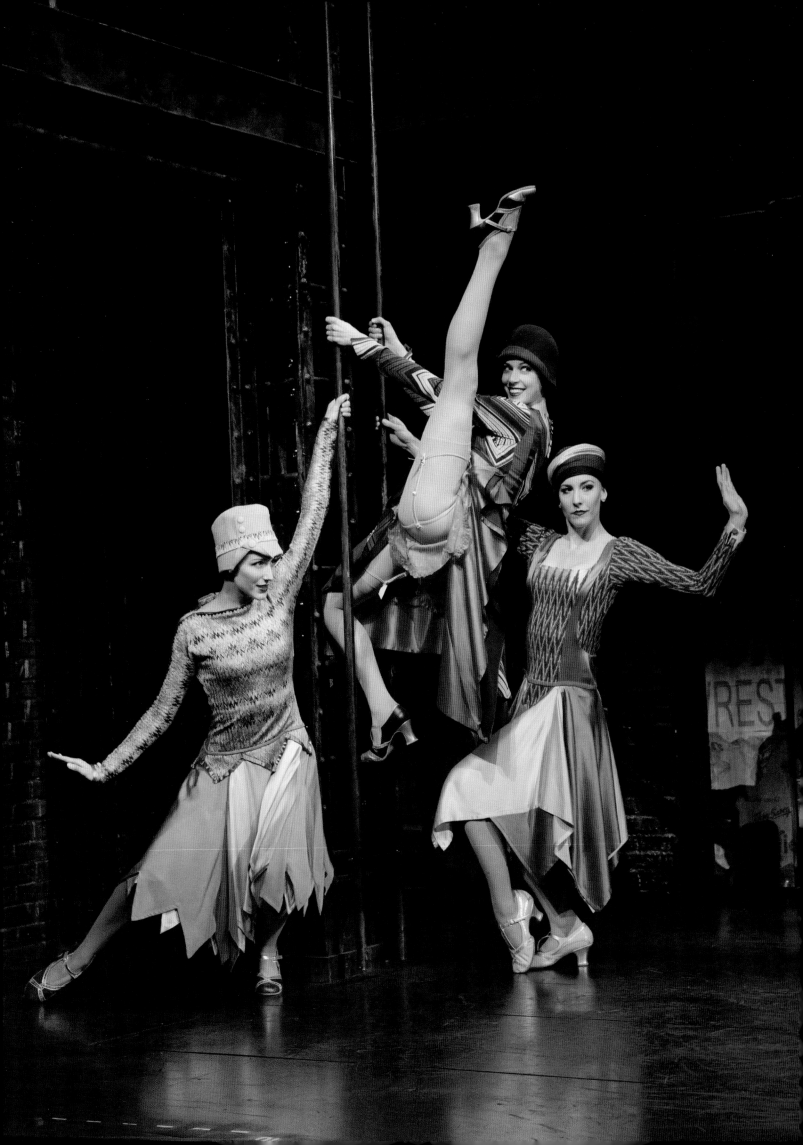

"The magic I discovered with Patricia Underwood's hats is that they can be worn eight shows a week; they can be worn a year, they're so well made. Then we have to figure out how to put them on and how to secure them. A lot of the '20s and '30s clothes in the play needed wigs. A hat has to go over a wig *and* a mike. If you are a principal, you might also have mikes attached at the front. I'm not the only client: I have the director and the wearer—they have to like it, too.

"This is the progression: A lot of times my sketches weren't immediately readable to the hat-making team, so I did croquis and sketches. We make scans of sketches and then they become the interpreted ones, the final drawings. Patricia came up with a style of her own, and I immediately said, 'That's better than my idea; let's go with that!'

"There's a scene in the play where we featured some widows in tight black hats. It looked all wrong: widows all in black made for a black set. The scene just wasn't cutting it. Finally our director realized we needed red hats (these were merry widows!), so Patricia made some red hats and broadened the brim. The night the new red hats went in, Patricia single-handedly saved the scene from being cut!

"Underwood did two dozen hats for the show—three ensemble looks, individual looks, and swing looks—three girls on stage, two others that swing in and out. The hats in theater are the finishing touch—it's all about making the outfits look good. I learned that concept a long time ago."

DANIEL ORLANDI

The noted costume designer Daniel Orlandi was a big fan of Underwood's straw hats—their unusual shapes and colors—and was delighted when she agreed to collaborate with him on creating the hats for the movie *Down with Love*, a musical spoof of the Doris Day/Rock Hudson lighthearted romantic comedies of the early 1960s. During that period everyone wore a hat, so Patricia got to make a variety of hats for the principals, Renée Zellweger and Sarah Paulson. Says Orlandi, "I knew that Patricia would understand the style and period, and there is no one else who would have been able to get it done so quickly with so much style.

Underwood topped off Daniel Orlandi's costumes for the movie *Down with Love* (2003) with period-appropriate hats: an upturned brim in white double Starbrite; a '60s stewardess pillbox; and a charming, banded coachman hat

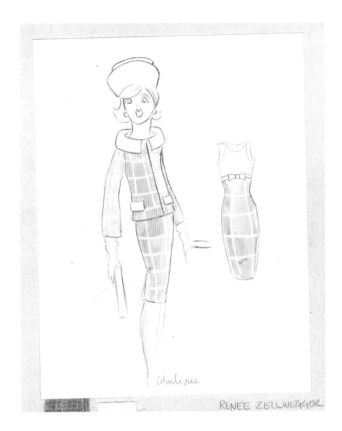
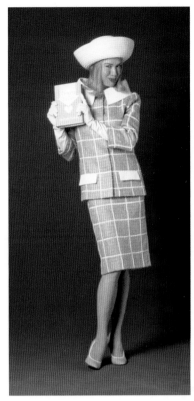

RENEE ZELLWEGGOR

Early '60s style is sleek and simple and seemingly effortless, but it really has to be done with skill. I went through every issue of *Vogue* from 1961 to 1964 and compiled books of research, then sent them to Patricia, along with my sketches and head measurements. We did everything by telephone, so although Patricia and I never actually met, I was very happy with the results. *Down with Love* was a dream job for me: those '60s Doris Day movies were among the first films I ever saw and loved. They set me on the road to my career in film."

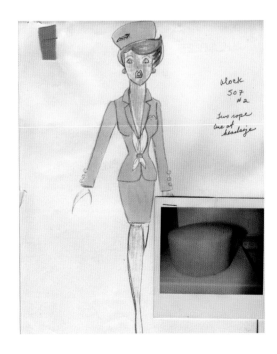
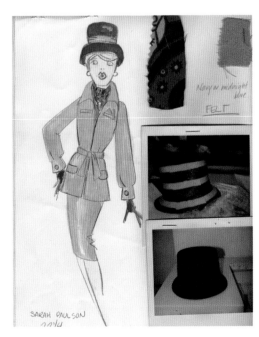

SARAH PAULSON

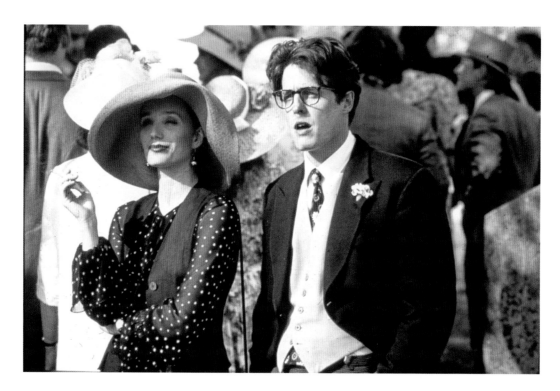

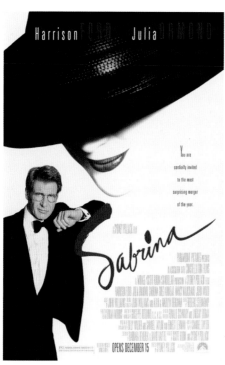

Top: In *Four Weddings and a Funeral* (1994), Kristin Scott Thomas wears Underwood's square-crowned, oversized straw hat.

Center: The poster for *Sabrina* (1995) features Underwood's medium-brimmed leather hat. Julia Ormond, as the title character, wears the hat in a scene from the film.

Bottom: White silk-satin top hat on Molly Ringwald in *Betsy's Wedding* (1990)

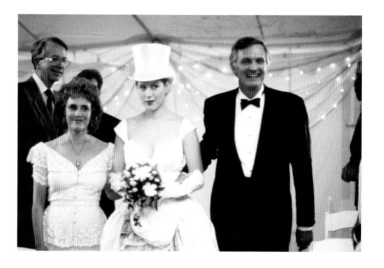

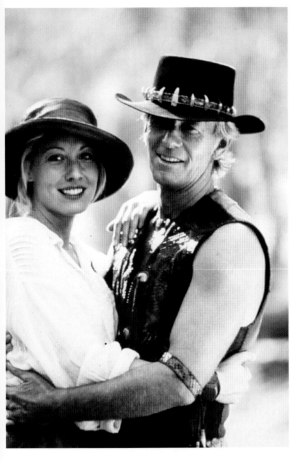

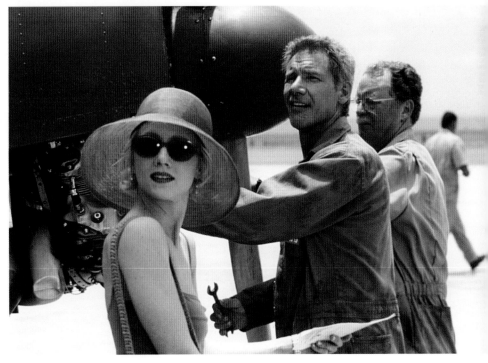

Top: Kim Cattrall
wears Underwood's
giant cartwheel
straw hat in *Sex in the
City 2* (2010)

Bottom left:
Linda Kozlowski
in Underwood's
stripped leather hat,
with Paul Hogan in
Crocodile Dundee II
(1988)

Bottom right: Anne
Heche in a deep-
crowned mushroom
horsehair hat, with
Harrison Ford in *Six
Days Seven Nights*
(1998)

THE MAKING OF A HAT

Couture millinery has been compared to magic, sorcery, sometimes even sleight of hand, but it is also painstaking work. In Patricia Underwood's lofty, sun-flooded 37th Street and Seventh Avenue studio, with the spire of the Empire State Building looming just outside the workroom's giant windows, there is a beehive of activity. A gently industrious whirring sound fills the room as a veteran hat-maker works at the straw-braid sewing machine, slowly shaping each hat as she sews, pulling at strands of braid that are wrapped around a spindle. She stops to check the precise size of the brim she is building, row by row by row. Then she starts the machine again.

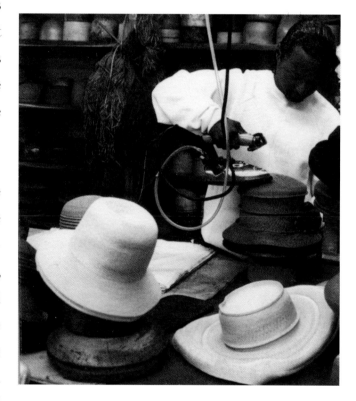

This is not a factory by any stretch of the imagination. The few machines here were likely made before the dawn of the twentieth century. The hat-making process, especially for straw hats, has not changed significantly in 150 years. Custom hats are largely handwork, done by skilled people who possess the patience of several Jobs. Using hand tools, thimbles, thread and needles, and scissors large and small. They sew, shape, pull, manipulate, and almost "will" straw, felt, fur, and sometimes leather into an array of precisely structured, artfully textured, and elegantly simple hats—and they do it one at a time and slowly.

On floor-to-ceiling shelves against a long wall sits Underwood's collection of hundreds of wooden hat blocks, like rows of handsome sculpture. These are the molds on which the crowns of Underwood's hats are blocked while they are being steamed and shaped. The blocks, most of them antique, are made of beautifully polished samba wood and have a cool sculptural quality. While the hats are being shaped on the blocks, the hat-makers

manipulate them until they are perfect, all the while checking whether the proportions are correct. Nimble hands and a light touch are necessary when shaping the hats: old pros who have worked with these materials for years are sometimes able to make ten or more hats a day: Betty Carroll, one of Underwood's longtime hat-makers, was an extraordinary exception, and was known to turn out as many as forty, but by and large the business of hat-making proceeds at a snail's pace.

The choice of materials is important: whether paglina braid, horsehair (or crin) braid, metallic braid or silk horsehair from Tressa in Switzerland, fine Milan straw from China or Italian leather, the method is the same: the plait of braid is sewn in a circular motion to the shape required, then put on the block for a final gentle press. Underwood is also a big fan of felt for her hats, as it can be steamed and manipulated without worrying about seaming. With felt, the seamless body is placed on a block from which the hat will take its shape. While blocking, the hat-maker "reads" the block with her hands to achieve the shape. Later, the hat is dried in an oven, which causes it to shrink and "firm" to the block. After the hat is welted (or hemmed), it is sweated, trimmed, and finished. The term "sweating" refers to sewing in the grosgrain sweatband of the hat; the hallmark of a custom hat, this ribbon at the inside base of the crown not only helps hold the shape but actually makes the hat fit better and gives it a finished, friendly appearance.

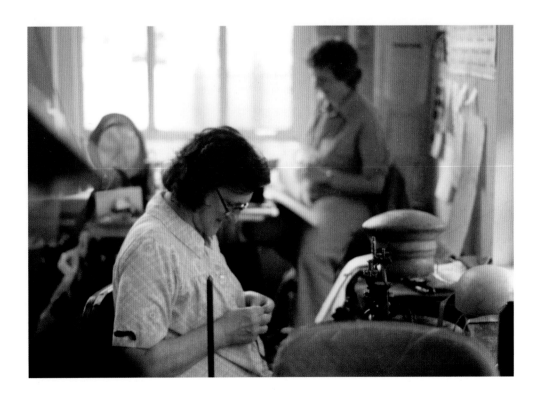

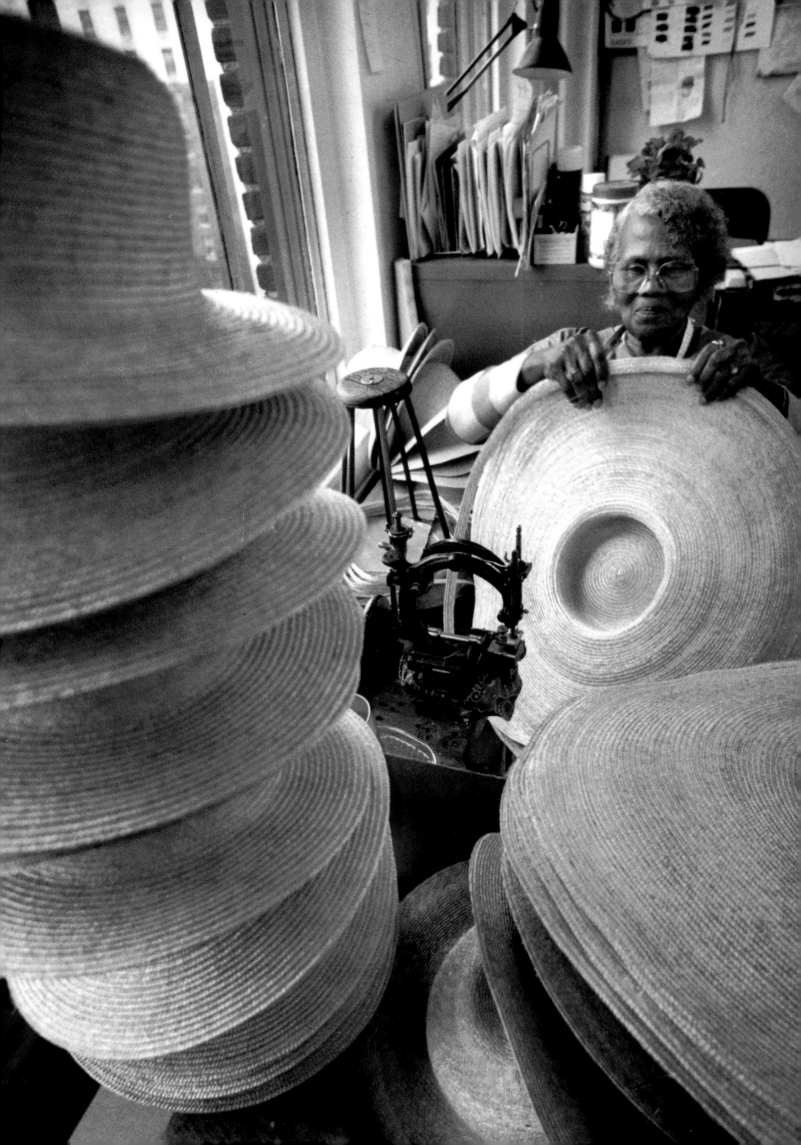

hats off

UNDERWOOD HAS SOMETIMES thought of her hat-making business as theater—a cast of diverse characters, working together in a small space, where there is always the potential for comedy, tragedy, and farce, and sometimes, all three at once. But she has been very lucky with the team she has assembled. Some of them arrived with hat-making credentials. Others came with diplomas from schools that specialize in art or design. And a few of them knocked on Underwood's door just looking for a job—any job—to support their families, and in time, acquired new sets of skills that have materially changed their lives. Underwood underlines the point that "hat-making is a collaborative process—it works both ways—we learn from each other." Underwood feels both proud and privileged to work with her team, some of whom have been with her for years.

Judy Hummel, president of Patricia Underwood, who runs the day-to-day business, came to New York with dreams of becoming a dancer. Over time, instead of dancing, the nimble Judy learned how to "think on her feet." Arriving at the millinery studio at 7 a.m. each day, she brings her organizational skills and knack for problem solving to the company and provides both the steadiness of a rudder and an unending desire to improve things.

Long-timer Betty Carroll had been a seasonal straw sewer and had never worked with felt, but she made the transition in order to have a year-round job. She and Underwood spent two years inventing the technique of stripped leather sewing. "Dottie" Tillett loved to listen to her soap operas on the radio (also on a headset), calling them her "stories." She was a master at hand work, draping and trimming,

once sewing one thousand taffeta bows onto a wedding veil Underwood created for a private client of Bill Blass. Dottie knew exactly which hats would go to which orders, keeping them organized as they came through production. She was the hub of the workroom. Betty and Dottie had great work ethics, always punctual and diligent.

Eleanor Williams was a seasonal sewer who would join the millinery team for six months each year in the winter/early spring. Her specialty was stitching the difficult, large wide-brimmed straw hats. Helen Chen, who had worked in a lampshade factory, learned from Betty how to sew straw braid. Having already worked "in the round," it was easy for her to go from lampshades to head shades!

Jose Torres worked as part of the team for over thirteen years, pressing the hats and giving them the final touch. He could recognize every shape and knew all the blocks by heart.

Not a hat-maker, but a good salesman, Don Robertus dated back to the early days at Bes-Ben in Chicago and really understood the relationship between fashion and hats. His own taste was a little more eccentric. The day Underwood first met him, she was wearing a twinset and pearls; Robertus showed up in a Claude Montana jumpsuit. He had expected her to be wearing something "cutting-edge" as a designer, and she had pictured him in a suit and tie. They got along famously!

Miki Katagiri, a thirteen-year veteran, worked her intricate Japanese magic on the complicated fabric hats for the Ralph Lauren collaborations.

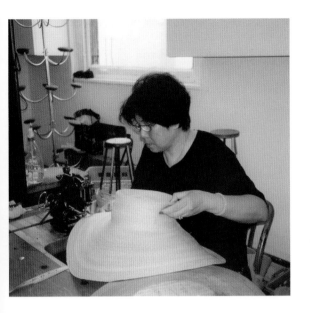

Betty Sesme knocked on Underwood's door one day fifteen years ago, asking for work, and proved to be a talented addition, with a wonderful "touch" for sewing braid and leather. Her specialty is horsehair hats and she is particularly adept at creating the "tip"—the very beginning of a hat.

Englishwoman Victoria Perry, a pretty young hat-maker who was schooled in London, contributes her artistry, craftsmanship, and unerring eye. She is also the perfect hat model.

Ivan Leon, who started as an intern from the High School of Fashion Industries, grew interested in the hat-making around him, learned to block hats, and finally started making a few of his own. Young and hip, he has worked on expanding Underwood's social media reach.

For Judy, it's a system that really works. "It all happened organically," she says. "As I understood more about organizing, it freed up Patricia to do other things." Some years ago, Underwood made the decision to spend more time with Moynihan, who had in the meantime become head of a company in London, so Judy took over the entire management of the office. "It was an eye-opener to see women work together year after year," says Judy. "They are artisans—manipulating with their hands, with their fingers dancing on the straw, felt, fur, and fabric. There is a real sense of three dimensions in hat-making. It has a good sense of work about it—a handmade art and craft to it." In the spirit of the quilting bees of old, the women of all ages, from diverse backgrounds, are connected in their work, supporting and empowering each other.

Top left: Patricia Pastor in a pork pie—her first Patricia Underwood hat

Top right: Mirjana Winterbottom wears her straw hat in the garden.

Bottom left: Cathy Hardwick and her then assistant, Tom Ford, try on Underwood hats.

Bottom right: The late Sidney Burstein and his wife, Joan, longtime proprietors of Browns in London. Queen Elizabeth has just recognized Mrs. Burstein, in her hat by Patricia Underwood, with a CBE award in acknowledgement of her achievements at Browns and her support of the British fashion industry.

Top left: Marilyn Cane, Underwood's best friend, in a summer straw at Lincoln Center

Top right: Cane in the milliner's sleek black gaucho with a giant red rose tucked behind her ear

Bottom left: Liv in a hat her grandmother Patricia Underwood knitted for her

Bottom right: Annual August 10th birthday luncheon for fashion public-relations doyenne Eleanor Lambert, celebrated by Han Feng; Patricia Underwood; Eric Wilson; Mary Ann Restivo; Miss Lambert and her aide; Monika Tilley; Cathy Hardwick; and Mary McFadden. Says Tilley, "Patricia never missed. Even if she had just landed from London that morning, she would make a point of making it to Eleanor's birthday luncheon. That's the kind of friend she is."

patricia underwood's favorite hats

Beret

Classic French, flat-crowned hat, usually with a tightly fitted band, the beret is indigenous to France's Basque country and is also worn in Spain and other European countries. It has often been used in the military as a mark of distinction for the United States Army Special Forces (and the British commandos of the Second World War); at the same time, it has been chosen by revolutionaries like Che Guevara on whom it represented a sort of "outlaw" appeal. Schoolgirls sport berets as part of their school uniform, and women have loved the hat's soft and sexy appeal. Scottish soldiers wear beret-like hats as part of their uniforms. Actresses Jane Russell and Marilyn Monroe wore them in *Gentlemen Prefer Blondes*; Warren Beatty's glamorous accomplice, Faye Dunaway, wore them to great effect in *Bonnie and Clyde*; and Kim Cattrall was devastating in them in *Sex and the City*. Big or small, berets are chic, as worn by Coco Chanel with a bow, or squashy and oversized, as worn by artists through the ages. And everyone loves to snuggle into a soft, cashmere beret for comfort and warmth when winter winds blow.

Boater

The boater showed up in Great Britain's Royal Navy at the end of the nineteenth century when the short-crowned, flat-brimmed straw hat was issued to midshipmen to protect them from the tropical sun. It was soon adopted by English gentlemen as a sort of summer version of the bowler, and ultimately picked up by American Ivy Leaguers, who would wear them banded with a wide-striped grosgrain ribbon in their school colors. A frequent sight at regattas and garden parties, the lighthearted boater is the perfect summer straw brimmed hat for women as well, as evidenced in the movie *Gigi*, where actress Leslie Caron wears it with a feline, feminine charm.

Bowler

The bowler is a man's hard felt hat with a round, dome-shaped crown and smallish brim, which became hugely popular in the mid-nineteenth century. Created by Lock's of St. James, it was first called a Coke hat, after William Coke of Norfolk, for whom the hat was designed. Later referred to as a bowler, after the Bowler family who actually made the hats in Southwark, England, the hat became a favorite of the working class and only later did the middle and upper classes truly embrace it. Also known as a derby, the bowler was as sturdy as can be—reportedly, a man could stand on it without crushing it. Unsurprisingly, this stalwart endured as a popular style for men for almost a hundred years.

Cloche

The word *cloche* means "bell" in French and according to lore, this hat was originally blocked on an actual bell, literally taking its shape from it. A close-fitting hat that extended from just above a lady's eyebrows and covered the back of her neck (sometimes shaped with a very small brim), the cloche was all the rage for the flappers from the 1920s through the mid-1930s—a look exemplified by F. Scott Fitzgerald's madcap wife, Zelda. Says Underwood, "Cloches make me think of long, lean lines in clothing, hats for getting about, for looking demure; and yet, they were made for girls who had lopped off their hair into bobs after the First World War, the 'It' girls of their time."

Cowboy Hat

Huge and hugely practical, the cowboy hat originated in the American Southwest, but was probably inspired by the wide sombreros worn by Mexican cowhands to protect them from the relentless sun. A high-crowned, wide-brimmed hat, the "ten-gallon hat" (so named for the amount of water it could hold in order to sustain a cowboy's horse), is almost synonymous with John Wayne. "Tom Mix," a slightly taller version, was named after a lanky silent-movie hero; and myriads of other macho cowboys of television and movie fame wore cowboy hats. Smaller, shallower-crowned versions, with curved brims, are done for women, often in lighter-weight straw. As cowboy heroes no longer dominate the airwaves these days, ironically, this iconic Southwestern American hat is probably most associated with New York–born designer Ralph Lauren and his wife, Ricky—both of whom wear it well.

Doo'lander

A Scottish version of the newsboy is called a Doo'lander, because the cap is big and flat enough for a "doo" (dove) to land on it. Baker boys, tradesmen, and even the singer Madonna wore an oversize version, "the applejack."

Fedora

The fedora, usually made of felt, has a generous crown that is creased down the center and pitched, with a medium brim and a ribbon band. Named after the lead character in the play *Fedora*, a role originated by the great actress Sarah Bernhardt, it started out as a woman's hat and only later was it adopted by the menswear industry, where it became synonymous with gangsters and film-noir detectives. Fedoras have shown up in modern culture in versions that range from Indiana Jones's brimmed felt, the crisp brimmed hats of television's *Mad Men*, and, of course, Michael Jackson, who may have made the biggest dent in the industry with his signature black fedora. Underwood considers fedoras on women to be "boyfriend" wear—they actually enhance one's femininity.

Fur Hat

Think Julie Christie as Lara in *Doctor Zhivago* or Keira Knightley as Anna Karenina—for romance and pure allure, nothing can rival a face framed in fur. Giant fox

hats that form a silver cloud around the face; sable-colored fox, faux-leopard berets; white mink boaters; toques in lush shearling.

Gaucho Hat

Often thought of in popular culture as the "Zorro" hat, the Spanish-influenced gaucho hat was worn by herdsmen in the South American grasslands for many years to keep the hot sun from scorching their faces. No doubt a forerunner of the cowboy hat, the gaucho has a shallower crown and smaller brim, as well as a cord under the chin to keep it in place. Worn simply with one's hair knotted into a bun and a red rose, it has a devastating charm.

Knit Hat

Ali MacGraw, heartwarming in her knit hat in *Love Story* or Barbra Streisand in *The Way We Were*, sporting a stocking cap—knit hats are cozy, charming, and instantly feminine. When Holmfeld and Underwood began to collaborate on knits, they chose embroidery wool, as it was soft and durable, and came in a huge variety of colors. With the help of Midge Varon, a skilled and knowledgeable knitter, they were inspired to experiment with wool and chenille yarns in a plethora of patterns and colors, making hats, scarves, and bandeaux. Their inventive "knit-knot" was super-chic and versatile and sold out every year. They later used cashmere yarn from Scotland for Underwood's fully fashioned berets, toques, hoods, and fur-trimmed pieces, which are still very much a part of their collection as they provide serious warmth and travel well.

Newsboy Cap

The newsboy cap is a rounded cap with a small stiff visor or peak in front, often in wool or tweeds or leather. The style is based on the cap worn by young newsboys in the early part of the twentieth century.

Picture Hat

These grand hats took their name from the "picturesque" way they framed the faces of the ladies who wore them. Think Vivien Leigh as Scarlett O'Hara in *Gone with the Wind* or Gainsborough portraits of English beauties. Wide-brimmed and often beribboned and trimmed with flowers, they blossomed romantically in the late nineteenth and early twentieth centuries and, at the same time, served to block the sun from the faces of those who wore them. There are many variations on the theme, with rolled brims, flat brims, and giant cartwheel brims. And, according to Patricia Underwood, they can shed light on the face or create total, sun-protecting shade, depending upon the kind of straw and the weave used to make them.

Pillbox

A pillbox is a cylindrical hat with a flat top and no brim. Pillboxes—worn by bell-boys and princesses and presidents' wives alike—convey openness and confidence and always remind us of Jacqueline Kennedy, the icon of feminine chic.

Sou'wester

Originally designed as pragmatic foul-weather gear, and especially worn at sea, this classic has a flattering wide slanting brim that is longer in back than it is in front, keeping the neck from getting wet. Often done in oilskin or other waterproof fabric, this shape in straw or linen-like fabric also makes a great sunhat.

Top Hat

A tall, formal-looking, flat-crowned, brimmed hat said to have originated in England in the late eighteenth century with the dandies and their leader, Beau Brummell, the top hat started with the upper classes and ultimately filtered its way down to the common man. Originally made of felted beaver, it later was covered in silk. At its tallest, it stood about eight inches high and in its lower range it stopped at about five inches. Variations include the taller Stovepipe, which Abraham Lincoln made famous, and the Coachman Hat, which is a few inches shorter than the traditional top hat.

Toque

The toque is a brimless hat that adds graphic angles to the face. In fur, as worn by Marlene Dietrich, complemented by a matching stole, it is glamour personified. The toque conveys luxury and power and has the added benefit of adding height!

Trilby

The trilby is a relative of the fedora but smaller in scale, with a shorter brim, rolled in back. It is traditionally creased lengthwise down the crown and has an angled front brim and an upturned back. Styled after a character in George du Maurier's novel of the same name, the trilby has a unisex appeal. Most recently revived by young men dressed to look hip for the club scene, it is very much a hat of the moment. Trilbies can be worn at rakish angles for flirting and are useful for all-weather traveling, in straw, felt, or leather.

Turban

The turban is memorable on Gloria Swanson in *Sunset Boulevard*, the model Paulina Porizkova in an Estée Lauder advertisement, or Elizabeth Taylor—everywhere! And it's one of Prada's favorite shapes. It is a timeless look from ancient times, particularly in Middle Eastern and South Asian countries. Originally conceived as a single strip of cloth that could be as long as five yards, the turban was wound around the head, forming a knot or peak at the top. A modern turban is permanently draped and sewn, so it can be put on like a hat and is perfect for protecting the hair from sun and salt. Bandeaux create the same "eyeline" without covering the hair and are perfect for winter sports.

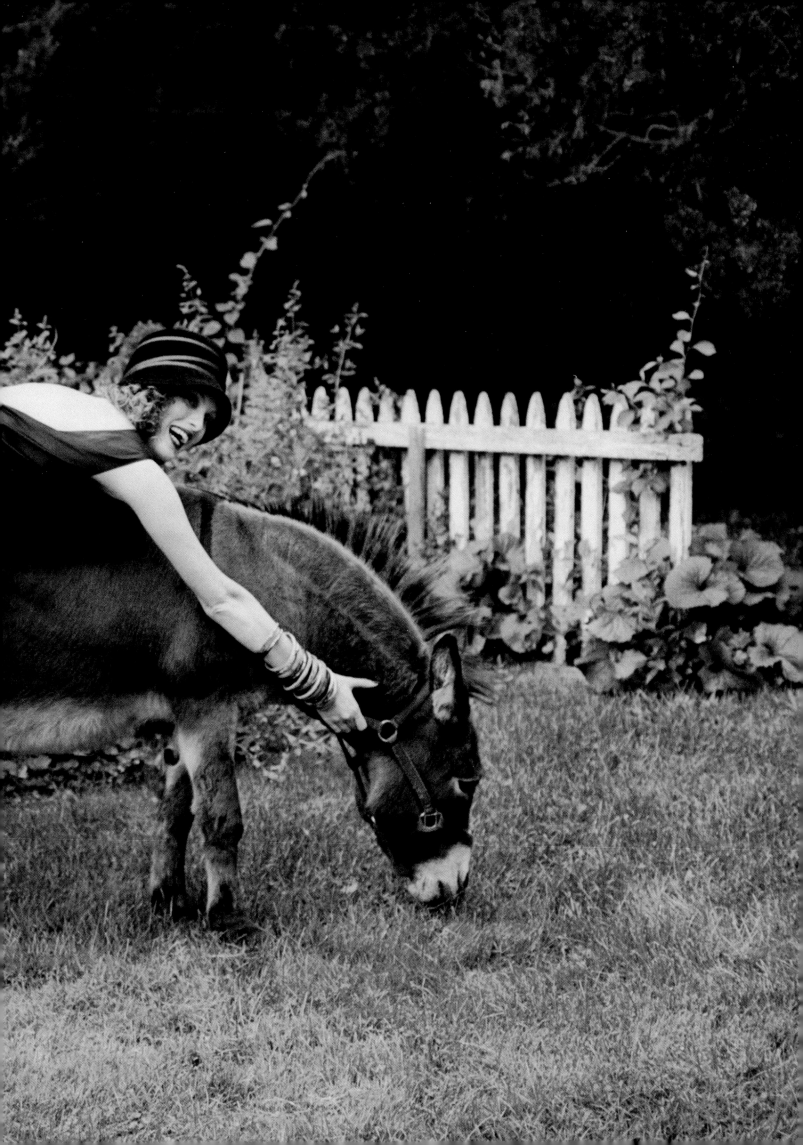

acknowledgments

The authors thank the following individuals who were vital to the making of this book, most importantly the talented Patricia Underwood for inspiring us with her four decades of modern millinery—hats of such wondrous simplicity and beauty that they always appeal. And Jon Moynihan, Underwood's husband, for his wisdom and unflagging support.

At Rizzoli USA, our redoubtable publisher, Charles Miers; our multitalented editor, Philip Reeser; and our inventive art director, Phil Kovacevich, who all helped shape this book. And Isaac Mizrahi, fashion designer and Renaissance man, for penning his thoughtful foreword.

Over the years there have been brimsful of editors, stylists, associates, and friends who have contributed greatly to the success of Patricia Underwood's career. She is profoundly thankful for them all, and acknowledges them here:

At Patricia Underwood

Lipp Holmfeld, who has been there from the very beginning and who remains to this very day a great friend and contributor; the late Eileen Carson, who was so very talented; Judy Hummel, who is the engine of the business and is "Montana strong"; Victoria Perry, who has blossomed here at Patricia Underwood; Ivan Leon, who has flourished here at Patricia Underwood; Jon Moynihan, my darling husband; Matthew Thurley, who makes things happen; Vivecca Underwood Mazella, my wonderful daughter, whose birth coincided with the birth of our company; Reginald Underwood, who brought me to America and gave me my name and Vivecca; and Don Robertus

Friends and Supporters

Kristen Altuntop, Katina Arts-Meyer, Annabelle Baker, Carter Berg, Buffy Birrittella, Rose Marie Bravo, Russell Brock, Dr. Joyce Brown, Joan Burstein, Joanna Caine, John Calcagno, Marilyn Cane, Mary Randolph

Carter, David Crystal II, Hilde de Hooghe, Marianne Engberg, Tom Fallon, Gretchen Fenston, Patricia Field, Marc Fowler, Lisa Gold, Rebecca Gold, Pamela Griffiths, Bethann Hardison, Cathy Hardwick, Margaret Hayes, Stan Herman, Mary Hilliard, Jennifer Houser, Joan Kaner, Donna Karan, Elsa Klensch, Michael Kors, Jed Krascella, Eleanor Lambert, Ralph Lauren, Erica Lennard, William Ivey Long, Roxanne Lowit, Julia Marozzi, Patricia Mears, Dawn Mello, Isaac Mizrahi, Jocelyn Montgomery, Monty Montgomery, Leigh Montville, Ira Neimark, Claire Nicholson, David Norbury, Perry Ogden, Daniel Orlandi, Miguel Osuna, Cathy Parrot, Patricia Pastor, Bonnie Pressman, Mary Ann Restivo, Heather Richardson, Fiammetta Rocco, Sally Ross, Debbie Safrin, Ellin Saltzman, Audrey Smaltz, Rodney Smith, Leslie Smolen, Valerie Steele, Nan Talese, Burt Tansky, Monika Tilley, Isabel and Ruben Toledo, Diane von Furstenberg, Shawn Waldron, Bruce Weber, William Wegman, Sandra Wilson, and Mirjana Winterbottom

Editors and Stylists

June Ambrose, Charlie Anderson, Martha Baker, Tina Bossidy, Nicole Brewer, Bernat Buscato, Harriet Cain, Jule Campbell, Jenny Capitain, Ann Caruso, Paul Cavaco, Kim Chandler, Grace Coddington, Joni Cohen, Bill Cunningham, Charles De Caro, Christine de Lassus, Carrie Donovan, Edward Enninful, Kyle Erikson, Laura Ferrara, Pamela Fiori, Rosemary Forman, Nicola Formichetti, Robert Forrest, Bonnie Fuller, Lori Goldstein, Tonne Goodman, Wendy Goodman, Rae Ann Herman, Romita Herreira, Jane Hsiang, Brooke Jaffe, Will Kahn, Tricia Kenny, Marilyn Kirschner, James La Spada, Donald Lawrence, Freddy Leiba, Renata Lindler, Mary Lou Luther, Beatrice Mandelbaum, Joe McKenna, Polly Mellen, Darcy Miller, Meenal Mistry, Mel Ottenberg, Tina Perlmutter, Patricia Peterson, Sarah Gore Reeves, Linda Hopp Rodin, Carine Roitfeld, Elissa Santisi, Laurie Schecter, Marina Schiano, Anne Slowey, Diane Smith, Mary Alice Stephenson, Marie Amelie Suave, Cricket Tedesco, Karl Templer, Liz Tilberis, Barbara Turk, Elissa Velluto, Robert Verdi, Michel Voyski, Samantha Walker, Erin Walsh, Alex White, Eric Wilson, Patti Wilson, Anna Wintour, Kate Young, and Joe Zee

And a huge thank-you to the dynamic, distinctive women who live life and have fun wearing the hats we make.

In recognition of her outstanding work, Patricia Underwood has received a COTY award, a CFDA award, an American Accessories Achievement award, and Fashion Group International Entrepreneur of the Year award. She is currently a board member of the Council of Fashion Designers of America.

"Underwood is as resolute as she is creative. When the CFDA had to elect a new president, she convinced me that I was the man for the job and that she would enlist the support of her pals to help get me elected. She wasn't kidding. With her core group of friends she saw to it that not only was I elected, but I won unanimously. I don't think there's anything that she couldn't do!"

—Stan Herman

photo credits

Thank you to the many talented photographers who have photographed my hats over the years, especially to the ones represented in this book.

Page 1: Photo by Evan Sklar. Courtesy of Patricia Underwood.

Pages 2–3: Paul Sunday

Page 5: Daniel Jackson / Trunk Archive

Page 6: Arthur Elgort / *Glamour* © Condé Nast Publications

Page 7: Jim Varriale

Page 9: Yu Tsai

Page 10: Tom Munro

Page 12: © Denis Piel. Joanna Pacula, NYC, 1985. Photographed for *Vogue*.

Page 14: Photo by Dan Lecca. Courtesy of Isaac Mizrahi.

Page 17: Arthur Elgort / *Vogue* © Condé Nast Publications

Page 18: Photo Rick Gilette

Pages 20–21: Photograph by Annie Leibovitz / Contact Press Images. Originally photographed for *Vogue*.

Page 22: Steven White

Page 26: Collection of Patricia Underwood

Page 27: Photo by Helene Joseph

Page 29: Photograph by Richard Avedon © The Richard Avedon Foundation

Page 30: Steven Meisel / *WWD* © Condé Nast Publications

Page 31: Collection of Patricia Underwood

Page 32 (top and bottom): Collection of Patricia Underwood

Page 33 (all): Collection of Patricia Underwood

Page 34: Collection of Patricia Underwood

Page 36: Photo by Mirella Richiardi. Courtesy of Patricia Underwood.

Page 37 (all): Collection of Patricia Underwood

Page 38 (top and bottom): Collection of Patricia Underwood

Page 39: Photo by Jon Calcagno

Page 40 (clockwise from top left): Photography by David Banks; Collection of Patricia Underwood; Photo by Jon Moynihan; and Courtesy of The White House.

Page 41 (clockwise from top): Collection of Patricia Underwood; Collection of Patricia Underwood; Collection of Patricia Underwood; and Photo by Jon Moynihan

Pages 42–43: Photography by David Banks

Page 45 (top): Georges Seurat (French, 1859–1891), *A Sunday on La Grande Jatte – 1884*, 1884–86. Oil on canvas, 81 3/4 x 121 1/4 in. (207.5 x 308.1 cm). Helen Birch Bartlett Memorial Collection, 1926.224. Collection of the Art Institute of Chicago.

Page 45 (bottom): Video still by Benita Cassar Torreggiani

Page 46 (clockwise from upper left): *The Scarlet Empress*: Courtesy Everett Collection; *Bonnie and Clyde*: Courtesy Everett Collection; *Destry Rides Again*: Courtesy Everett Collection; and *The Kiss*: Courtesy Everett Collection

Page 47 (left to right): Moviepix / Getty Images; *Morocco*: Courtesy Everett Collection; and *His Girl Friday*: Courtesy Everett Collection

Pages 50–51: Craig McDean / Art + Commerce

Page 53: Marianne Engberg

Page 54: Photo by Bruce Weber

Page 55: Toby McFarlan Pond / Trunk Archive

Pages 56–57: Photo by Carter Berg. Courtesy of Ralph Lauren.

Pages 58–59: Arthur Elgort / *Vogue* © Condé Nast Publications

Pages 60–61: Photo by Carter Berg. Courtesy of Ralph Lauren.

Pages 62–63: Photo by Bill King for *Vogue*. © Janet McClelland.

Page 64: Photo by Gomillion and Leupold / Contour Style by Getty Images

Page 65: Laspata DeCaro

Pages 66–67: Ellen von Unwerth / Trunk Archive

Pages 68–69: Marianne Engberg

Pages 70–71: © James White / Corbis Outline

Page 73: Gilles Bensimon / Trunk Archive

Pages 74–75: Denis Piel / *Vogue* © Condé Nast Publications

Page 77: Tim Zaragoza

Pages 78–79: © James White / Corbis Outline

Pages 80–81: Denis Piel / *Vogue* © Condé Nast Publications

Page 83: Ellen von Unwerth / Trunk Archive

Page 84: Photographer Dimitri Hyacinthe

Page 85: Photographer Dimitri Hyacinthe

Page 87: Inez and Vinoodh / Trunk Archive

Pages 88–89: Susie Cushner

Pages 90–91: Albert Giordan

Page 93: Ellen von Unwerth / Trunk Archive

Pages 94–95: Photo by Gomillion and Leupold / Contour Style by Getty Images

Page 97: www.trunkarchive.com

Page 98: © James White / Corbis Outline

Page 99: © Antoine Verglas / *Sports Illustrated* / Contour by Getty Images

Page 101: Diana Koenigsberg

Pages 102–103: Will Davidson / Trunk Archive

Pages 104–105: © James White / Corbis Outline

Page 107: Photo by Carter Berg. Courtesy of Ralph Lauren.

Pages 108–109: Photo by Carter Berg. Courtesy of Ralph Lauren.

Page 110: Photo of Jocelyn Montgomery by Monty Montgomery

Page 111: Patrick Demarchelier / *Vogue* © Condé Nast Publications

Page 112: Arthur Elgort / *Self* © Condé Nast Publications

Page 113: Arthur Elgort / *Self* © Condé Nast Publications

Page 115: Sharif Hamza / Trunk Archive

Pages 116–117: Josh Olins / Trunk Archive

Page 118: © Rodney Smith

Page 119: Miguel Reveriego / Trunk Archive

Pages 120–121: Raymond Meier / Trunk Archive

Page 122: Ellen von Unwerth / Trunk Archive

Page 123: Patrick Demarchelier / *Vogue* © Condé Nast Publications

Page 125: Photo by Thom Gilbert

Pages 126–127: Arthur Elgort / *Vogue* © Condé Nast Publications

Pages 128–129: © James White / Corbis Outline

Page 131: Arthur Elgort / *Vogue* © Condé Nast Publications

Page 132: © James White / Corbis Outline

Page 133: Collection of Patricia Underwood

Pages 134–135: Photo by Kyle Ericsson. Courtesy of Patricia Underwood.

Page 137: Photo by Carter Berg. Courtesy of Ralph Lauren.

Page 138: Tom Munro

Page 139: Photo by Kyle Ericsson. Courtesy of Patricia Underwood.

Pages 140–141: Collection of Patricia Underwood

Page 142: Collection of Patricia Underwood

Page 143: Collection of Patricia Underwood

Page 145: Collection of Patricia Underwood

Pages 146–147: Yeste Txema / Trunk Archive

Page 148: © Rodney Smith

Page 149: © Rodney Smith

Page 150 (top and bottom): © Rodney Smith

Page 151: Sheila Metzner / Trunk Archive

Page 153: © William Wegman

Page 154: Photo by Barry Lategan

Page 157: Photo by Barry Lategan

Page 158: Photo © John Deane. Model: Debbie Gryte. Fashion Stylist: Jeffrey Thomas.

Page 160: Photo by Carter Berg. Courtesy of Ralph Lauren.

Page 161: Photo by Carter Berg. Courtesy of Ralph Lauren.

Page 162 (left): Photo by Roxanne Lowit

Page 162 (right): Photo by Barry Lategan

Page 163 (top): Rachel Scroggins

Page 163 (bottom): Paul Sunday

Page 164: Illustration by Ruben Toledo

Page 167 (all): Illustrations by Ruben Toledo

Page 168: Sketch by William Ivey Long

Page 169: Photo © Paul Kolnik

Page 171 (top left, bottom left, and bottom right): Sketches by Daniel Orlandi

Page 171 (top right): *Down With Love*: Mary Evans Picture Library / Everett Collection

Page 172 (clockwise from top): *Four Weddings and a Funeral*: Mary Evans Picture Library / Everett Collection; *Sabrina*: Paramount / Courtesy Everett Collection; *Betsy's Wedding*: Walt Disney Co. / Courtesy Everett Collection; and *Sabrina*: Paramount / Courtesy Everett Collection

Page 173 (clockwise from top): *Sex And The City 2*: New Line Cinema / Courtesy Everett Collection; *Six Days Seven Nights*: Walt Disney Co. / Courtesy Everett Collection; and *Crocodile Dundee II*: Mary Evans Picture Library / Everett Collection

Page 174: Collection of Patricia Underwood

Page 175: Collection of Patricia Underwood

Page 176: Photo by Ray Lustig

Page 177: Photo by Thom Gilbert

Page 178 (left to right): Collection of Patricia Underwood; and Photo by Thom Gilbert

Page 179 (left to right): Collection of Patricia Underwood; Photo by Victoria Perry; and Photo by Thom Gilbert

Page 180 (clockwise from upper left): Photo by Thom Gilbert; Collection of Patricia Underwood; Collection of Patricia Underwood; and Courtesy of Cathy Hardwick

Page 181 (clockwise from upper left): Courtesy of Marilyn Cane; Courtesy of Marilyn Cane; Courtesy of Cathy Hardwick; and Collection of Patricia Underwood

Pages 186–187: Arthur Elgort / *Vogue* © Condé Nast Publications

Page 190: Photography by Rick Haylor

First published in the United States of America in 2015 by

Rizzoli International Publications, Inc.
300 Park Avenue South
New York, NY 10010
www.rizzoliusa.com

Rizzoli Project Editor: Philip Reeser
Rizzoli Production Manager: Susan Lynch
Designer: Phil Kovacevich

Subtitle taken from lyrics of "They Can't Take That Away From Me"
from *Shall We Dance* (1937) and *The Barkleys of Broadway* (1949)
Music and Lyrics by George Gershwin and Ira Gershwin
© 1936 (Renewed) Nokawi Music, Frankie G. Songs, and Ira
Gershwin Music
All Rights for Nokawi Music administered by Imagem Sounds
All Rights for Ira Gershwin Music administered by WB Music Corp.
All Rights Reserved / Used by Permission
Reprinted by Permission of Hal Leonard Corporation
Reprinted by Permission of Alfred Publishing

ISBN: 978-0-8478-4478-4
Library of Congress Control Number: 2014954066

Distributed to the U.S. trade by Random House, New York

Printed and bound in China

2015 2016 2017 2018 / 10 9 8 7 6 5 4 3 2 1

Page 1: Banana-
colored stitched
Starbrite and
paglina straw hat

Pages 2–3: Patricia
Underwood for Bill
Blass: big-bowed,
tricolor, brimmed
hat in paglina straw

Page 5: Actress
Elle Fanning
in shredded,
herringbone straw

Page 6: Into the
woods: black knitted
newsboy cap with
leather brim

Page 7: Naomi
Campbell in
Underwood's striped
"off sailor" hat

Page 9: Lily Rabe in
wide-brimmed white
hat with black band

Page 10: Linda
Vojtova in a jaunty
Underwood black
fedora

Page 12: Joanna
Pacula in a flirty
summer-weight
white organdy
bucket-boater

Pages 186–87:
Ribbon-banded
cloche in felt on
Karen Elson, kicking
up her heels on a
summer afternoon